MUNCH

In His Own Words

POUL ERIK TØJNER

MUNCH

In His Own Words

Prestel

Munich · London · New York

For Per Kirkeby

© 2001 Prestel Verlag, Munich, London, New York for the English language edition
Original title: Munch – med egne ord
© Forlaget Press, Oslo, and Forlaget Søren Fogtdal, Copenhagen
© Poul Erik Tøjner: text pp. 9–59, 62, 74, 90, 102, 130, 152, 176, 211–213
© Edvard Munch's manuscript and photographs: Munch Museum, Oslo
© Edvard Munch's works: Munch Museum/Munch-Ellingsen Group/BONO 2000
© Photographic reproductions: pp. 18, 23, 25, 33, 93, 165 (left) and 184: Nasjonalgalleriet (J. Lathion)
© All other photographic reproductions: Munch Museum (Andersen/de Jong)
All photographs were lent by the Munch Museum's archives
The following photographers have been identified (the portraits on pp. 56–57 are numbered from left to right):
Ragnvald Væring: pp. 37, 56–57 (no. 10), 167, 214, 217, 220
Wilse: pp. 56–57 (nos. 8 and 9), 165, 212
A. F. Johansen: pp. 51 and 156
J. Lindegaard: pp. 56–57 (no. 1)
Julie Laurberg: pp. 56–57 (no. 5)
Kristiania Røntgeninstitutt: p. 189
E. Munch: pp. 60–61, 72–73, 88–89, 100–101, 174–175, 223
Frk. Emanuelsen: p. 224

A Library of Congress Card Number is available for this title.

Prestel-Verlag
Mandlstrasse 26
D-80802 Munich
Germany
Tel.: (89) 38-17-09-0
Fax.: (89) 38-17-09-35
www.prestel.de

4 Bloomsbury Place
London
WC1A 2QA
Tel.: (020) 7323 5004
Fax.: (020) 7636 8004

175 Fifth Avenue, Suite 402
New York
NY 10010
Tel.: (212) 995 2720
Fax.: (212) 995 2733
www.prestel.com

Prestel books are available worldwide. Please contact your nearest bookseller
or any of the above addresses for information concerning your local distributor.

Translation of Edvard Munch: Jennifer Lloyd
Translation of Poul Erik Tøjner: Ian Lukins/Jennifer Lloyd

Design, collages and image editing: Subtopia a.s. (www.subtopia.no)

Typeset in Adobe Sabon, Hoefler Text (www.typography.com) and ITC Galliard
Graphic production: PDC Tangen, Norway
Printed on 150 gsm Galerie art silk

Printed in Norway

ISBN: 3-7913-2494-2

Edvard Munch in Kragerø.

CONTENTS

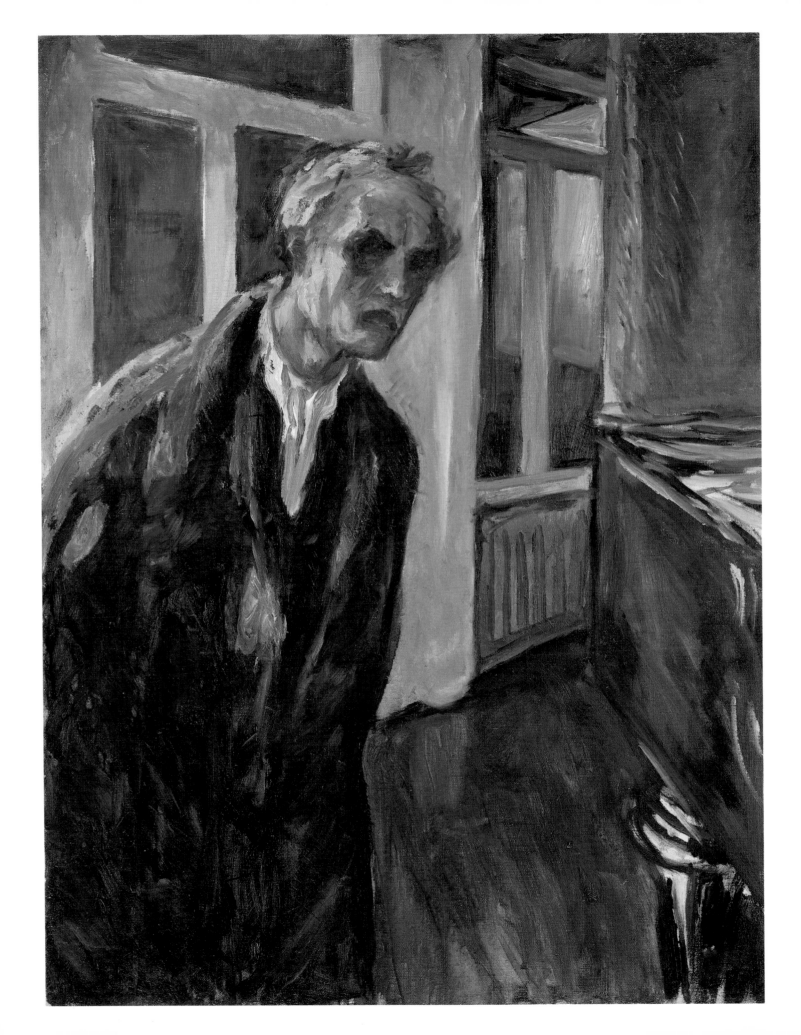

FOREWORD

This book has been written and published on the basis of my many years' intense fascination with the artist Edvard Munch. The book contains a large selection of Munch's own writings, the majority of which have never been published before. It also includes an essay that attempts to present what is specially characteristic of Munch as an artist.

Edvard Munch is a truly original and unique artist with an artistic perspective that stretches back to the Middle Ages and forward to well beyond his contemporaries – to us, and to everyone who stands in front of his pictures. It is naturally the view of the writer that, in the final analysis, what matters is the viewer's encounter with the pictures – and it is also here, in front of the picture, that the art and the artist must stand their test. That Munch succeeded in this respect hardly needs to be pointed out here.

The choice of text material is based on copies of original material which is in the archives and library of the Munch Museum, and references (such as **N 545** in the extracts) relate to this. I have retained Munch's rather inconsistent orthography, not only for philological reasons, but also because I believe that it makes a distinctive and untraditional comment on the character of the man.

I would like to thank the following people very much for their help in making this book possible: former senior librarian Sissel Biørnstad for checking the copies against the originals, director of the Munch Museum Arne Eggum for his support in the work, Jan Verner-Carlsson for his part in the editorial process, Lars Roar Langslet for assisting in the linguistic assessment of the material, and Karen Lerheim for helping with the visual material. Finally, I would like to thank Håkon Harket, Lars Erik Strandberg, Erik Steffensen and Steen Bang Rasmussen for their efforts. Last, but not least, I would like to thank my family for all their support and forbearance.

Poul Erik Tøjner

SELF-PORTRAIT, THE NIGHT WANDERER
1923–24, oil on canvas, 121.5 x 118.5 cm
Munch Museum

Postcard with drawing by Edvard Munch.

PLUMBING THE DEPTHS OF SUPERFICIALITY

"If a book were to be written about me,
it would be wrong to make it too neat.
I'm no fine young lady."

MUNCH, TO STENERSEN

I

When looking at Edvard Munch's work, most people are tempted to begin by examining his life, and delving into how this influenced his work. However troubled his life became, it is strangely enough the magnet that attracts most strongly, and is the most usual starting point for presentations of his work. Few are able to break free of this approach, which is in a way paradoxical, as few artists have attained Munch's way of administrating his art. On the one hand he placed his whole life and its misfortunes into his paintings, excessively privatizing the images – and on the other hand he produced art of such a general iconic character that the artist's personal entanglement with his art seems quite irrelevant.

By risking everything, Munch could be said to have carried existential intimacy beyond the bounds of reason – there was nothing more to say. More precisely, no words of explanation were necessary outside the pictures themselves. Oscar Wilde, one of his contemporaries who specialized in superficiality as an art form, voiced the following thought through one of his characters: "The only artists I know who are personally endearing are amongst the bad ones; good artists put everything into their art, and as a result are themselves quite uninteresting."

In other words: are Munch's own biographical notes – to which this book is of course dedicated – indispensable in approaching his work? There can hardly be any doubt that if we as viewers are more interested in his pictures than in Munch himself, we would be doing what Munch himself attempted to do throughout his life: to go beyond himself. To escape from himself. To reinvent himself, which is a more comfortable formula for self-recognition, especially if he was discontented with certain aspects of his character. This shift of interest allows us to step closer to the deepest intentions in the work. The important relationship between the artist and his work needs to be dissected in order to be more clearly understood from both sides. The pictures themselves achieve this – their form, subject-matter and physical painting techniques formulate that relationship.

II

Munch's contemporaries disliked and distrusted him. He was misunderstood, and the fact that his images plumbed the depths, so to speak – including the mental abyss – was probably one of the reasons for this. He insisted upon revealing the unmentionable – bringing contemporary issues up to the surface and letting them remain there, quivering and brutally present. The shock of Courbet's and Manet's realism had left its mark, and Munch was far from the first to have painted dreams, flesh and death. But the manner in which he did so repelled his contemporaries.

For them, this was the ultimate deathblow to art – the point at which artist, subject matter and painting technique merged and became one. The comfort of "good form" ceased to exist, and what remained was reality. Art as documentary, as experience – mine and yours, and the artist's. For example: think of Caspar David Friedrich's famous depiction of the chaotic sea of ice that draws the ship down to eternal damnation – *Das Eismeer* (*The Sea of Ice*) (1823/25). The painting is about chaos, but is itself organized with meticulous care. The iceberg in the foreground of the painting is repeated almost holographically on the fading horizon. It represents no threat – the danger is not imminent, as Burke, the British philosopher remarked about the aesthetic relationship to the sublime. But with the passing of time, it has become so. With Munch. Depiction is no longer enough – it is no longer "about" a subject, or the subject painted from a distance. It is the image itself – experienced at that very moment.

It is, in fact, as simple as content wanting to be form – and vice versa – but this was not easily digested in Munch's time. Scandal was the order of the day – and when the young Edvard Munch showed his *Sick Child* together with a number of other pictures, scandal certainly did rage in Kristiania (Oslo). This established a pattern; Munch's paintings were misunderstood and badly received by his contemporaries and the general public during the course of the ensuing years.

They perceived his work as being sick to the core. It was not only the fact that Munch could not paint hands – as his naturalistic Norwegian colleague Gustav Wentzel remarked – it was that he painted like a swine! But in a way Wentzel was right, perhaps without knowing it. The artistic energy in the picture of the sick child was based upon an idea of foulness, of pestilence – a prematurely severed existence – which is illustrated, almost tactilely, in painterly terms. Here is a subject; its unbearable nature cannot be kept separate from its portrayal. It is exactingly observed. Traces of the time-consuming work involved in building up the painting can be seen – the oil paint has even formed the cicatrices of the subject. It is an insurmountable painting of an insurmountable situation. We do not have to do much research in order to understand that it is an event the artist found unbearable. Although we know that its source is the early death of Munch's sister Sophie, we can see his pain just by looking at the painting.

This early work is an emblem of the whole of Munch's artistic oeuvre – the painter's own attempt to come to grips with grief is visible in the physicality of the painting. His experience is directly available to the viewer. It is probably true that he could not paint hands, but then it is not the fine interlacing pattern of fingers that is at issue here – it is nothing less than the physical interdependence of mother and child that is being severed. That is why their hands are one flesh – positioned right in the middle of the painting. One frozen moment, soon to come to an end.

No one can be unaffected by the pain in the painting, and yet it is not sentimental. Munch says somewhere in his diaries that when we die it is the world that dies from us, and one could also add that the pain remains with those left behind. This is another aspect of the painting, emphasized through its composition, which Munch altered as he worked. The viewer's point of identification is not the dying child. The painting is not about the fear of dying, but about being abandoned. It is the mother who feels death and hides her face in despair. It is the mother, ourselves as viewers, and the artist who are the subjects of the painting. The child is already on her way into some kind of transfiguring light that nobody can explain. That is why there is a bottle on the table, and a glass, clumsily and carelessly painted. These objects represent our world, and those who always remain behind. What makes it so relentlessly brutal is the inevitability of the situation – a situation that will be replayed many times in the future.

The painter offers no comfort. That is why the public screamed, laughed, and derided the painting openly at the time. Because as they saw it, the painter had failed in his task. He had failed to ensure that the work of art held a back door open to a world of peace and order, regardless of what it might depict in the foreground.

This was the scandal of the times, back then in the mid-1880s, and similar scandals will continue in the future. Typically these include artists who do not respect pre-ordained and often conservative ideals within the field of art – or artists who fail to fulfil a specific expectation. Munch made no concessions to such thinking.

III

When time has made its assessment, a man like Munch either ends up shining like a star in the heavens, or imploding like a black hole. Munch managed both of these. Although his life was not exactly paved with success, one could say that during his own lifetime he managed to experience a little of the status which he subsequently achieved. During his early years (in the 1880s), apprenticed to the Kristiania-Bohemian painter, Hans Jaeger, he was weighed down by family grief. The early death of his mother was probably the most significant bereavement he suffered. In response to this, he clarified his thematic world in a series of pictures. These were based upon the idea that all subject matter should be painted intimately, the inner life as well as the outer one (visible as well as invisible), and that it should be possible to feel this proximity upon the skin – both the canvas and the body. Intimacy is the keyword, in both art and life. No discernment, but identification. No distance, but intensity. In fact, this holds true for all of Munch's work, even though his life changes course, even though history moves forward. He found himself in Berlin at the beginning of the 1890s and created a furore there. The outcry was enormous, because Munch painted no visions of the future, choosing instead to concentrate upon existing situations and the fascination of transience.

It could be said that as an avant-garde artist he was the right man in the right place, precisely because he was the wrong man. It has since become clear that on a number of occasions during his career he was used as a pawn in a local game of art politics in connection with the Central European Secession exhibitions. Nevertheless, he survived as an artist. He came close to losing his life on a number of occasions – bouts of drunkenness, paranoia and neurotic sickness all took their toll. Love and intoxication spun their unreal/ultra-real web around him, finally tightening their grasp so much that he was barely able to move. About twenty years after Nietzsche embraced a horse out of pity in a street in Turin, Edvard Munch contented himself with being admitted to Frederiksberg Clinic in Copenhagen for general detoxification after progressive paralysis. At this point in his career he had experienced an explosive development in his painting, assuring him a place amongst the most significant painters of the century. The attention he now attracted was difficult for him to bear.

This European avant-gardist now embarked upon a no less powerful retreat. It was 1909. He abandoned his position in the turbulent, fashionable art world, in order to live the life of a hermit – far from the petty arguments and scandals of Kristiania. He was intent upon discovering another rhythm of life, far away from women and alcohol. Increasingly taking on the mannerisms of a hermit, he took up residence by the Oslo fjord, at Ekely, from 1916 until his death.

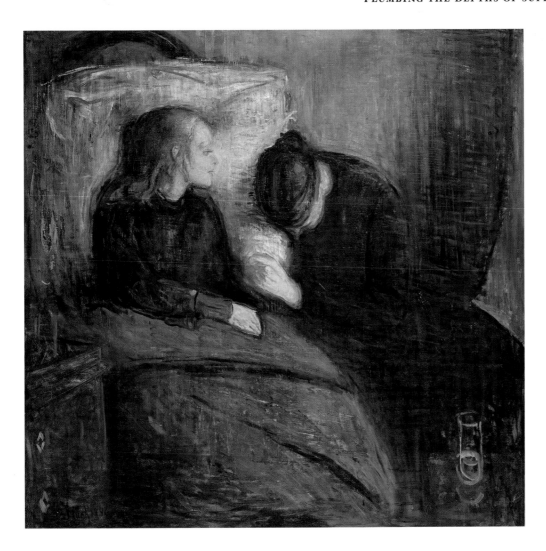

The star had in a sense imploded, but, as is the case with such celestial bodies, this gave it a much greater force of attraction. Munch became the object of many people's interest and admiration. In his own view, he attracted interest from the wrong people. Bitterness was partly consuming him, but the large commission he was engaged upon for the Aula at Oslo University probably prevented this bitterness from dominating his life.

He now lived in the midst of his art, he lived from it (inasmuch as he wanted to sell anything at all), and most importantly, he immersed himself in it. Seen from his point of view – and Munch saw a lot from his point of view – everything seemed to be complete. As this book shows, he also wrote a great deal, and his own texts clarify this sense of completion.

Munch developed the ideas he had worked on in his younger years, yet his compass

THE SICK CHILD
1896, oil on canvas, 121.5 x 118.5 cm
Göteborg Museum of Art

was now bearing in another direction. He gradually extended the scope, and especially the size of his work, but this happened almost seamlessly, making it difficult to distinguish the two movements from each other.

Munch identified with his subjects. He wished to do so, and this tangible immersion in his subject matter pulled the body of his work together, giving it greater definition. A Danish writer used the phrase "a genial monotony" to describe this situation, and the phrase is very relevant to Munch's oeuvre. During the course of his life he was monomaniacally preoccupied, even obsessed, with certain subjects and ideas. At the same time he possessed an openness of spirit and a lack of direction that bordered on dissolution. When Munch decided to buy the property at Ekely in Kristiania, he gave himself the space and opportunity to immerse himself in his work.

IV

All the compass points of Munch's life were related to the world as he experienced it. His relationship with the surrounding world was problematical. For long periods of his life he experienced the world as a demonic force, which filled him with fear and sadness. He tried to keep it at bay, terrified by its panic-inducing power over him. For Munch, the world represented the "other" – something outside himself to which he was resigned, but which he was unable to control. From time to time he attempted a more easygoing, harmonious relationship with the surrounding world, but his inborn fear was never far away. His paintings express this innately problematic relationship. It is represented in several ways: the images he painted were often of people who were on the edge of society, or the world – at odds with it. In addition, all his paintings express the theme of the surrounding world through their physical reality, through the way they have been arranged, composed, and painted.

Munch's relationship to the surrounding world lends an almost geological pattern to his art. It is orchestrated in innumerable ways. All the decisions he made, including those regarding the choice of technique and subject matter, are saturated with it. It could be said to be the hallmark of his oeuvre.

It is significant in several ways: firstly, the paintings were always about people who had an accentuated relationship to space or to the world about them; secondly, the world, or space that Munch described in his paintings, took on a colour or a form that represented the subject's relationship to it; thirdly, the link between the subject and the surrounding world in the painting is impossible to separate from the link between the artist and the painting; and finally, this link is repeated in the relationship between the viewer and the painting – a relationship that Munch was always aware of.

In *Selvportræt med cigaret* (*Self-portrait with Cigarette*) from 1895, Munch's glance implies the desire for self-knowledge: Who am I? Do I exist at all? And in relation to what? This is precisely the point of the painting. I am unable to separate myself from my world – I am just as ephemeral and elusive as the smoke that envelops me, revealing my intricate character, and connecting me with the air around me – with the world. So flimsy and transparent, consisting of nothing. At this point in Munch's life, love was a guiding force. There was always fire when it made its appearance. Munch was particularly fascinated by women's hair, and described it in great detail; the delicate strands could be grabbed and held, even if the woman was as elusive as the smoke in his self-portrait.

Munch's subjects are portrayed either as one flesh, as the mother with her sick child, the lovers in *Kys* (*Kiss*), the dancing couples on the beach, the group of women on the bridge, or the inappropriately titled *Vampyr* (*Vampire*); or they are represented by the finest web, where it is hardly possible to distinguish between dream and illusion.

Nevertheless, Munch's later paintings, produced during his period of residence at Ekely, represent another side of his work. They seem to be less soul-searching – it would appear that he had come to terms with himself, and was now more interested in exploring

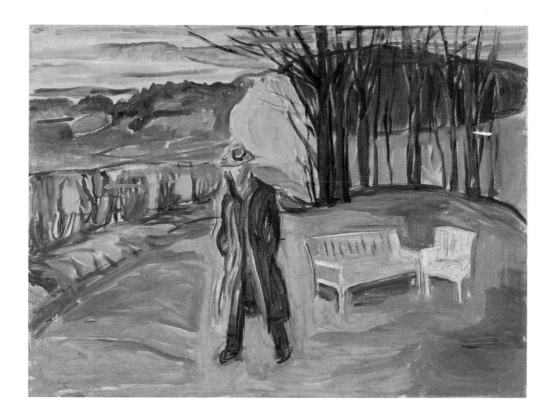

SELF-PORTRAIT IN THE GARDEN, EKELY
1942, oil on canvas, 60 x 80 cm

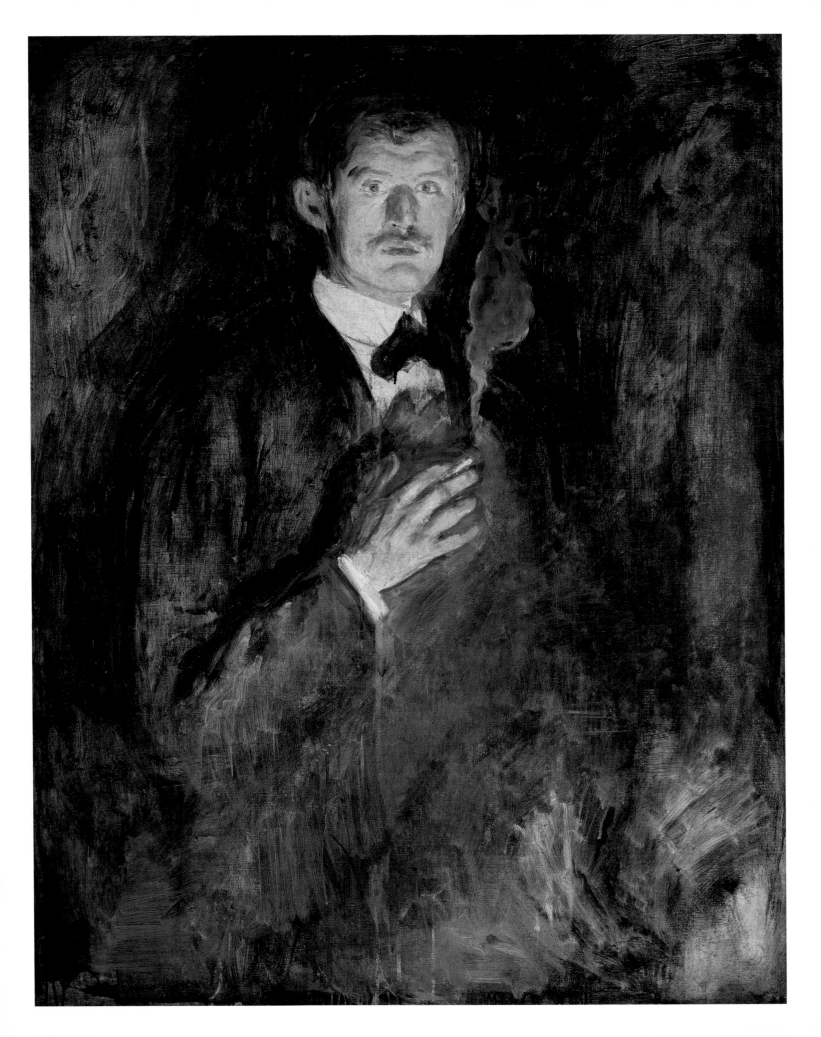

more tangible issues. He concentrated his efforts, asked fewer questions, and painted situations and people exactly as he experienced them.

One of his major works, *Slåttekar* (*The Haymaker*), depicts a man standing cutting a field of flowers with a scythe. Munch is not painting a metaphor for death – the grim reaper. He is simply painting a man – a man with a scythe positioned in the middle of the picture, in the middle of the field. The sky is pink, and there are some trees on the right-hand side of the horizon which appears to be in the near distance. The trees are round and lush.

What is it about, then? Simply about cutting the hay with a scythe. About the movement of cutting with a scythe. That semi-circular stroke that fills the space in front of the man. The movement that occurs before the hay falls to the ground. Stroke after stroke. The semi-circular movement through the hay is repeated in the rounded back of the man, and again in the shape of the scythe blade. We are observing reality: experiencing how it feels to cut hay with a scythe. The swishing stroke of the scythe is echoed in the rounded form of the Earth. This is how Munch paints the landscape. It curves from the horizon, repeating the shape of the Earth – towards the foreground of the picture where it dips violently – more or less under the feet of the working man. The clouds in the sky are round, the trees are round. The man's cap, seen from above, is also round. Munch has swivelled the brush in one movement, repeating the shape. He has painted the hay in the field in the same way – from the background to the foreground – almost in one movement – just like a stroke of the scythe.

The picture is harmonious, even though it is full of movement. It is a picture about the harmony of movement. About things fitting together. This represents another side of his work, far from the disintegrating universe of nagging doubt, and the torment of self-loathing.

V

Irrespective of the distance there seems to be between the melancholic introspection of the earlier pictures and the seemingly transfigured and more action-orientated life of the later ones, the basic thread that runs through Munch's work is the inscrutable relationship that exists between man and the world that surrounds him. In this chemical blend the particles can no longer be separated. It may represent loss of identity, which is primarily the case in Munch's early works, but it can also represent a more light-hearted depiction of self that we find in his later works.

SELF-PORTRAIT WITH CIGARETTE
1895, oil on canvas, 110.5 x 85.5 cm
Nasjonalgalleriet

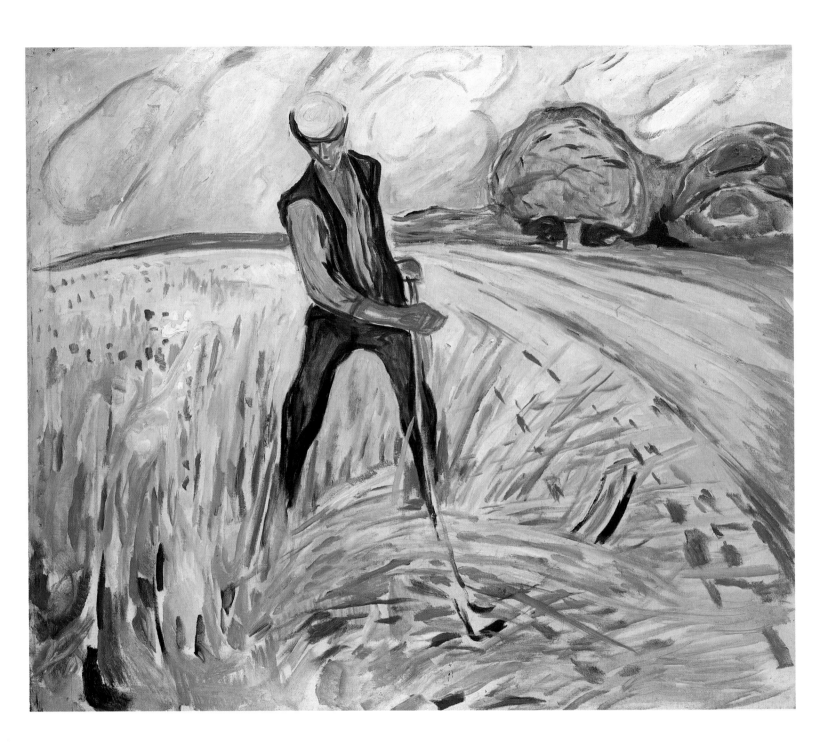

THE HAYMAKER
1916, oil on canvas, 130 x 150 cm
Munch Museum

Take *Skriket* (*The Scream*) (1893), for example. We know what Munch himself wrote: that he felt an enormous, infinite scream course through nature – that he heard a loud scream that was quite tangible to him. We can see that in his painting. The person on the road is holding not only his ears, but his whole head, in an effort to protect himself from the horror. What we cannot see is whether it is an internal or an external pressure that is the cause of the horror. The sound rises and falls like blood pulsing through the picture. It is as if the person is trying to press the plasmatic magma out of his body, yet at the same time, it appears as if he might implode. There is an exchange of traffic, not on the road but between eye and ear.

The energy is centred upon that blind spot. The tiny space where it is impossible to tell what comes from where. Is the world around this person coloured by his mind, or is his mind perishing due to exterior pressure? We cannot tell. Man and world have penetrated each other, and neither man nor the world can from this point onwards be depicted as an entity.

En Pløjemand

Consequently, both world and man are dependent upon one another. When Munch paints landscapes, they are affectively unfurled. We can see this in the snow-covered fields near Elgersburg. They arch their backs, furrows and field boundaries towards the viewer, and the landscape seems to slide towards the viewer. In another painting, the starry night sky shines its light directly upon the shadow of the viewer/painter. When Munch paints houses, they have faces; when he paints people, their bodies are tattooed with points of contact with the surrounding world.

Photograph with drawing by Edvard Munch.

The paradoxical solace of Expressionism is that man and the world are as one, but that the manner in which they are linked is unbearable in many ways. As the world becomes the epitome of what is human, there is no aid at hand for souls in distress. All aspects of life have to be borne by those who choose their own paths. Freedom offers both pleasure and pain. Claustrophobia, fear, and eternal battles of self-doubt represent the negative side of freedom – the feeling of eternally searching for the centre of one's being.

VI

Claustrophobia is noticeable in Munch's work in many forms. As a general theme, it is the dominant feature of the existential suite – scenes from injured life – which appears time and time again in his work. Even in the more cheerful pictures, claustrophobia is apparent as a kind of constant background. The subjects of his paintings are often

imbued with the negative aspects of their surroundings. What good is it to me that the world resembles my heart and mind, if they are too fragile? There is nothing more violent than the claustrophobic feeling of being locked inside a world of mirror images. The demonic is the enclosed. We are familiar with this from the work of Kierkegaard, and Munch was also aware of it. He hardly paints a picture in which this state is not invoked. Enclosure is simply something to be wrestled with – something the picture has to wrestle with.

The psycho-existential imperative becomes Munch's aesthetic dogma, and if one is to talk about Munch's aesthetic, this is the key. It is based upon enclosure, and, consequently on outgoing movement. In all his pictures, there is movement outwards, a movement which inevitably involves the viewer. This is a typical feature of Munch's work, and through this, the claustrophobia also becomes recognizable as the massive, violent, iconographically well-planned and executed choreography that it is.

It is not difficult to recognize this aspect of confrontation in Munch's pictures, because as you look at the picture, it catches sight of you. You are hit by it, you become the object of its approach – you are the one to release the picture from its internal tension. In a way, the viewer takes over the position which has previously been held by the painter. The viewer completes the relay.

The painting becomes both question and answer, proving its strength to break through the constrictions of enclosure and its ability to communicate.

Think of the distance between Monet and Munch. From the contemplative aesthetics of Impressionism to the confrontational art of Post-Impressionism or Expressionism or Munchism – take your pick. Impressionism draws the sensitive person into the endless depth of the picture, as a sponge absorbs water. To see is to travel, to see is to move, deeper down, farther in. To see is to allow the almost botanical qualities of the picture to open and flower. The sun rises and the sun sets – the picture is pure weather, forever changing. It presupposes extreme sensibility. However, this is not particularly relevant to Munch's work. Looking at his work, one does not travel anywhere; one is immediately fixated in front of the painting. There is nothing before and nothing after that has any real significance when you look at Munch's work. That sudden moment of discovery, and the extreme confidence with which the painting is executed, are hallmarks of his work.

Munch has the skill of a poster painter without actually being one. He is a painter with a grasp of the multiplicity of the senses, but first and foremost he is aware of the surface of his painting, and its profound power of statement. He stamps out his subjects, and even though they may be executed with the most slovenly of brushes, they are still astonishingly accurately balanced, and seem almost able to talk. He seems to have captured his subjects at the decisive moment in a long conversation – they are painted at exactly the right moment, capturing a kind of taciturn eloquence.

THE SCREAM
1893, tempera and crayon on cardboard,
91 x 73.5 cm
Nasjonalgalleriet

All the characteristics of confrontational aesthetics are also in place, and he deploys them in many paintings. He plans the space with a characteristic sloping foreground. The pictures dip, they are like a chute sending the depicted subject straight into the arms of the viewer.

Munch's pictures are full of these chutes – and historically speaking we are at a point in time before Futurism, so it is not a question of fashion and style. Its meaning is much deeper than this, as is the case with the surfaces of Munch's paintings.

The arrangement of space is not a perception of space. It is not that he sees it like this, it is how he constructs it. This is a rhetorical feature of his art. The paintings reach beyond the constrictions of the laws of perspective – hence the many bridges and roads cutting in – but always end by coming out towards us. There is a lot of traffic in Munch's paintings – horses galloping towards us, workers marching towards us, bright waxy-faced citizens of Kristiania tottering forwards in pent-up crowds – the mass as an anonymous category – the green-faced murderer, not to mention the many portraits, in which most of the subjects gaze directly out of the picture.

Was he a painter of inner life? Everything indicates that this claim has to be tempered by Munch's obvious fascination with what lay beyond the boundaries of the painting – and with the surface of the painting.

VII

There is one constant element that is more significant than all others in Munch's work, and that is the glance – the eye. If one wants to see people looking, one need go no further than the work of Munch. Few other painters have painted the eye, painted sight, painted the glance, painted the gaze, or the look, to the same degree.

In its most stylized form, we find the gaze only in the person who is looking out of the picture, looking out at the painter who is painting her or him, at the viewer who is observing her or him. Dagny Juel, Munch himself, Strindberg – the subject is of little importance, as nobody knows these people any longer nor is able to say whether they are accurately depicted or completely distorted. These things are also irrelevant, because the gaze has survived as a completely inextinguishable point of contact between the picture and the viewer.

We say that the eye is the mirror of the soul, but in fact the pupil is no more than a black hole. Undeniably, there is a kind of damnation in this when a painter like Munch concentrates all his power of statement upon the face. It is portrayed as a black abyss, a mental vanishing point in a psychological perspective. Nevertheless, the gaze of the subject seems to strike at us with a perceptible life and intensity. One never disappears into a reverie when looking at a face painted by Munch. His subjects have an iconic power, and an "Ecce Homo" is heard before any further approach to the subject is possible.

PORTRAIT OF THE ARTIST'S SISTER INGER
1892, oil on canvas, 172.5 x 122.5 cm
Nasjonalgalleriet

This "Ecce Homo" is not the result of perfectionist toil; it is spontaneous. It can be seen as a kind of framework for Munch's art, and is to be found in numerous variations and forms: from the self-portraits where Munch thrusts his head into the picture at an angle, seemingly only in order to be able to look out of it again, to the more meta-artistic emphasis upon the viewer/painter relationship.

An early work, the strangely prismatic *Militærmusikken på Karl-Johan* (*The Military Band on Karl Johan Street*) from 1889, is an example of this. The houses, the wall of people in the background, and the orchestra have created a scene where claustrophobia and agoraphobia are two sides of the same coin. The two people – children? – about to cross the street stand poised at the start of their journey through life; the opposite pavement appears very far away. Only one small step for mankind, but an enormous step for these two. It is not just a scene from Kristiania on a Sunday; it is a fabulous presentation of life, theatrically staged as an event encompassing more than the crossing itself. We are aware of it instantly, and why? Because Munch has painted this naive, almost clown-like boy in the bottom right-hand corner. A kind of jester of the gaze, screened off from the reality of the picture, an observational footnote, demanding the viewer's attention.

There are a number of later examples, perhaps the most subtle of these being *Den druknede Gutt* (*The Drowned Boy*) from 1908, in which a horse turns its head as if disturbed by a press photographer fumbling with his camera, although of course it has not. The horse is there because Munch needs a focal point around which the painting turns: the release of the picture through the gaze. The gaze as a bridge reaching out to the viewer.

The bridge occurs in many works by Munch – *Damene på bryggen* (*The Ladies on the Bridge*), for example, in one of its many versions. There is always a point of contact. In one version it is direct, very direct – the woman simply walks towards us. In another version it is a girl in the background whose gaze attracts the viewer instantly. In a third version, the hats now replace the eyes, giving the viewer a chance to hide from all those eyes, but if one looks more closely, the hats themselves appear to be staring eyes. Look at the windows in the houses – perhaps they are eyes, too – and that bright sun – an abundance of colour shining out at the viewer.

Munch has gathered together all these elements in the painting *Øye i Øye* (*Eye to Eye*) from 1894. It resembles an allegory from the early Middle Ages. The man and woman look at each other; the woman is depicted, with pastose sensuality, as a wild, flaming entity, whereas the man is portrayed as a scrawny, anaemic weakling. The vitalists will dwell on the symbolic significance of the severed branch, but although this naively positioned focal point could be interpreted in several ways – a wound, or female sexual organs – it most closely resembles an eye.

PLUMBING THE DEPTHS OF SUPERFICIALITY 27

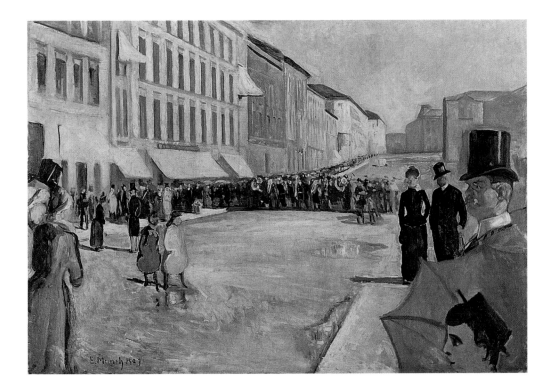

The eye gazes back at the viewer who is gazing at the eye. In a perfect way the painter manages to draw the significant coordinates of the surface out into the room. This gaze becomes the "Eye to Eye" – the relationship between the viewer and the painting. The gaze entices the viewer into the painting – it is so compelling, that the fact that the shed in the background is clumsily painted in flat, two-dimensional terms is inconsequential. It is of no importance, because the significant space is not what is behind the two figures but what is front of them. We are a part of the painting, and it is part of us.

VIII

An important stage in Munch's development as a painter occurs during a crossroads in his life. These few works are painted at a time when everything is disintegrating – including Munch himself. Munch is saved by his hospitalization at a clinic in Copenhagen in 1909. This hospitalization constitutes the first attempted rescue of the hard-pressed painter.

We can see a change of style in the pictures he painted during this period of his life – *Marats død II* (*Death of Marat II*), *Amor og Psyche* (*Cupid and Psyche*), *Trøst*

THE MILITARY BAND ON KARL JOHAN STREET
1889, oil on canvas, 102 x 141.5 cm
Kunsthaus Zürich

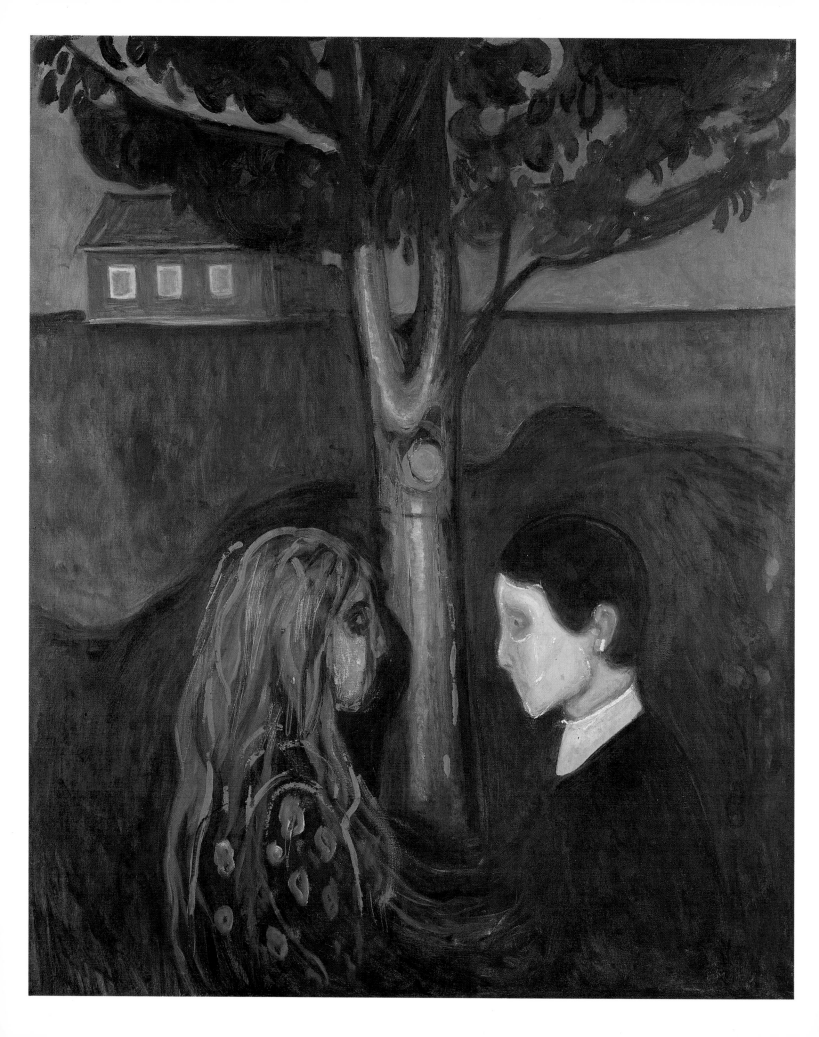

(*Comfort*), and a self-portrait. We are able to talk about style here as it is this, in particular, that Munch experiments with at this time.

What characterizes these four pictures is Munch's sudden attempt to separate things that he had previously linked together. The otherwise intimate connection between subject and method of painting is discontinued, almost as if the painting could liberate itself from the subject. It is abstraction that lies in wait here, as a temptation to Munch, who has otherwise been conservatively figurative throughout the whole of his life. Moreover, mythological subjects appear in two of the pictures, albeit as metaphors for extremely private experiences. The famous Tulla Larsen shooting episode, and the way in which this problematical relationship destroyed Munch, hover in the background of the Marat picture. *Cupid and Psyche* is slightly more general, but nevertheless, it is classically "Munchian" in its representation of the troubled relationship between two people.

In *Marat's død II* (*Death of Marat II*), confrontation has been brought to a head – Munch positions the woman in the main focal axis. Her gaze dissects the dead body of Marat. His dangling hand is positioned in a blood-stained triangle, to which the viewer's glance is immediately drawn. Nevertheless, this dramaturgy is not the most significant feature of the picture. What is significant is the way in which the painter has applied the paint to the canvas. In all three pictures there is a kind of stubbornly dynamic, but also coarsely executed Pointillism. The colour forms an interlacing pattern and is allowed to live its own life as systematized gesture across the surface. It is as if Munch is trying to liberate and overcome the depicted space, turning it into pure painting. There is a great difference between the first and second versions of the Marat painting – Munch is really exploring the possibilities of this style, and perhaps the novelty of this new working method brings some comfort to the hard-pressed painter.

For Munch, this new style of painting is a potential way into abstraction, into pure sensuality, yet it is not a sensitive hand that is at play here. It is not action painting with all the expression and all the energy involved. We are dealing with a painter who is attempting to beat out a rhythm, bringing order to the tragedy. Munch is attempting to protect himself – for the first time in his life – as a painter. The fact that it is also an attempt to be avant-gardist *ad modum* Paris does not change anything.

Without going too far, one might call Munch's pictures escape routes, although the surface remains, although the picture remains – even when the image is being transferred, via the eye, to the viewer.

EYE TO EYE
1894, oil on canvas, 136 x 110 cm
Munch Museum

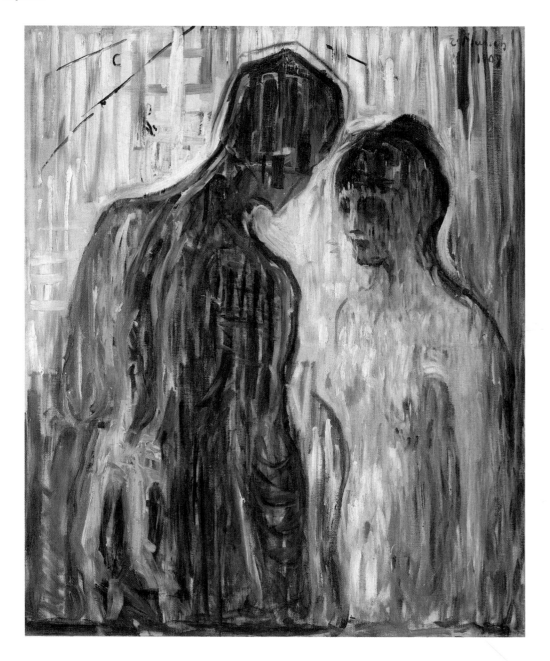

CUPID AND PSYCHE
1907, oil on canvas, 119.5 x 99 cm
Munch Museum

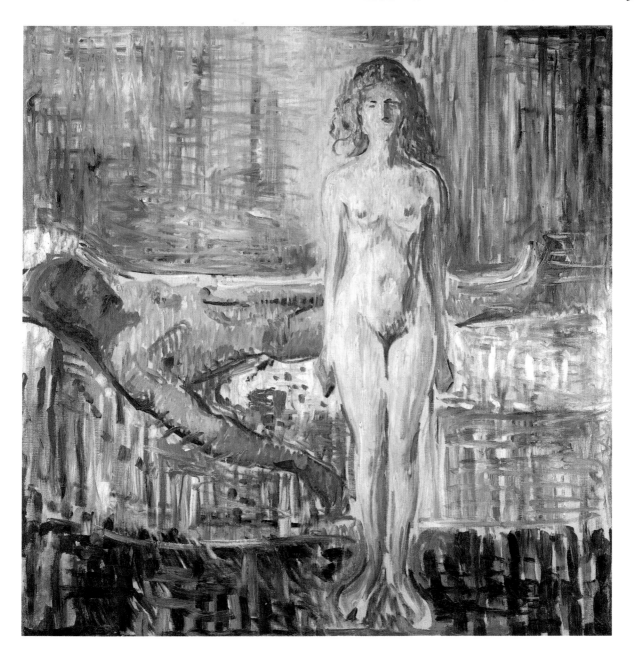

DEATH OF MARAT II
1907, oil on canvas, 152 x 149 cm
Munch Museum

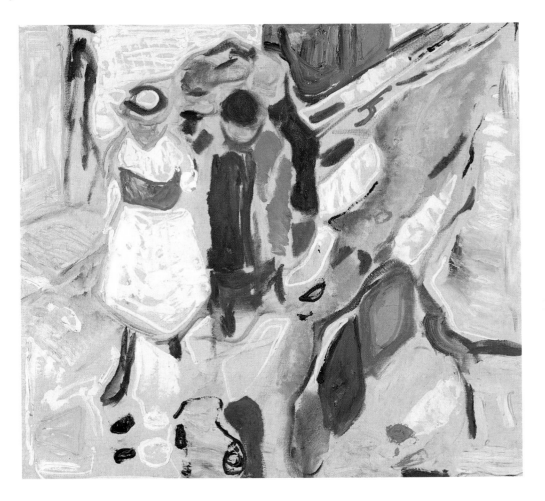

IX

The temptation of abstraction represents no real escape route for Munch. Once in a while he flirts with 1907's mental stylistic experiment – for example, in a late portrait from 1935 of Ebba Ridderstad. These experiments turn out to be a dead end – for a few moments they release the painter from himself and from his well-known vocabulary. Nevertheless he produces some excellent paintings during this period – some of the landscapes, and in particular, the wonderful *Barn på gaten* (*Children in the Street*).

Munch had difficulty finding a place for himself in the complicated world that surrounded him, but he realised that letting go of it represented an even greater risk. What would he be left with? Kierkegaard asked the question, "What is one left with if one loses one's soul?" For Munch, a similar question might be more relevant: "What is one left with if one loses the world?" – for the answer might be, the soul.

CHILDREN IN THE STREET
ca. 1915, oil on canvas, 92 x 100 cm
Munch Museum

Munch keeps a grip on the world, although he finds it threatening and terrifying – it scars his mind, and deals him the harshest of blows, but he keeps a strong hold upon it nevertheless.

He is a visual person and cannot paint anything he has not seen – there are numerous examples in his notes and diaries, telling us about his relationship to his models, to the garden at Ekely, indeed to all kinds of things. "I prefer to have the person I am painting or the actual landscape in front of me. I feel freer if I paint like that ..." he says to Stenersen.

What Munch has seen still represents a potential source of liberation for him. The images he paints are certainly manipulated by him, but at the same time they respond, so to speak, in another voice.

Munch ends his life as an imploded star, as a black hole into which all available light is sucked. He buys the property at Ekely with several acres of land, with fruit trees and animals, and he begins a series of paintings that are sparked off by his immediate surroundings. He paints the same objects over and over again. In a quarrel with his housekeeper he asks her to sell his horse because he has finished painting it – it had simply functioned as a subject for this particular series of paintings, and he no longer needed it.

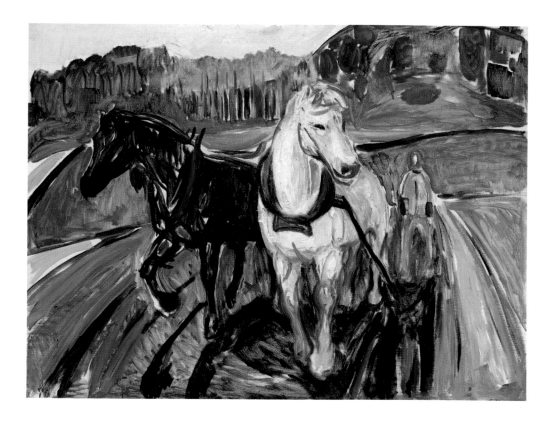

HORSE TEAM
1919, oil on canvas, 110.5 x 145.5 cm
Nasjonalgalleriet

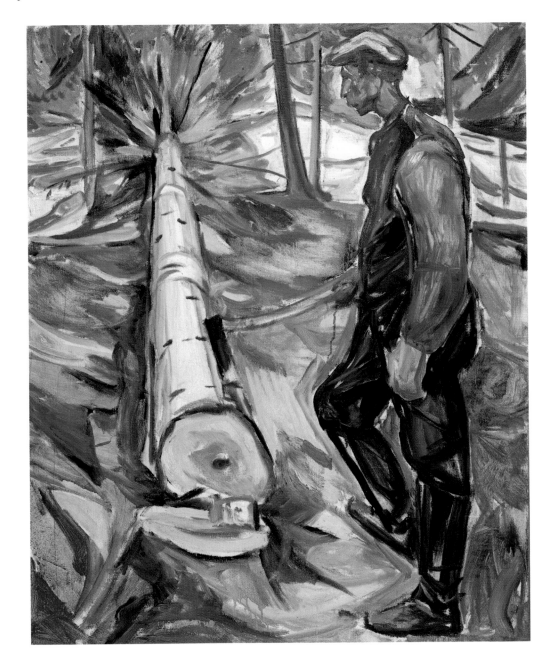

The plainness and simplicity of Munch's work come to an end towards the end of his career. He seems to have found a solution – a way into the picture that is also a way out – a liberating space both for the painter and the viewer. Munch retains his sense of the commonplace, although his choice of subject matter changes. Two important aspects of human life now interest him – work and nature. Munch's preoccupation with mankind in *The Frieze of Life* is now supplemented, and animals now appear. The

THE LUMBERJACK
1913, oil on canvas, 130 x 105.5 cm
Munch Museum

difference between mankind and animals becomes less important than the similarity between them, and this easy alliance – also noted by Franz Kafka – gives Munch the chance to incorporate them into his work as part of the rhythm of nature.

X

Munch has an ambivalent relationship to nature. It can be a place of damnation, although he never really attempts the theme of sublime landscape. His landscapes seem to be more a question of the relationship between the metabolism of human life and nature's own life. There are symbolist tendencies at play here, but also a kind of philosophical empathy with nature. There is an urge to be at one with nature, and this is especially well expressed in Munch's marvellous pictures of workers, painted towards the latter part of his career.

In the famous *Melankoli* (*Melancholy*) from 1892, the main character has been led astray by his state of mind to such an extent that he has almost vanished from the picture. The petrified subject seems to resemble nature itself, especially the rocks that surround him. Nature is obviously weighing down his mind, and is offering no comfort. The subject is caught up in this terrible resemblance to the world – he can escape neither from himself nor the world around him.

There is an element of the same static peace in the frequent use of nature as the background in many of the *Frieze of Life* pictures. The intertwining tree trunks evoke a feeling of predetermination, whilst the more dynamic coastline develops into a Jugendstil ornament, controlling the laws of nature.

The paintings of the wood-cutters are not about people placed in nature, but people working in it. The sick-room of self-observation has been aired, one of the subjects has picked up an axe, another a brush – Munch! – and they start off on a decent day's work. There is a tree, felled – the sunshine illuminating the mark of the axe, an eye that is no longer an abyss but is alive with colour – the pure strong colour so typical of Munch – like the girls' hats on the bridge. In the background, the conifer's round, bristly branches gleam. The glaring yellow trunk is the epitome of all Munch's poster-aesthetics – it consumes the gaze, whilst attacking the viewer between the eyes. What was embryonic in the bathing pictures from Warnemünde (where masculine mystique was played down in favour of bodily simplicity) has unfolded here. The decoration of the University Aula represents the completion of these ideas. The enormous sun shines down upon the viewer like the happy apotheosis of the eye. It is no longer an abyss of fear, but a joyful focal point, exuding life, colour, and radiance.

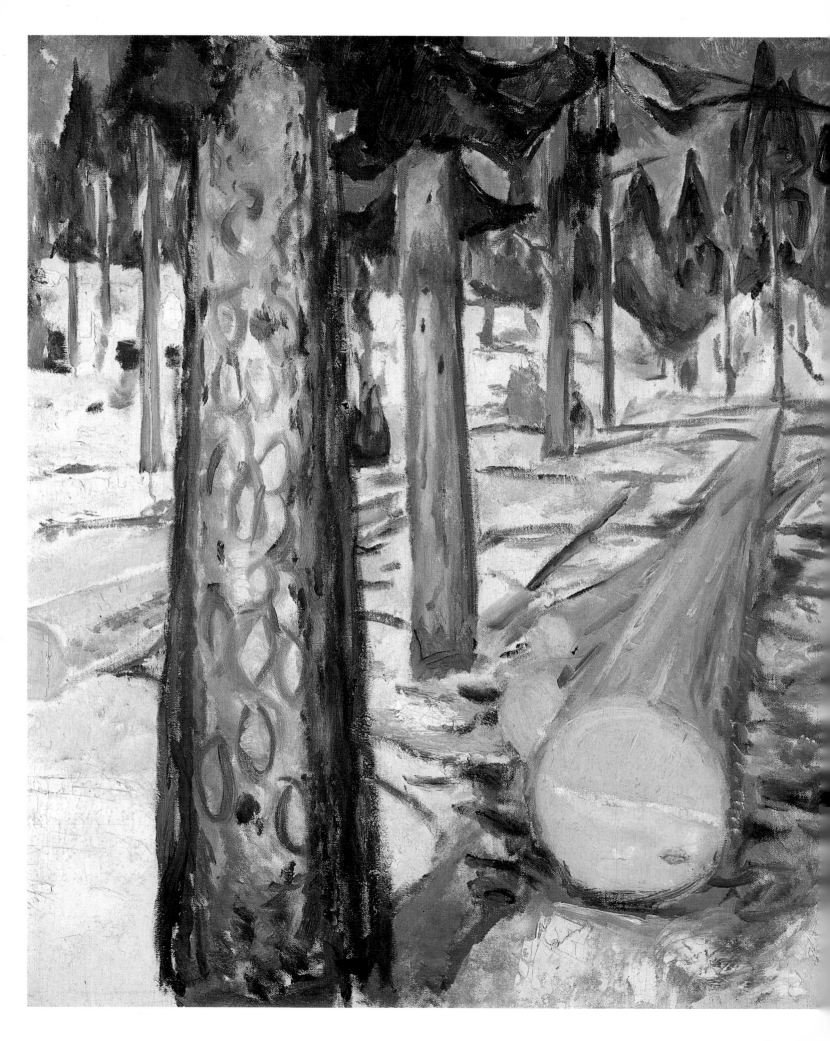

THE YELLOW LOG
1911–12, oil on canvas, 131 x 160 cm
Munch Museum

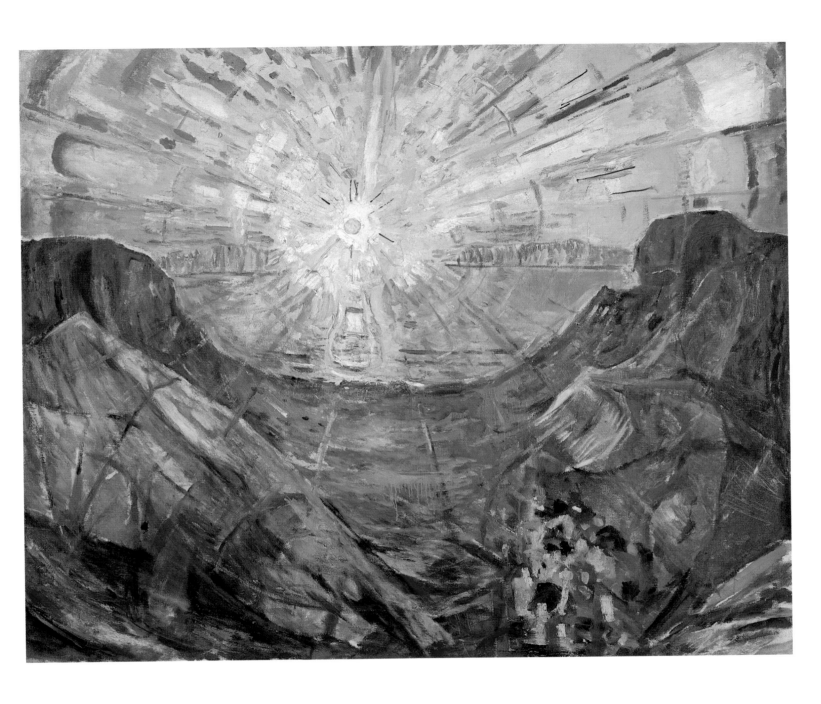

THE SUN
ca. 1912, oil on canvas, 163 x 205.5 cm
Munch Museum

XI

Munch would not be Munch if that were the end of the matter. It was simply one of his escape routes. Nature and work, repeated in the nature of work, was just one of those ways out. He continues to believe that nature may be a liberating force, an important step forward.

Munch employed a rather special method of coming to grips with the reality of nature – he allowed nature to patinate the pictures, leaving them exposed to the elements during the working process. This drastic method tested their resistance to the real world. "Paintings should be able to take up the fight with the sun and the moon," he remarks. The paintings became a part of nature – representing art's calm entry into the rhythm of life. Munch's love of the large format (as seen in his large decorative commissions) was part of this process of liberation. The distance between the viewer and the work was now larger, due to the very size of the paintings, and Munch saw this as yet another form of liberation – a larger perspective.

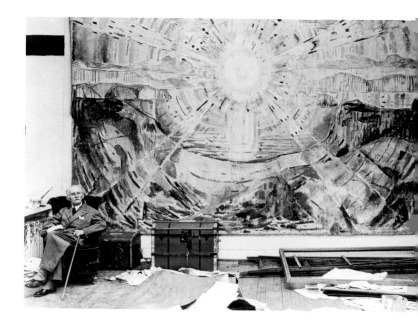

Munch in front of The Sun *in his winter studio, 1943.*

Munch had built a number of studios and open-air working spaces at Ekely, proba-bly in order to spread his investments (the paintings) in case of fire. In effect, the many outdoor studios came to mean that a large amount of Munch's work could be neglected for weeks on end. Birds defecated on the pictures, they were at the mercy of the ele-ments – rain, snow, and wind. On occasion he even threw them up into the apple trees. It is difficult to completely understand this drastic treatment – it is probably a mixture of the ageing painter's complete indifference, and an eccentric idea given full reign. But the interesting point here is that this peculiar "naturalizing process" echoes Munch's aesthetics in some way.

Munch hoped that his art would attain a kind of autonomy that could be compared to the workings of nature. The picture had to be forced to the point where it became a living object – a kind of natural form that could just as well have been produced by nature itself as by Munch.

There is a textural quality in Munch's work – an artistic presence that, before it becomes invested with all manner of ideas, has simply to do with tangibility. A picture had to be just as self-reassuring as it had to be effective. It had to ensure the relationship

between affect and effect by consolidating itself as a part of nature – something the world could breathe through.

He imagines this last idea in very specific terms – he was furious with the Nasjonal-galleriet in Oslo for varnishing his pictures. In his eyes, this treatment prevented the paintings from breathing, causing them to choke upon their own illusion of self-sufficiency. He experiments with various techniques of painting – amongst other things, with casein as a binder – ensuring that the greatest possible degree of pigment adheres to the canvas. Porosity becomes something to strive for – a living, breathing technique, whilst a brilliant, varnished surface represents the opposite – a strangulated abyss. Munch experiments, and masters various forms of porousness in his painting – he thins the paint with so much turpentine that the binder is sucked out of the priming and the colour is left almost without adherence.

WINTER LANDSCAPE, ELGERSBURG
1906, oil on canvas, 84 x 109 cm
Munch Museum

This gives an openness, a lightness, and a calcareous dryness of expression, an ethereal painting, that has its own authenticity.

There is something of the shaman about Munch, something he transfers to his distinctive photographs which, like his paintings, transform the transient into a kind of rite of passage – a voyage into the picture and out again. Like breathing itself.

XII

Everything that closed in on itself or trapped itself appeared as a reminder of demonic power in Munch's later work. If the loud scream that coursed through nature was terrifying to him, then the big sigh that hid in silence was no less frightening. Munch always

BIRCH IN THE SNOW
1901, oil on canvas, 60.5 x 68 cm
Private collection

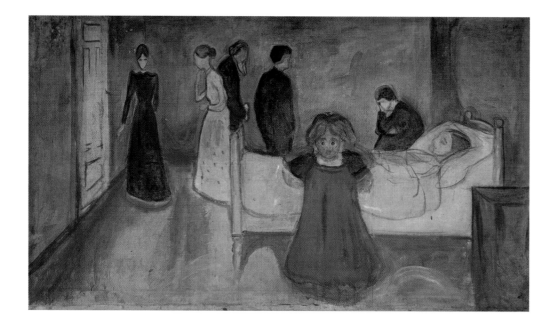

had the radio on whilst he worked at Ekely. He was totally indifferent to the content matter, and was just as happy with the sound of interference between two wavelengths. It did not matter what it was, just as long as the background noise kept the horror of silence at bay. He had painted his interpretation of this fear many years earlier, in a picture that can be seen as a counterpoint to *Skriket* (*The Scream*). The same feeling is expressed in *Den døde mor og barnet* (*The Dead Mother and the Child*) from 1897/99. It is that terrifying silence, the paradoxical echo of absence that he is portraying – and the girl covers up her ears in consequence.

Paintings offer themselves for interpretation, becoming part of the public domain. Munch has a social intention with his art – he wants the public to be affected by it, to have the opportunity of developing a relationship to it. This not only holds true for the large, accessible public commissions – for example those made for the University Aula, but also for other areas of his production. His printmaking became an important link to the public, representing a more collective idea. It is not a case of Munch taking a political standpoint, but he becomes increasingly interested in certain aspects of social-ization. These ideas are in no way alien to Munch's art – which always contains the strangely propitious mixture of the absolutely private and the completely public. It remains figurative and recognizable, thus maintaining the references to a shared reality.

The pictures have to find their place in this shared reality. And Munch believes that they have an important place. His large public commissions are one thing, appearing in buildings where large numbers of the public have access to them, but he also believes that his work has a place in the world almost as a kind of Platonic idea. This may be

DEAD MOTHER AND CHILD
1897, casein on canvas, 105 x 178 cm
Munch Museum

the key to the "Munchian mystery" – to that tormented search for escape from the encroaching world. Perhaps it is possible to imagine that works of art have an independent life of their own, and that Munch's formula for a successful picture was that very search for the painting's own voice, which he so strongly believed in.

XIII

When Munch had sold a picture it was not unusual for him to recall it for a while, making a replica of it for himself. Neither was it unusual for him to make several versions of the same picture – his printmaking production speaks for itself in this connection. His whole working method indicates this strangely metaphysical approach: pictures are found, and are made, in that order. He often took a canvas and sketched on it, then took a new one when he had the feeling that a picture had been found. At that point is was simply a question of carrying it out.

Can we allow ourselves to call Munch a conceptual artist of the senses – that is, an artist who works with ideas, but unlike the rather anaemic brotherhood of contemporary conceptual artists, one who realizes them?

I think so. At least it helps to explain some of the methods Munch used in the production of his pictures. The double-sided fatal and careless relationship to his work may derive from a resigned awareness of their place in the world. They exist, which is why he could casually throw them on the floor and trample all over them, or lay them like lids on a boiling pot of soup – which happened every now and again at Ekely.

The entire move towards simplification that pervades Munch's work points backwards to the time when it was not only the simple realization of a picture, but also the existence of the idea or ideal to which it related, that had significance.

Sometimes Munch feigns an almost demonstrative indifference with regard to technical execution. Take one painting – *Morder i alléen* (*Murderer in the Alley*) from 1919. The picture comes alive because of its clarity of vision, certainly not its technical merit.

The murderer in the foreground is completely transparent, as though added at the last minute, just as a marker, a kind of thematic signature. It also has a tragicomic aspect – the eye seems to be crying, simply because the paint Munch had on his brush was too much and a little too thin. In style, this effect is a little like the baroque humour found in the raised eyebrows and upturned eyes of the foetus that is placed in the border of *Madonna* from 1895/98.

This could be a way of expressing Munch's strange combination of the picture as a synthesis of idea and sensation, of form and life, and the picture as an autonomic naturalized thing, as liberated area, as plain picture.

If this is correct, then one has to say that Munch's transfer of self had been achieved without Nirvana entering into it. Munch had not abolished his sense of self; he had not said goodbye to the world. He had not consigned himself to the conceited nothingness of self-effacement. He had simply forced the human element into focus to such an extent that he was able to see himself outside himself – both as himself and as something else. He called his pictures his children – something of himself that really had become another.

In a way it is what he had wished for, as an artist, all of his life. Maybe his life had not been a success. Maybe the final pictures do not radiate happiness and warmth, friendliness and pleasure, reconciliation and energy, confirmation and harmony. Maybe the haemorrhage in his eye, and consequent loss of vision (1930–31), landed like a great brutal bird in the middle of his field of vision. Perhaps he experienced it as a memento of a kind of obsessive Phoenix that re-emerged and spread out its ominous black wings again. Maybe the daily dread replaced the daily bread and beat its rhythm through the often despairing universe depicted in the work. Nevertheless, it did not prevent Munch

THE MURDERER IN THE ALLEY
1919, oil on canvas, 110 x 138 cm
Munch Museum

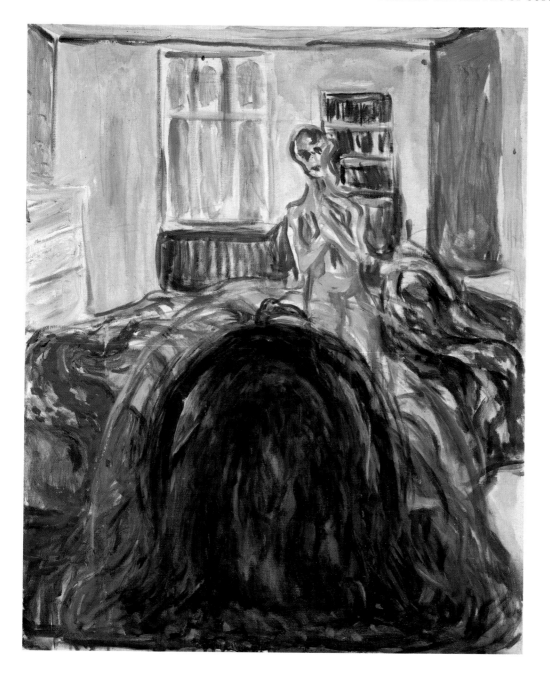

the artist from being overtaken on the inside lane by Munch the painter. The painting, the picture, was always in focus. This was after all, the way he worked throughout his life. Perhaps the artist died, perhaps he was doomed from the start, but his life was an expression of his never-ending quest, and the work he created during this quest successfully survives.

SELF-PORTRAIT DURING THE EYE DISEASE I
1930, oil on canvas, 80 x 64 cm
Munch Museum

XIV

Munch is saved by his belief in the surface: there can hardly be any doubt that it is the depths, rather than the surface, which destroy – the terrible abyss. One is stifled, one loses everything, one perishes, one drowns, one becomes invisible, one falls and falls and – probably worst of all – nobody notices. One can lie floundering in the abyss for a whole lifetime, without anybody noticing – not a favourable position for an artist to be in.

Ideas must be brought to the surface, preferably in an elegant manner – achieved only by the few. The surface should be seen, and be seen through – be visible and yet transparent. The surface should be significant, yet subordinate. This is typical of Munch. Few of his contemporaries were so radical – especially when they painted portraits. Munch reduced everything to its lowest common denominator. Objects vanished or were reduced to the square root of nothing – backgrounds became almost invisible – a rudimentary space. What was left then? Portraits were reduced to the essentials: the head, the gaze, the eyes – the rest is form, shape, paint.

It is a deep superficiality, because what it does is emphasize what is important. Whenever things are reduced there is a contrapuntal intensification. The more reduced a picture becomes, the more intense become the remaining elements. This became Munch's style – taking away in order to display. The power of plainness, simplicity, surface.

BEACH LANDSCAPE, AASGAARDSTRAND
1891, drawing, 170 x 270 mm
Munch Museum

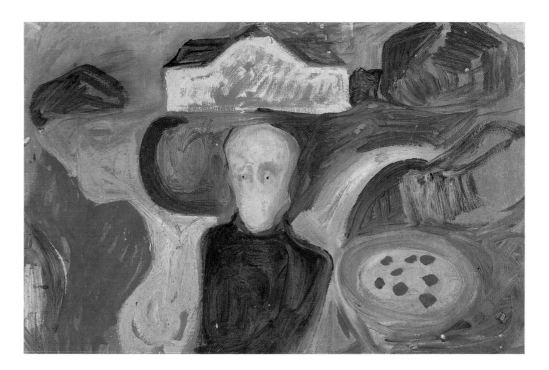

In keeping with this, decoration comes to play a special role in his oeuvre. It is displayed without existential demands – it is repetition beyond monomania because it is a pattern. It is inanimate, or at least becomes so after a while. It pulsates across the surface, and is perhaps the most successful example of something that can be a picture without being art. Munch has almost become a kind of anti-aesthete. This has been developing through the years, exemplified by the numerous pictures that are dependent on a participant outside the picture – the viewer or the painter. His preparation is now complete, and things now seem simple: a man is out in the garden, there are the trees, snow, dogs, and here is the man, the painter, Munch – painted just as the clock chimes. The painting *Selvportrett. Mellom Klokken og Sengen* (*Self-portrait Between the Clock and the Bed*) (1940/44) is as simple as it may seem. The face of the clock is rubbed out. Time has stopped, and the grandfather clock has found an accomplice – he is called Munch, and he is no longer alive. He stands there, portrayed just like a piece of furniture, carefully placed in the room. Can there be a more powerful image – a painter portraying his own death?

Perhaps the breath of the painter is expelled gently through the black and red stripes of the bedspread – re-emerging fifty years later in a Jasper Johns! It lies there exuding peace and quiet. Curtain fall.

SYMBOLIC MOTIF
1902–03, oil on cardboard, 44 x 67 cm
Munch Museum

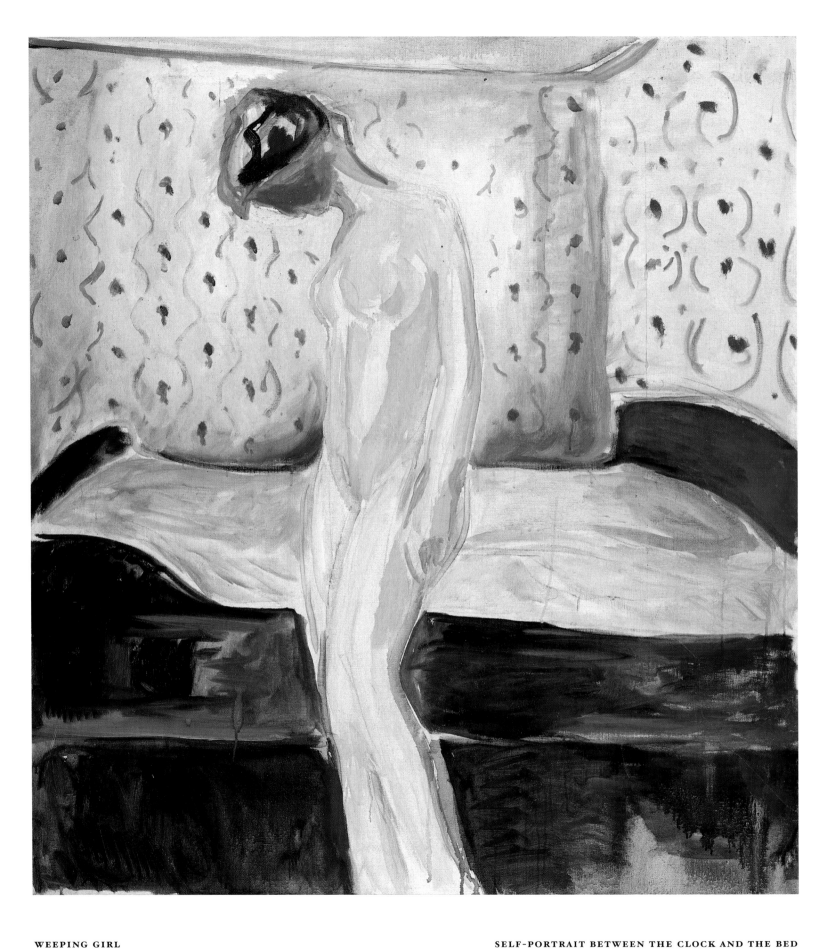

WEEPING GIRL
ca. 1907, coloured chalk and oil on canvas, 110.5 x 99 cm
Munch Museum

<div align="right">

SELF-PORTRAIT BETWEEN THE CLOCK AND THE BED
1940–42, oil on canvas, 149.5 x 120.5 cm
Munch Museum

</div>

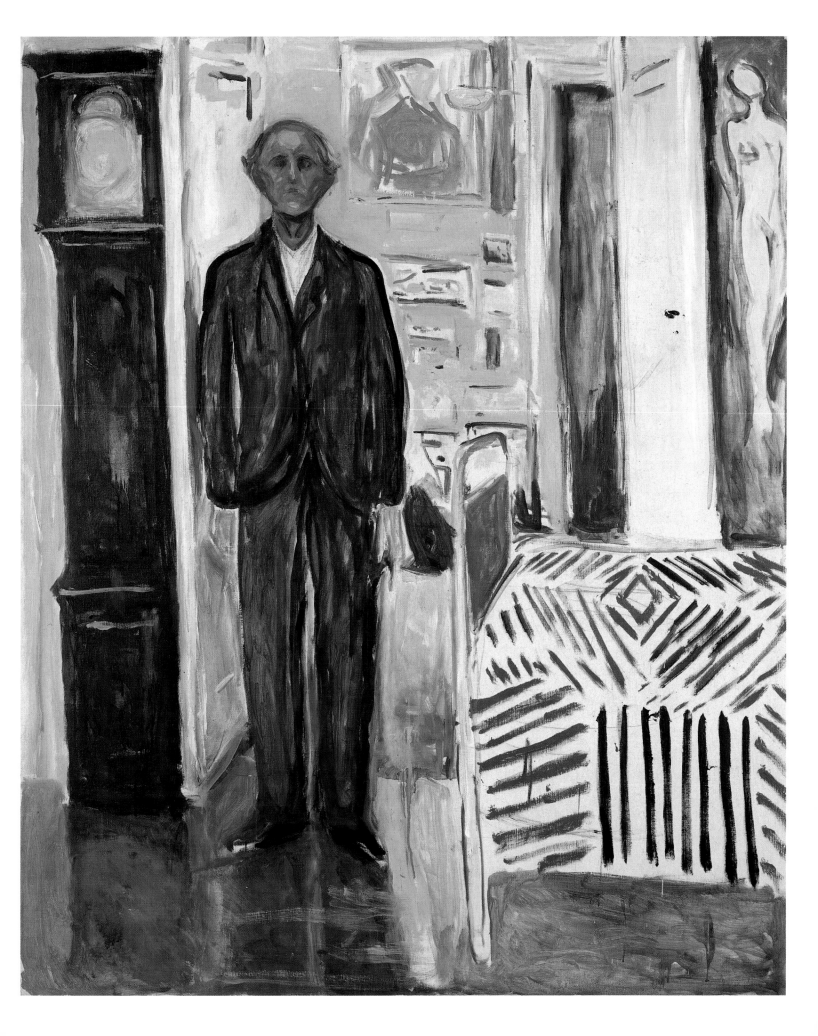

XV

Munch was superficial – *aus Tiefe*. If we are to compare him with someone, we might just as well go all the way. His contemporaries are uninteresting. Emil Nolde says things about the gesture of naturalization that are close to Munch's poetics (and perhaps he was influenced by Munch) – he also experimented by painting outside in frosty weather, which gave peculiar results, and he remarked: "I naturally rejoiced in this collaboration with nature, and the whole of the intimate connection between nature, artist, reality and picture." But Nolde does not add anything in relation to Munch. It is like comparing one apple to another apple: the first one has fallen somewhat farther away from the tree because Munch is special – and great – and wildly self-willed.

Other comparisons may be more fruitful, but we would have to move further if a comparison is to have any topical appeal.

My proposal is Andy Warhol. Not because it is a daring suggestion – such ventures are never more than coquetry in the art writers' immaterial academy – but because I believe it is correct. Not that Munch is the Warhol of his generation, not that Warhol is Munch's heir, but in the middle of all the striking differences there is a curious fellowship.

It is impossible to know how Warhol felt; that was his hallmark. His art (some would argue) lacks the gravity and existential weight of Munch's – so what does their work have in common?

Warhol's art is about the pictures being there before they are produced. I am not only thinking of the Pop artist's use of existing pictures here, I am thinking of the iconic aura that Warhol managed to invest his oeuvre with. The relationship between Warhol's series and the single picture, the relationship between the conventional photograph – figuration and added colour – this affective intermediate layer in his pictures – the productivity, the loneliness, the skill as well as the unmistakability – all of these elements relate to Munch.

Their departure points are vastly different; they both belong to their time and their space. Their temperaments are probably (as temperaments usually are) – not comparable, and yet there is a meeting point. In Warhol's case, the role of the artist took centre stage – as it did for Munch – and in Warhol's case transfer of self was also the hidden artistic dream. "I want to be a machine," he said. This is a modern version of wanting to be nature.

Warhol is a rhetorician. His work is rhetorical from beginning to end – no-one has such a grasp of clichés as he has. But what about Munch? Is Munch not a rhetorician? Is there not also a "Munchian" rhetoric?

Munch and The Sun *in his outdoor studio at Skrubben, Kragerø, 1911.*

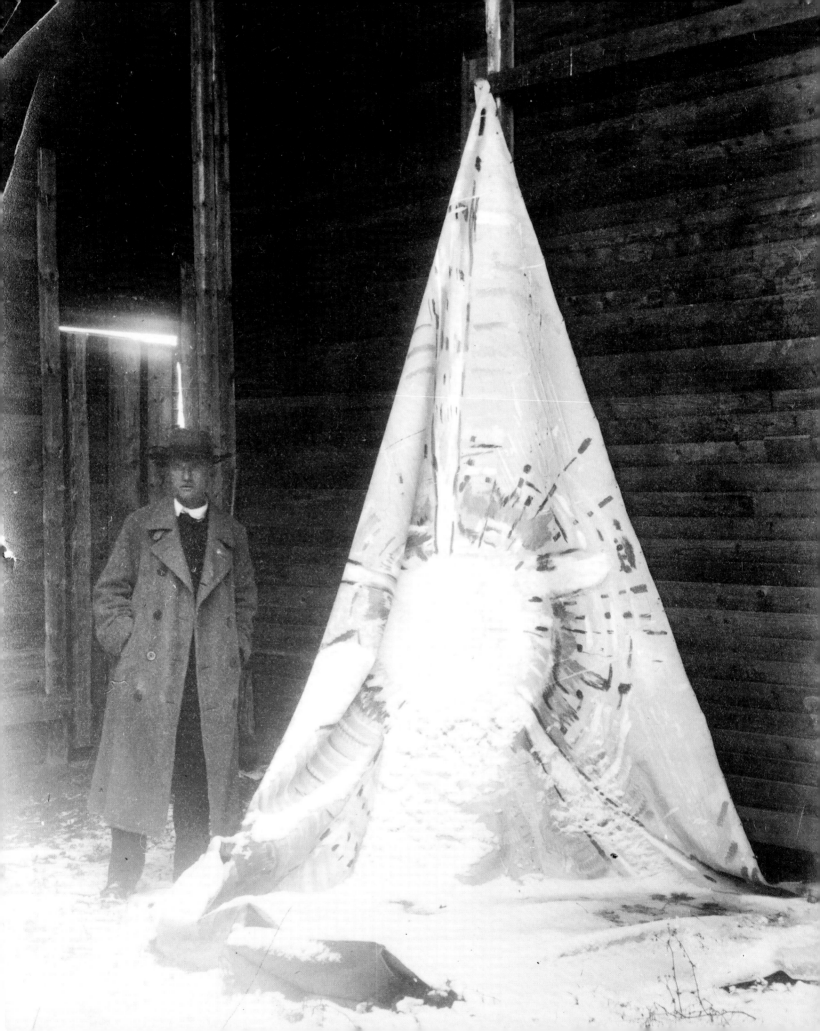

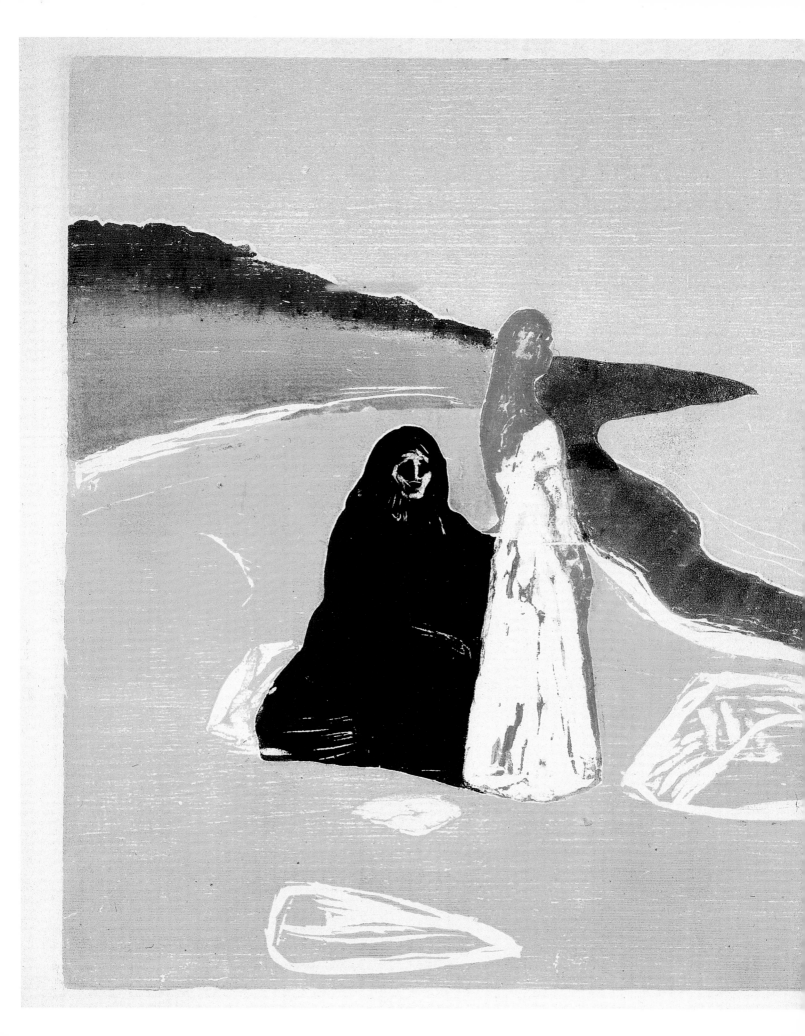

TWO WOMEN ON THE BEACH
1898, woodcut, 45.7 x 50.7 cm
Munch Museum

Very definitely – and it is hardly necessary for us to mention the shadow, the pillar-like reflection of the moon in the sea, the grammar of mental states, confrontation, the gaze, the dipping lines, the build-up of space as the stage, the theatrical instinct – all of this enables us to recognize a Munch picture when we see one.

XVI

The aesthetics of Expressionism have done Munch a disservice, particularly in their more popular form, where they describe the artist as someone who paints with his life-blood undiluted, controlled by his senses. Nothing could be less true of Munch.

He was a serious painter – that much can be said. He was a worker, not a dreamer. His professionalism as a painter was enormous. He had a relationship to his art – both to its aims and its methods. He knew what he was doing, and he did it again and again. He knew what a picture should be – hence the many discarded attempts – hence the many repetitions. His speed and skill were legendary. His expertise regarding the commercial aspects of art was no less legendary than Warhol's: Munch was one of the first to demand an income from the entrance fees to his exhibitions. His scandalous paintings went on tour due to their notorious reputation. Last, but not least, Munch made the most of his reputation as a portrait painter.

Nevertheless – and maybe as consequence of all these factors – he felt the role of the artist to be unbearable from time to time. His public image and the role he imperceptibly created for himself became a burden. What does this image have to do with a day's work? Almost nothing. It became something to avoid, and perhaps the only way to do this was through an honest day's work. That was the relationship Munch had to his painting towards the end of his life. He was simply a man who wanted to paint – whether this was motivated by desire or compulsion seems beside the point.

There is a letter from Nietzsche to his friend Jakob Burckhardt, dated 6 January 1889 – the year of his breakdown, when his surface cracked. The first two lines could be dedicated to Munch – because, in spite of the odds, he managed to be what Nietzsche did not, a more or less ordinary man, supported by those paintings that never let go of the surrounding world – Munch's world, the viewer's world. "Dear Professor, In the final instance, I would much rather be a professor in Basle than God ..."

SELF-PORTRAIT WITH GUARDIAN ANGEL
1939, oil on canvas
Private collection

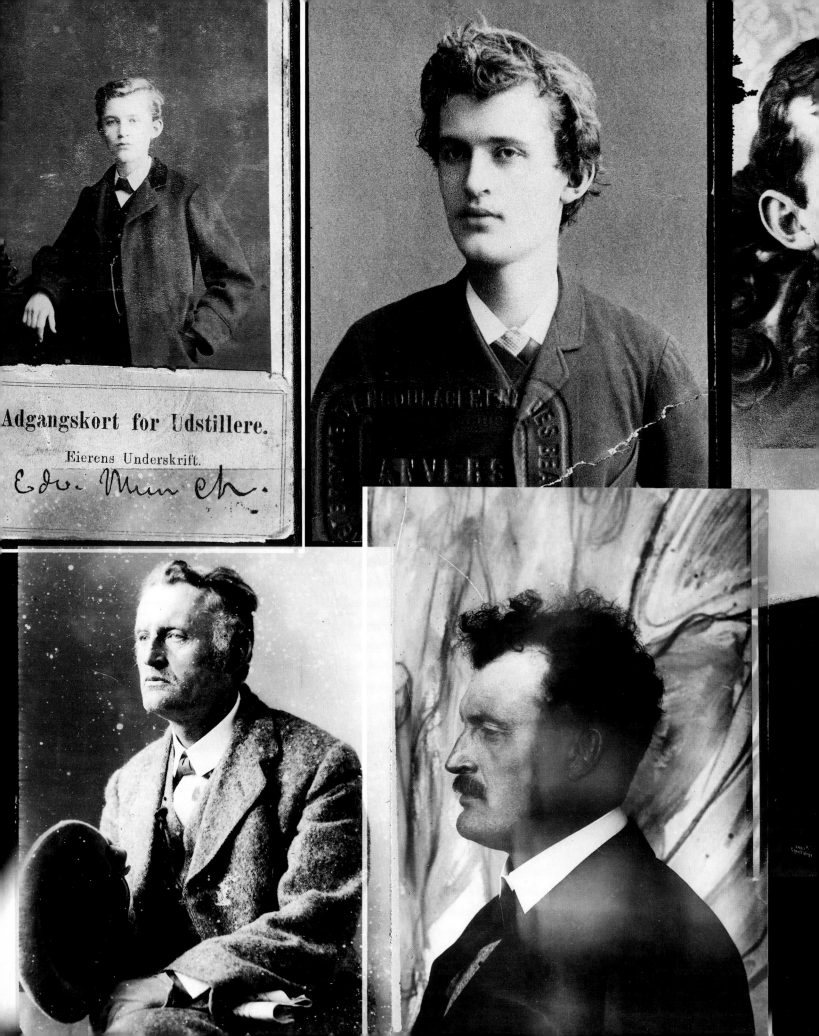

Adgangskort for Udstillere.

Eierens Underskrift.

Edv. Munch.

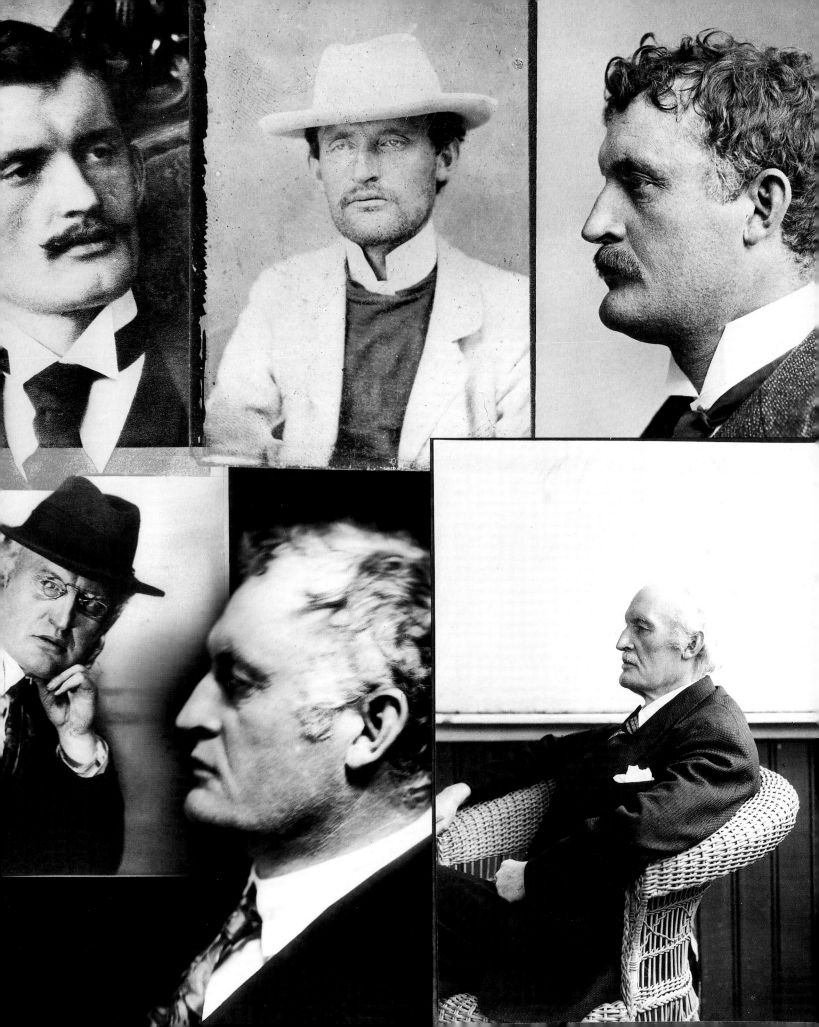

MUNCH AND HIS OWN WORDS

"My pictures are wiser than I am," says the German painter Gerhard Richter when he is asked about everything connected to his pictures, both before and after their creation. We, who are outside the picture, always find these questions at least as interesting as the picture itself.

Are Munch's pictures also wiser than Munch? Or, to put it another way, can what happens in Munch's works be said in another way, using his own words? Or do his pictures have a sovereignty that seals everyone's lips, including his own?

There is no doubt that Munch's art is supreme. It does not require any external support, as its strength lies precisely in its having freed itself from its originator in an ongoing loyalty to something commonly recognizable. The pictures are obviously Munch's from beginning to end, but they are also ours.

To the extent that they are ours, they function in a sphere of incidentally acquired knowledge – how much do you know? how much do I know? – where in reality the biographical aspect plays an almost uncontroversial role. This is rarely the case among interpreters of art. What one knows inevitably influences what one sees. This is true regardless of whether one chooses systematically to use it, believing in its explanatory powers, or whether one tries systematically to disregard it, full of suspicion of the possible betrayal in the idea of particularly authentic sources of understanding.

To the extent that the pictures are Munch's, the written material actually appears with just as subdued a profile. It is an integral part. It courses through the pictures as an ornament communicated by another medium – language. It is neither origin nor conclusion; it is another way of saying the same thing. Munch painted, drew and wrote, and wrote, drew and painted.

Although it all seems to belong together, I have with the present selection of Munch's texts organized the written material into a number of chapters, not least for the sake of clarity. I have given these chapters titles in accordance with the traits visible in the material – without regard to chronology. In any case, such a chronological order would have been difficult to carry out, because Munch himself more or less ignored it.

No doubt the selection of Munch's texts could have been made in other ways, and the existing solution does not at all reflect any compositional pattern found in Munch. Munch was no systematist, even though he was systematically dedicated to certain subjects – not least, among these, Edvard Munch. His written expressions are random, one moment

flickering like a candle in the wind, the next moment cutting right through like a hissing welding flame. The body of text is jumbled and confused, the dating is insufficient, and the wordings form their own spiritual archipelago, isolated as they are, often in capital letters and with showers of dashes spread out over the pages ... in a way nothing for a philologist; or perhaps a lot! If, however, one approaches the texts with his pictures in mind – and of course with Munch that is the first thing one does – the material, nevertheless, gathers into concentric circles, and makes sense – together with all the rest.

Undoubtedly, Munch's pictures are wiser than Munch, but this does not mean that Munch was not knowledgeable about his pictures. Just as earnestly as he is working with his pictorial oeuvre, he is equally persistent in his formulations of the surprisingly few themes he is tackling on paper: the autobiography, the philosophy of life, that grammar of pain levels, the borderline experiences, the fear, and then, especially towards the end, the resistance to submitting completely to resignation – or perhaps rather the attempt at doing so without the total loss of artistic intensity. Seen in the long perspective – which is not so long after all, as much of what Munch wrote was written after great delay in relation to the events, and in marvellous disorder – an obstinate energy shows itself in Munch's texts. It is an energy corresponding to the increasing reconciliation with life and art, as expressed in the oeuvre.

In this respect Munch's own words are quite pertinent for Munch. The texts, too, show the compulsive repetition found in the pictorial work. Munch writes the same things again and again with only few variations. As in art, there are two possible explanations of this condition: it could be called experimenting. I do not think that is the case. Munch is not a man who constantly reaches outwards, on the contrary. This is just the opposite of experimenting. There is a belief in some fundamental experiences – usually tragic ones – and there is a knowledge of a number of ideas – usually stubborn ones – and there is a familiarity with some artistic techniques – formidable ones, without exception. All this is part of the arabesque of repetitions on the paper, whether it is in the form of sheets, scraps, bills, or old envelopes that serve as the shaky surface. Thus, the idea that Munch's texts could be the key to his pictures vanishes.

All of it is about the same thing. And is it not just this that makes Munch such a great artist. He – and his art – were as wise as he himself was. Neither more nor less.

THERE SHOULD BE NO MORE PAINTINGS OF INTERIORS
AND PEOPLE READING AND WOMEN KNITTING.
THERE SHOULD BE IMAGES OF LIVING PEOPLE WHO
BREATHE AND FEEL AND SUFFER AND LOVE — I SHALL
PAINT A NUMBER OF SUCH PICTURES — PEOPLE WILL
UNDERSTAND THE HOLINESS OF IT, AND THEY WILL
TAKE OFF THEIR HATS AS IF THEY WERE IN A CHURCH.

ST. CLOUD, 1889

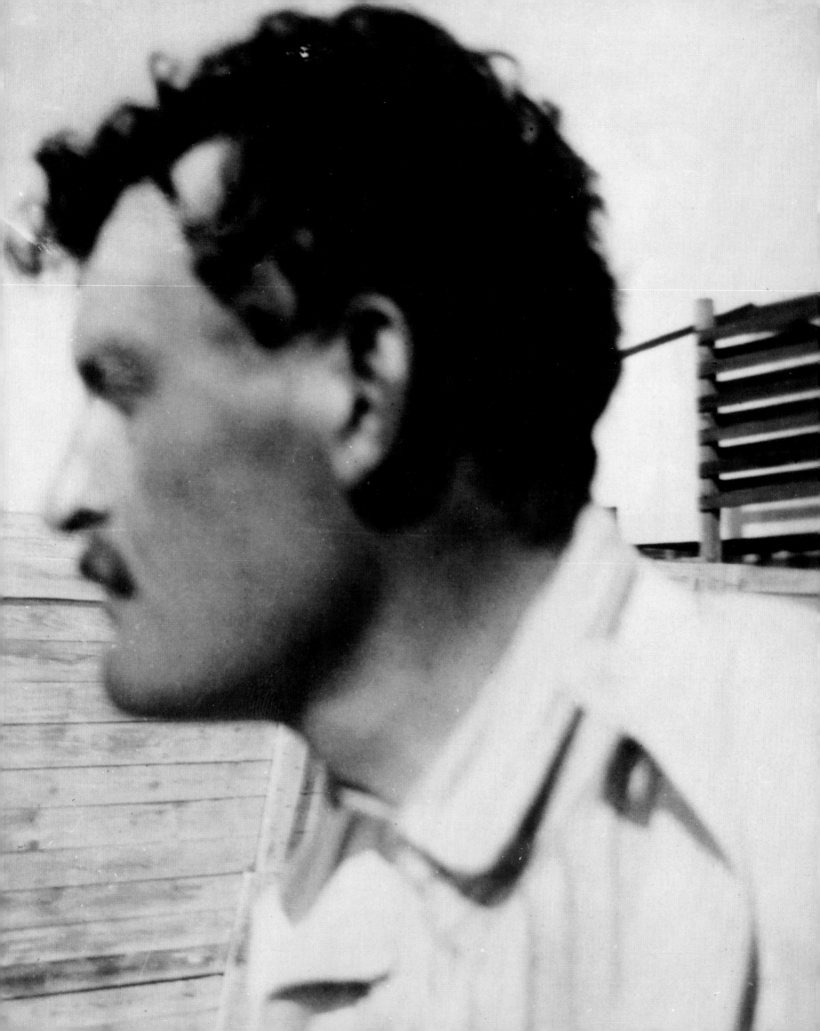

"AMIDST LIFE THAT IS ALIVE"

Munch writes in one of the following notes, "I stagger about amidst life that is alive." This could serve as a heading for all these notes. Like the figure in *Skriget* (*The Scream*), Munch also has difficulty in controlling the balance between outer and inner life. This is not least noticeable in descriptions of himself. These range from almost pure incantations to fully-conscious introspection, while also sliding back and forth between the suggestive metaphors of literary experimentation and the sometimes equally experimental precision of direct speech.

However, in every case there is a peculiar innocence in Munch's view of committing thoughts to paper. There is no sign of any stylistic consistency, and even though he writes freely in places, there is no attempt at artistic originality – which was characteristic for him as a painter. All his experiences seem to be so weighty that they can only be paraphrased in concrete terms.

Because of this, he never really becomes part of life that is alive. He just tumbles about in it. Only the idea of the initial experience, the initial impression, remains as a kind of artistic point of orientation that the painting process aims at capturing. The ideal is the fundamental, the moment, but it vanishes when he reaches out to grasp it. It can only be captured afterwards in the pictures, and it is also described in the writings – afterwards. The only way in which Munch can really come to terms with his own misfortune is through the actual loss of consciousness – with drunkenness as the price.

Even though many of Munch's pictures act as immediate interpretations of situations, every-one, including Munch, knows that they also live due to the distance of delay. Munch himself calls it "the simplicity of the pictures", and with this, expresses his urge to keep the impression of originality alive – an originality that poetry can cover with its layers – in the way the painter applies layer on layer in *Den syge pige* (*The Sick Girl*), and inserts his own observations into the picture like a shadow of the eye that sees.

Let us allow the following notes be a kind of gateway to the body of the text, which in reality never finds its final form or rests in the clear light of self-knowledge. Experiences have their own radiance. One can see this everywhere, but the light from these experiences was blinding. It had to be deflected – and it was. For Munch became a visual artist, and thereby transformed the original "before" to an "after" – to the experience one gets standing in front of the picture.

T 2734
JANUARY

I act either rashly and full of inspiration on the spur of the moment (unthinking and unhappy – but with inspiration and a positive effect) or on the other hand with long deliberation and apprehension.

The result is often weaker and can be a failure. The result can be the destruction of the work.

This relates to myself as a painter and as a human being.

The Sick Child and *Spring* were both results of a long period of labour – many years. In the most accomplished, *Spring*, I was able to make use of several fortunate circumstances.

It was less nervous and not overly simplified or ruined by damaging, hasty whims.

Sick Child was a more impetuous mixture of unthinking work – inspired – and lengthy, sometimes nervous deliberation. It was finished with the aid of several inspired and rash revisions. The work was in a most unsatisfactory state – which accounts for its more intense and violent character.

My pulse is either violent to the degree of bringing about a nervous attack, or sluggish with soul-searching melancholy.

Sometimes I use up to eight days to finish a letter. At other times I commit my impressions to paper in a hasty, inspired manner.

N 74

I painted canvas after canvas according to the momentary impressions that had attracted my eye. I painted the lines and colours that had attached themselves to my inner eye – to my retina.

However, I almost never painted my recollections without adding something – without the simplicity I no longer saw. That explains the simplicity of the paintings – the seeming emptiness.

I painted impressions from my childhood – the blurred colours from those times.

By painting the colours, lines and shapes that I recognized from a time touched with emotion, I was able, just like a phonograph, to stir up that same emotional mood.

Thus were the paintings of *The Frieze of Life* conceived.

N 73

This was during the time of Realism and Impressionism.

From time to time, either in a shattered state of mind, or in a happy mood, I would come across a landscape I wished to paint. I collected my easel – set it up, and painted directly from nature.

It was a good painting, but not the one I wanted to paint. I was unable to paint the landscape as I saw it, in that unhealthy state of mind, or in that happy mood.

This happened often. In such circumstances I began to obliterate what I had painted. I searched in my mind to recollect to that first picture – that first impression, and I tried to re-establish it.

N 70

When I first saw *The Sick Child* – that pale face with the bright red hair against the white pillow – it gave me an impression that disappeared during my work with it.

I made a good, but different picture on the canvas. I re-painted that image many times during the year – erased it – let it emerge from the paint – And tried time and time again to hold on to that first impression. The trembling mouth – the transparent, pale skin – upon the canvas – that trembling mouth – those trembling hands.

Finally I gave in – exhausted. I had retained much of that first impression. That trembling

mouth – that transparent skin – those tired eyes. But the colours were not finished – it had become grey. The painting was as heavy as lead.

I started on it again, two years later – and managed to give it the strong colours I had intended. I painted three versions. These are all different, and each conveys some of my first impressions.

N 75

I had focused too much upon the chair with the glass; it drew attention away from the head. When I first saw the image I was hardly aware of the glass and the surroundings.

Should I remove it ? No, it accentuated and threw the head into perspective. I scraped away and smudged out the surroundings, leaving only descriptive masses. One looked over the table and the glass.

I was also aware that my own eyelashes contributed to my impression of the image. I made reference to them as shadows over the painting. In some way the head became the image. Wavy lines appeared – peripheries. With the head at the centre. I came to use these wavy lines in many later pictures.

T 2785

I made the observation that when I was out walking down Carl Johan on a sunny day – and saw the white houses against the blue spring sky – rows of people crossing one another's paths in a stream, as if pulled by a rope along the walls of the houses ... when the music strikes up, playing a march – then at once I see the colours in quite a different way. The quivering in the air – the quivering on the yellow-white facades. The colours dancing in the flow of people – amongst the bright red and white parasols. Yellow-pale blue spring outfits. Against the dark blue winter suits and the glinting of the golden trumpets that shone in the sun . . . the quivering of blue, red and yellow. I saw differently under the influence of the music. The music split the colours. I was infused with feelings of joy.

SELF-PORTRAIT IN BERGEN
1916, oil on canvas, 89.5 x 60 cm
Munch Museum

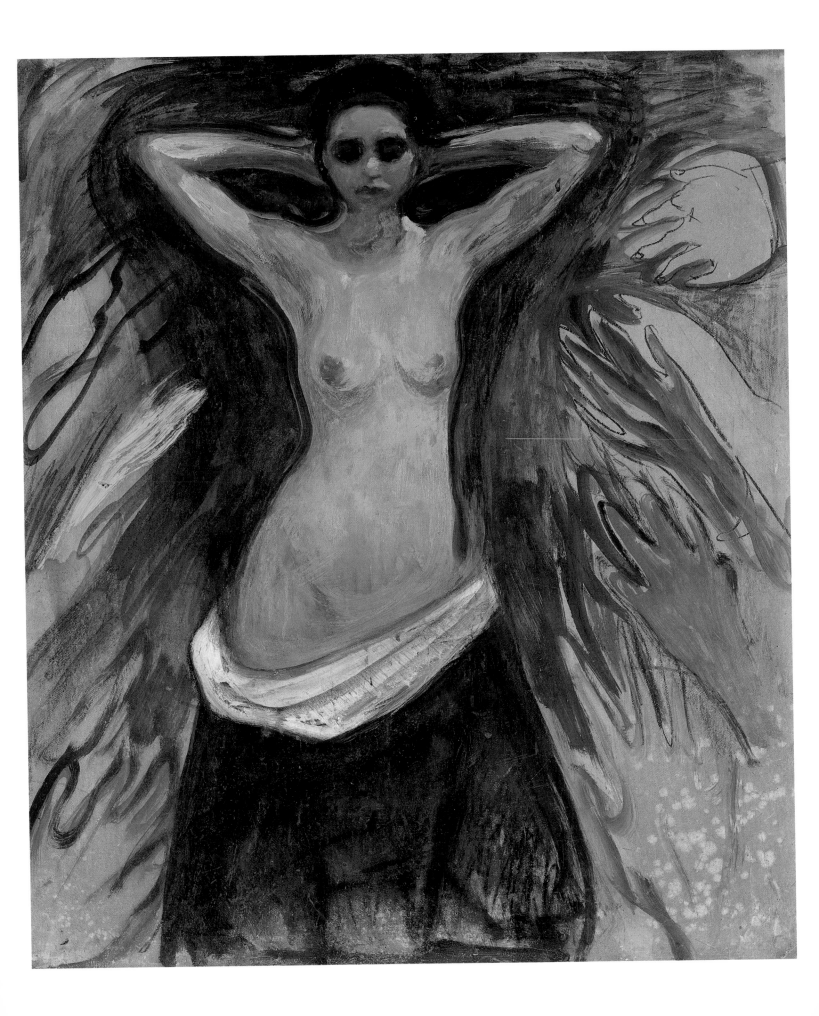

N 30

These paintings portray a general mood, impressions of that spiritual life which together create a development in the struggle between man and woman, called love. Right from the beginning, when it is almost rejected leading to the paintings *The Kiss*, and *Love and Pain* where the struggle as such has begun.

The painting of the woman who yields and is endowed with the tormented beauty of a Madonna.

The mystery lies in a collective development. Woman, in all her diversity, is a mystery to man – woman, who is simultaneously a saint, a whore and unhappily devoted to man.

Jealousy, an immense desolate beach.

The woman's hair has wrapped itself around him and infiltrated his heart.

The man is distraught by the struggle.

A sickly atmosphere in nature is for him a vast scream – those blood-red clouds like dripping blood.

(The girl with the hands) Lust.

N 613

Down here on the beach I seem
to find an image of myself – of my life.
Is it because we walked together
along this beach the other day?
That strange smell of seaweed
also reminds me of her –
the strange stones that mystically
rise above the water and take on
the shapes of strange creatures
that resembled trolls that evening.
In the dark green
water I see the colour of her eyes.

Far, far out there – that
soft line where the air meets
the sea – it is as incomprehensible as
existence – is incomprehensible as
death – as eternal as longing.

And life resembles this
calm surface – it mirrors
the bright clean colours
of the air. It hides the depths
with their slime – their
creatures – like death.

N 614

The deep purple darkness settled itself over the earth. I sat under a tree – whose leaves had begun to yellow, to wither. She had sat by my side – she had bowed her head over mine. Her blood-red hair had entangled me – it had wrapped itself around me like blood-red snakes – its finest threads had wrapped themselves around my heart. Then she stood up – I don't know why. Slowly she moved towards the sea – further and further away. Then a strange thing happened – I felt there were invisible threads binding us. I felt that invisible strands of her hair were still wrapped around me. Even when she disappeared over the ocean – I still felt the pain where my heart was bleeding, because the threads could not be torn away.

T 2748

I'm walking along a narrow path – with a sheer drop on one side. The depths of the sea there are unfathomable. On the opposite side are fields – hills – houses – people. I totter along the cliff's edge – I almost fall off – but I throw myself towards the field – the houses – the hills – the people. I topple and struggle with that living world of humanity – yet I am bound to return to that path above the cliff. That is my path – the one I have to walk. I am sure I shall fall over the edge – yet I throw myself back to life and humanity But I must return to the cliff path. It is my path – until I tumble into the depths.

4 DECEMBER 1929

There were times when it seemed – or I imagined myself making great progress.

THE HANDS
ca. 1893, oil on board, 91 x 77 cm
Munch Museum

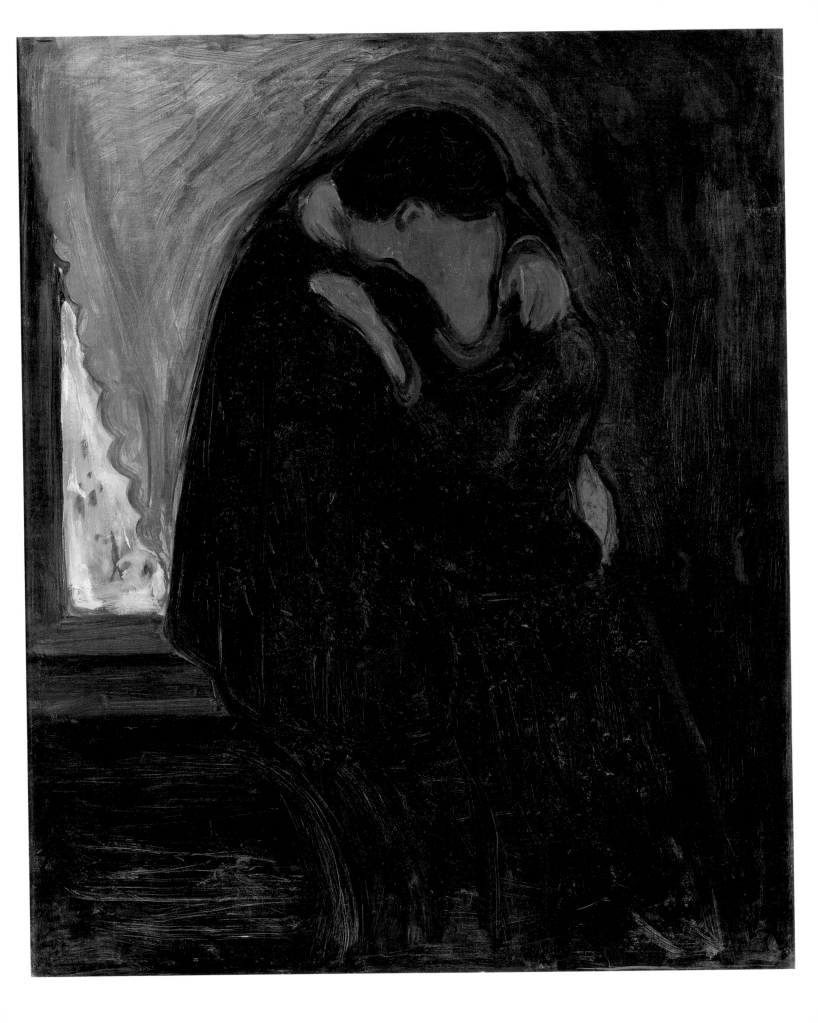

The last half of my life has been a battle to even keep going – to keep my balance. I have jumped from stepping stone to stepping stone – over the abyss – from mountain top to mountain top – or from tussock to tussock across fathomless marshes. Perhaps it has always been so.

THE SUBCONSCIOUS

I can remember the days before I was admitted to the Clinic in Copenhagen, the way I senselessly poured wine and Cognac down my throat and smoked the strongest cigars. Smoked and filled myself with alcohol from morning to night, a complete intoxication of the senses.

I remember one particular moment ... just before the poison reached a critical point in my brain – a cell whose destruction could bring about my death.

And I remember being aware of this, and wanting to hinder it from happening. A couple of days later I was struck down by an attack which brought me close to death.

Nobody will understand this, and all I can say is – I realize that. One will simply have to believe it.

It is most certainly true – if I break this promise then something terrible will surely happen to me.

I can explain it in the following way – in psychoanalytic terms. Something has happened in my life – something that has strongly affected my destiny. The awareness of this has been stored in my subconscious – but functions as a warning signal – unconsciously. It rises up like a ghost from the deep cellars of my soul. I remember saying to my friend Goldstein, the time I was a patient at the Mental Hospital in Copenhagen: I feel that evil has risen right up to here – and I made a mark upon my chest. Up to here, I said – just as a doctor makes a mark upon a test tube. I believed that sleep might bring some respite. For the duration of my childhood I was extremely ill – I often spent half the winter in bed. My entire youth.

That is why, in my subconscious, my bed has become a torture chamber.

When I lie, fully clothed, upon a chaise longue, my awareness of this fact is less strong – and when ever I feel like it I can get up and walk about the floor.

2 JUNE 1930

A large dark bird moved slowly in front of me. Dark brown feathers – with a clear blue sheen – turning to green and then to a beautiful yellow shining circle. As I walked through the room it moved – and whatever was touched by its colours began to move. Snakes slithered around chair and table legs – thick snakes in gorgeous colours wriggled around the legs of the chaise longue. From dark brown – to carmine red and golden yellow. It flew up towards the wall and the whole room was in motion and the snakes wrapped themselves in all the golden – green – red and deep brown colours. At night, when I drank my wine – another world lit up. Fireworks of gold that rose and fell and were surrounded by ...

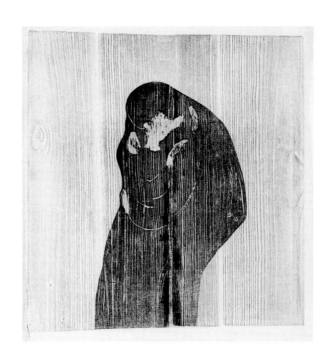

KISS
1897, oil on canvas, 99 x 80.5 cm
Munch Museum

KISS IV
1902, woodcut, 469 x 448 cm
Munch Museum

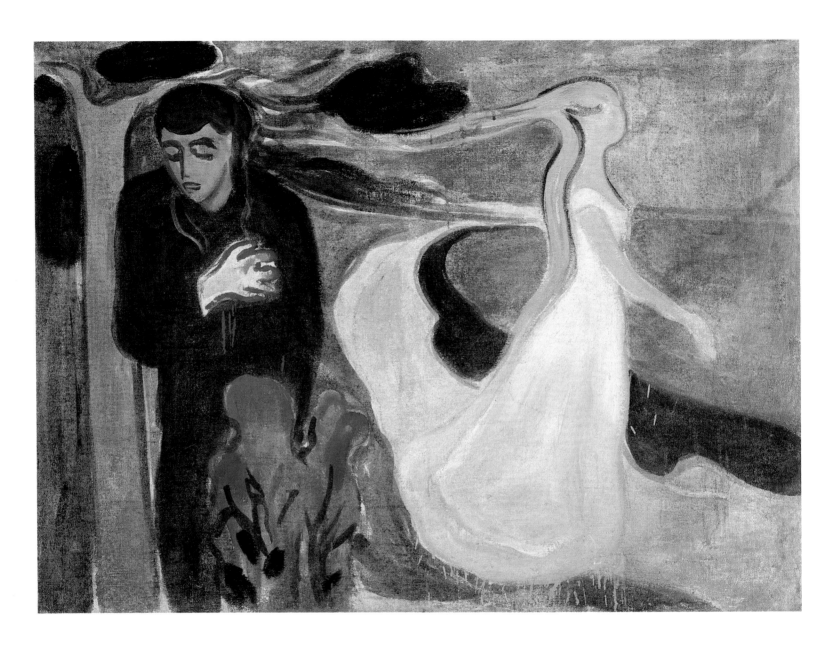

SEPARATION
1896, oil on canvas, 96.5 x 127 cm
Munch Museum

yellow burning clouds that opened and shut. An inferno of blood-red and yellow flames burst forth – these were transformed into hundreds of wriggling snakes. Sometimes there were marvellous colours: A deep blue vase – I had never seen such a clean pure colour. It was decorated with almost black-blue lines – and it glowed with a pure blue violet.

N 652

A bird of prey is clinging to my soul.
Its claws have ripped into my heart.
Its beak has driven itself into my chest and
the beating of its wings has darkened my sanity.

N 126

I would far rather be an outcast
upon the bosom of the great world
than be an accomplice to
a moral nothingness
rather a bloody spark that
no hand will shield
that glows wildly and is extinguished
and obliterated with no trace
Than glow as a lamp
with a calm measured flame
evening after evening
in that eternal sitting-room
where the canary slumbers
in its blanket-covered cage
and time is slowly counted out
by the old sitting-room clock
No the spark has the ability
to light the fire
and to know that it was responsible
for the sound of the fire siren
to know it was responsible
for the sea of flames
that broke with tradition
and turned the hourglass upside down.

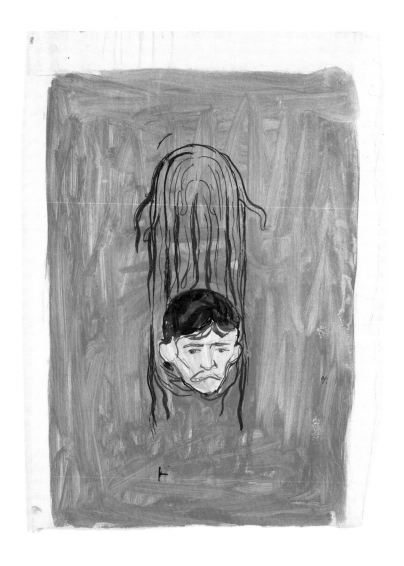

SALOME PARAPHRASE
1894–98, watercolour, ink and pencil, 460 x 326 mm
Munch Museum

**THE CAMERA CANNOT COMPETE WITH PAINTING AS
LONG AS IT CANNOT BE USED IN HEAVEN OR HELL.**

AASGAARDSTRAND, AROUND 1904

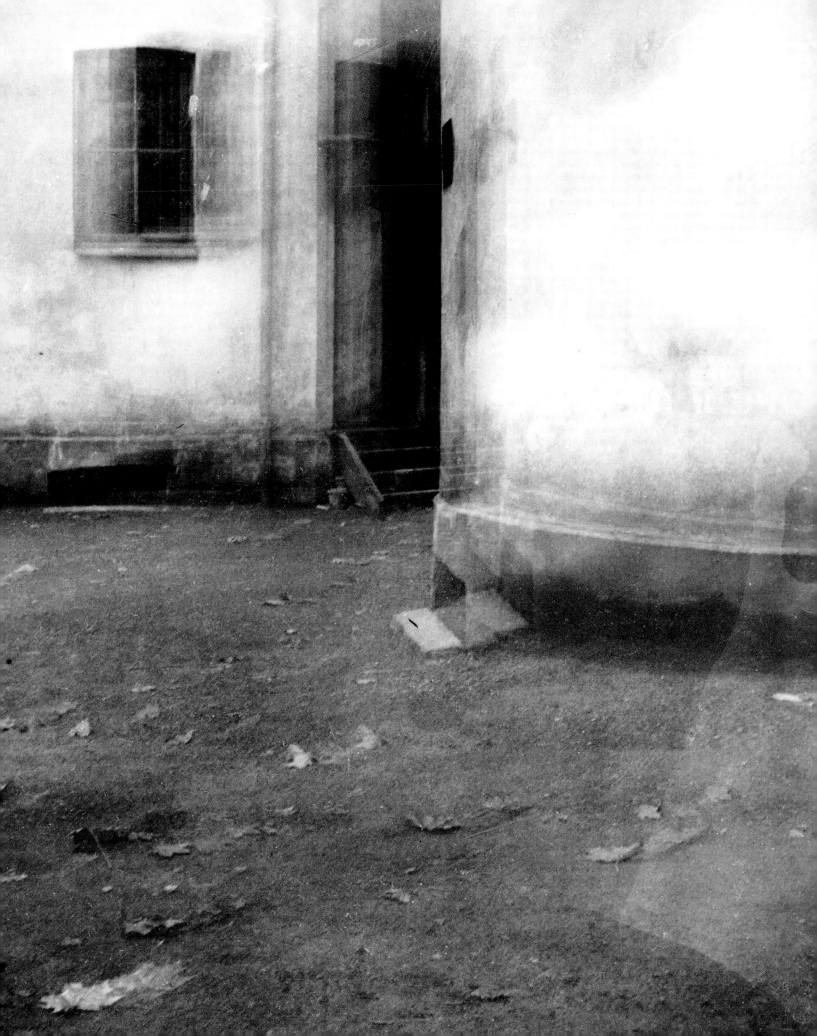

"AND THE WOUNDS ARE OPEN ..."

Luck and chance – Munch is in France. It is the 1890s, the weather is fine, generally speaking. Open the windows! Lovely, lovely ...

There is enthusiasm in the young artist's touch. He is in Paris, he is in Nice, and he is otherwise and engaged. Sentences are put to paper like cracks of a whip cutting the air. Syntax of the senses gives the structure. He sees this, hears that, smells that – and when darkness falls the blue fairy-like light spreads. Futurism *avant la lettre* mixes with the amorous sensibility of Impressionism to again ask the charismatic forces of Expressionism for a dance. Distance is the means to nearness. Munch performs like a journalist *par excellence*, but with his favourite subjects and not reality as a guideline. The giddy arbitrariness of roulette becomes the symbol of promise and forfeiture. If one sticks either to red or to black, one has to win, but the risk of irreparable loss had already been experienced as reality.

Munch's father is dead, back home, in 1889. It is the year before he takes his chance in Nice and Monaco; the great game ends in loss, the little one can continue. Every attempt Munch makes, becomes mere lyricism – on canvas or paper. And slowly but surely he slides outwards from one concentric circle to the next, ending up out on the periphery, still sensing, writing, but actually lost. The reason is that he has lost his mooring, and the circles are now able to form demoniacal arabesques where beginning and ending have vanished. This is the origin of the great existential ornament that cuts its way through the clever formulations. The painter has to relinquish the written word and tackle the painted one. "I'm only capable of letting my grief flow into the day that dawns and the day that ends." Neither red nor black gives winnings. The game is over – and can begin, in earnest.

T 2760

The Boulevard des Anglais gleams in the sunshine. There's a great swarm of people – the street is bright with red parasols and spring outfits in gay colours. There are pale girls, and Parisian ladies with their tiny lap dogs. There are Parisian dandies with trousers as wide as sacks, and consumptive patients, wrapped tightly in their shawls despite the warm weather.

And the blue sea stretches away into the distance – just a slightly darker shade than the sky – such a wonderful blue, and the air seems as if it is painted with naphthalene. Big waves roll up the beach, crashing as they break. The other side of the promenade is lined with hotels and villas in a never-ending row – blindingly white, with gardens of palms and huge exotic plants....

Nice – town of joy, health and pleasure. The newspapers are full of stories about the Siberian weather conditions that are affecting Europe. Algeria and Italy are experiencing snowstorms – and in Toulon and Marseille, children are freezing to death in the streets.

Whilst this is going on, we sit here in Nice, soaking up the sun at open windows. This January there have been a number of sunny days as warm as any in June, and the town of Nice, the queen of the Mediterranean, has never appeared so coquettish and radiant. The Boulevard des Anglais is at its most magnificent....

The market place is like a garden, brimming

over with flowers. They are sold in great baskets in preparation for the Carnival – it is time for the fun to start in Nice – the Prince of Festivities is arriving, and this is celebrated by a great deluge of flowers.

NICE, 7 FEBRUARY 1891

Like a lifeless machine packed in rags, the coachman sits high up on his seat.

"To the Gare du Nord." – and without a sound the machine lifts an arm and a whip. I creep into the carriage, and hear the crack of the whip and a whinny – and we trundle off. Through those dark and miserable streets. Now and then the light from a gas lamp illuminates the coach.

Then we come to a blinding mass of lights – a bluish fairy-like light. Locomotives shunt backwards and forwards continuously in the fairytale glow – like enormous trolls.

This is Gare Saint Lazare.

And then it is dark again – only the rumbling of the carriage can be heard – a swing around a corner – and an electric light shines in. And through the pale bluish haze – one can make out the pillars of the Madeleine – the boulevard lies ahead – radiant in the darkness.

Black top hats and elegant ladies pass by – over Place l'Opéra. The Opéra is almost invisible – because of the bright light in the foreground – it rises into the sky like a great mass – the elegant female shapes can be glimpsed, walking to and fro in the garish light. The carriage glides down Avenue l'Opéra – past Théâtre Français – one can hear the sound of the hooves on the asphalt.

Suddenly we stop – outside there is a chaos of carriages.

An omnibus towers above us – our driver gives a firework display of swearing and whip-lashing.

Then off we go again, with only the sound of hooves to be heard.

Here we are at the Gare du Nord.

"A ticket to Nice."

"Here you are."

"When do we arrive?"

"Tomorrow morning. 7 a.m. in Marseille, 10 a.m. in Nice."

So, we eat supper in Paris – and the day after, breakfast on the Mediterranean.

We sit frozen in the train carriage, with shawls wrapped around us up to our ears. Besides myself there are two Frenchmen and an English couple – and a sick German who has come down from the hospital in Le Havre.

The train moves easily – dancing over the railway lines – we hurry southwards – to the warmth and heat of the sun – bringing new life to sick bones. It flashes like lightning when we pass by a station.

The door opens.

We have arrived in Marseille. We turn towards the east. The sun streams in – the ice on the windows melts – we look out – the Mediterranean – a little bay – a white villa on a bluff – long green waves rolling up the beach.

Open the windows! We breathe deeply. A warm breeze from the sea plays around our faces – lovely – lovely.

The sick man lies back – he allows the sun to tickle his face. The blood courses more quickly through the veins – new life – another year. A life in the sun – under palm trees. How wonderful life is after all – so wonderful it makes one want to cry.

The Englishman is motionless – he doesn't even look out of the window.

The Frenchmen are jumping for joy.

How can one think of living anywhere else, thinks the sick man. He remembers the fog – the rain – the storms of Le Havre.

He has to speak.

"I have to tell you," he says to one of the Frenchmen, "I have been sick for 2 months – that's a long time. It's so wonderful to be able to come down here – to the sun."

"Oui oui," he replies, looking at him.

The train dances elegantly on. The smoke curls between the trees – like light, white drapery between the trees – green trees.

Cannes.

The merry Frenchmen disembark – they throw a glance at the lady – bid her farewell. "What children," says the Englishman. "Comical." The lady smiles.

Nice lies ahead of us. The villas are closer together – the gardens more luxuriant – the trees with the yellow fruit – why, those are oranges.

I awaken – get up – throw apart the curtains – push open the shutters from the windows and go out upon the balcony.

The first thing I see is something white – something bright.

Other hotels – with balconies – then I see the palm trees – like enormous fans in the gardens down there.

NICE, 1 MARCH 1891

It is morning – I open the curtains – open the window – and the sun streams in. The concierge is down in the hall. I walk into the garden – the sun smiles down upon the paths between the green leaves and exotic plants.

The palm trees line the path, stretching up into the sky like enormous fans.

I go out onto Promenade des Anglais. How quiet it is – how bright – how clear the air is here – how pure blue the sea. Is it Sunday ? – I don't know – I haven't counted the days – they pass as in a dream – but it feels like Sunday.

Only a few people are out walking this morning – some are reading the newspaper.

There is an old gentlemen with a white parasol – his back is ramrod straight, his head is held proudly – he stands quite still, looking out to sea.

Someone sits dozing on a bench – an open book on his lap, and in the shade one can see the pale face of a sick girl. She is sitting in a wheel-chair – wrapped in shawls.

The waves: long, sparkling in the sun, they glide slowly up the beach. Half dozing, I follow them with my eyes – till they break – one after another. The blinding sunlight – the brilliant colours and the regular crashing of the waves, lulls one into a doze.

The ocean seems to be an enormous, endless, breathing creature. Its huge breast rises and falls – I can feel its breath. And the crashing waves are like heavy sighs.

I wake up with a start.

Le Petit Journal – l'Eclaireur – le Petit Parisien – shouts the newspaper vendor hoarsely.

The dream is over.

I carry on walking.

The fragrance of violets fills the air. From the garden over there – between the palm trees under that tall white hotel, I hear the sound of singing and guitar-playing.

From the restaurant Théâtre Français, Nice.

That large head with thin hair sticking out at all angles – a bald pate – he bows as he enters. His body is so thin and small.

They laugh and make signs to one another – they can see what is going to happen.

The old man is in love – in love with the large lady who is in the habit of eating here.

Here she comes – she greets him casually. See how he bows and writhes. She asks him to join her. They converse eagerly. He moves closer, so as to be able to hear her better. How gentlemanly he is – he offers her wine – he passes her her plate. Oh Madame!

The old man is happy.

One day, there are three at the table. The lady, the old man and an important personage with a bright red beard – his whole face is in fact carmine-red – and he sports a carmine-red ribbon across his chest. The old man seems even smaller and narrower across the chest today. But he has a large head, and his unruly hair flutters wildly.

The next day, the old man sits waiting for the lady as usual, looking up every time someone enters.

The door opens – he stares. It is the man with the red face and the red ribbon.

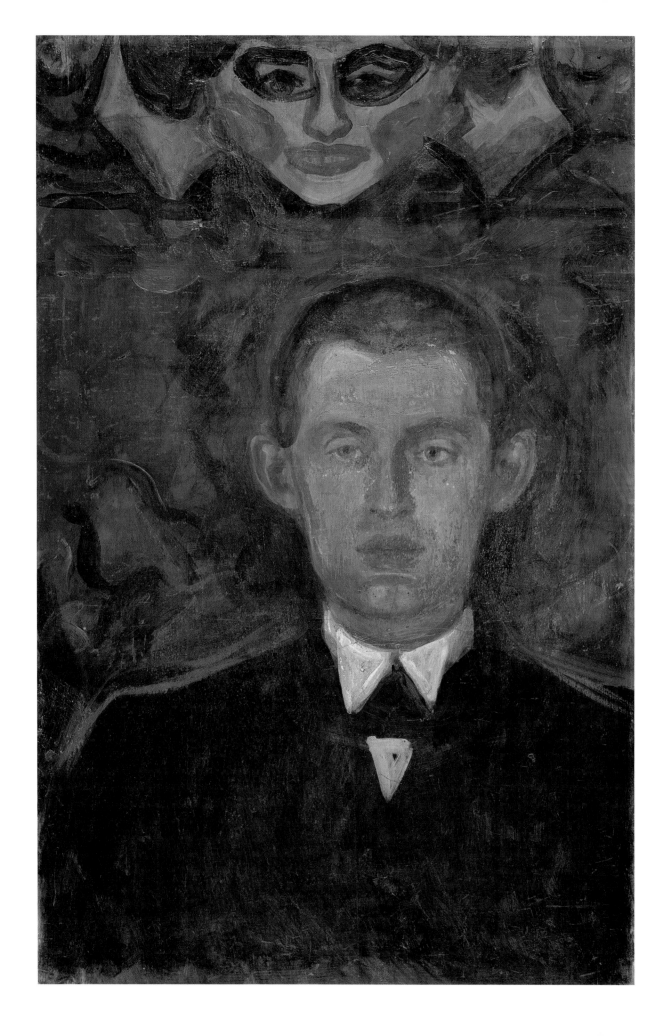

"Please sit down," says the old man, "if you would care to join me."

But he thanks the old man haughtily. The important personage seats himself at another table.

The old man retreats behind his newspaper – he has rather bad eyesight. The lady enters – well-dressed, tossing her head in the air.

The old man leans across the table to greet her – then he grasps his newspaper and begins reading it, for the lady has not even noticed him – she only has eyes for the man with the ribbon.

And the old man sits with his head deep in his newspaper – the writing upside-down.

NICE, 2 JANUARY 1891 NICE

That rich Swiss man. Four million francs in the bank.

"More coffee?" the waiter asks with a smile. The coffee is poured, and with shaking hands, the old man brings out a little hip-flask that hangs from a cord around his neck, and pours half of its contents into the coffee. Better save some for later.

Four waiters stand around smiling.

It might be fun to hold a little sermon for all those people who have looked at our paintings over the course of the years – and who have either laughed, or shaken their heads in incomprehension. They cannot perceive the tiniest amount of sense in these impressions – these momentary impressions. That a tree can be red or blue, that a face can be blue or green – they know it to be wrong. They have known since they were small that leaves and grass are green, and that skin is a kind of pale pink. They cannot comprehend that this is intended seriously – it must be some kind of careless swindle – or the result of lunacy – most probably the latter.

They cannot understand that these paintings are made with serious intentions – in suffering – that they are the product of nights without sleep – that they have cost blood – and nerves.

How these painters carry on – they get worse and worse.

They seem to follow this path of lunacy more and more actively.

Well, this might be the route to the future of painting – to this Promised Land of art.

The painter gives these paintings his dearest possessions – his soul – his sorrow – his joy – his heart's blood.

He gives these things to humanity, not to the object. One would expect these paintings to take a stronger grip upon people – first a few, then several more, then everyone. Imagine many violins in a room – one string is plucked, and the other instruments, tuned to the same frequency, all resonate.

I shall try to give an example to explain the use of these incomprehensible colours.

A billiard table. Enter a billiard hall, and when you have looked at the intense green of the baize for a while, look up. How strangely red it seems all around you. The gentlemen that you know to be dressed in black are now resplendent in carmine red – the hall is reddish – the walls and the ceiling.

After a time the gentlemen are once again dressed in black.

If you want to paint the atmosphere you have experienced – with a billiard table , then you should paint it carmine red.

If one wishes to paint momentary impressions – atmosphere – the human aspect – then one must do so.

N I

I am unable to sleep – I am aware of the little strip between the curtains becoming lighter and lighter. I toss and turn heatedly in bed – it is so obvious – why has nobody thought of it before me? Just wait – have patience – when one of the colours comes up a certain number of times, then one changes to the other colour. If one loses – one simply waits for the next turn. The larger the sum I win – the more I dare to bet. I shall become rich

SELF-PORTRAIT BENEATH WOMAN'S MASK
1891–92, oil on board, 69 x 43.5 cm
Munch Museum

– how obvious it is – I shall be able to devote myself to my work – pure art. And how surprised they will be when I send home a 1000 franc note.

I shall go there today – impossible to wait until Thursday, when I have an appointment there with my friends – the time will pass too slowly until then – I shall take the first train – 1st class – less then 4 hours.

I started to dress in the first light of day. How different everything looked. How strong I felt – I was no longer the nervous chap who constantly tormented himself with unhealthy memories – they were quite cast away.

I had never seen the street as it appeared now.

I went for a long walk – just to kill time. Finally I found my place in the train carriage – with an old man who looked terminally ill – a married couple and a young man. They were all going to Monte Carlo – this was the Monte Carlo express train. The young chap studied a gambling chart which he held in his hands – I laughed – I was so sure of myself.

The entrance. The doors of the gaming rooms were not yet open – a large number of people were waiting. As soon as the doors opened, people dashed forward to find a place at the tables.

I found the same table I had played at before. Some time passed before we began – one studied gaming charts – one changed money.

At last – Faites le jeu messieurs. There were only a few others betting small amounts – one wanted to test the waters – trial and error.

I had before me the gold coins I had won the day before – and I knew I had that banknote in my pocket – the one I needed to live on for the rest of the month.

But I wasn't going to touch it.

The game carried on for a while in a changeable manner – no suites came up. Finally, red came up 4 times in a row. I placed 10 on the black – red came up again.

I shall wait. I waited until the next suite came up – placed my bet – and lost.

This is strange.

I decided not to play for a while – just take notes and study the game. How strange this was – the game continued once again in a changeable manner – one red – one black – and so it continued. The man across from me noticed this – he placed his bets alternately, and won.

This alternating pattern carried on for a long time with no suites. I had not eaten. Mealtime had passed several hours ago.

The game had changed, so that black always came up several times in a row – whilst red only came up now and then. Black had come up 15 times – whilst red had only come up 7 times. We waited for a red suite.

Black came up six times in a row. In all probability, the red would now come up. I put 20 on red. Many have placed large sums of money on the same colour.

"Noir."

I doubled my bet.

Black has come up 24 times – red only 7 times – red is covered with money – towers of gold coins.

N 19

A couple is sitting directly opposite me. He gazes bleakly ahead – his nostrils quiver – and his hands shake. He sits with burning cheeks, following the roulette wheel with piercing eyes. They lose.

The game, which for so long has alternated between red and black, has suddenly changed character – red has come up 5–7 times – the couple have each time put money on black and lost, before doubling their bet. Red comes up another 5 times.

They carry on doubling in order to win again … they bet on black – it must come up sometime. Great piles of gold on the black – everyone cranes their necks – to see where the ball lands.

"Noir." One can hear the croupier's neutral voice – it seems loud in the silence.

"Faites le jeu messieurs."

More piles of gold on the black – red must come up sometime.

Noir pas plus et manque.

Everyone shouts – in surprise.

The croupier makes his call, and scoops up the piles of gold calmly – the gold and silver lie like long, shiny snakes before him.

One no longer dares – one has a strange feeling that a mystical creature lives in that wheel. Many have lost everything and given up.

The two over there sit staring straight ahead – they have no more money on the table.

"Faites le jeu messieurs."

1000 francs on the black.

The croupier sets the roulette wheel in motion. Gold and silver are thrown down and pushed on to the different spaces.

The roulette wheel slows down. The man over there has not yet placed his bet. A tremor passes over his face.

"1000 francs on the black" – and he motions towards his wallet.

"1000 francs on the black," repeats the croupier.

Rouges.

The man sits motionless – he has stuck the wallet back into his pocket.

He cannot pay. He has no more money. A terrible scene ensues. The croupier demands his money – they want to arrest him – he remains seated – scowling. His wife leaves – in despair.

But the game must not be interrupted – non scandale. The man remains seated – with a guard behind him.

N 20

The Riviera is a fairytale place, and Monaco a fairytale town. When the future tale of a thousand and one nights is written, the setting will be here.

The brilliant sunshine – all the riches and splendour that lead one's thoughts to dreams of happiness.

Just listen to the names – Menton.

I walk by the Mediterranean. The wide palm leaves arch overhead, and the smell of seaweed mixes with the scent of oranges – one looks into splendid gardens – villas can be glimpsed, glowing behind the shade of dark trees. You ask who lives there, and are told that it is an Indian prince or a Russian princess – or you are told it is somebody famous, who has been a household name since you were a child.

And the curious little town of Monaco – the fairytale town.

I stand on the terrace outside the casino one moonlit night – the immensity of the sea lies below me, glinting in the moonlight – over there is the Princess's palace – radiant with a thousand red and yellow lights along the ramparts, and the towers rising behind it – the town glows in the mystical, hazy moonlight beneath the high mountains.

But one doesn't stay here long. Come inside the casino, its towers reaching up into the sky – into the fairytale palace. Once you step inside – you become enchanted – you must return time and time again to the magnificent halls – where gold glitters upon the emerald green tables – where the air is intoxicatingly sultry and heavy with perfume – and fortune beckons you.

Thousands come here. Countless express trains shuttle backwards and forwards between the surrounding towns, bringing with them streams of fortune-seekers.

The earth of those shady gardens is saturated with blood. The blood of those who will not "live happily ever after".

The Parisian newspapers report that there have been 30 suicides during the last month – 3 of them yesterday. Nothing helps. One goes there for the first time out of simple curiosity – just to watch – one plays a little – and one is lost – one wishes to experience the wonderful thrill of winning, over and over again – the excitement – that strange feeling of fate. One wishes to return to these wonderful perfume-filled halls – where money has no value – where fortunes are won and lost.

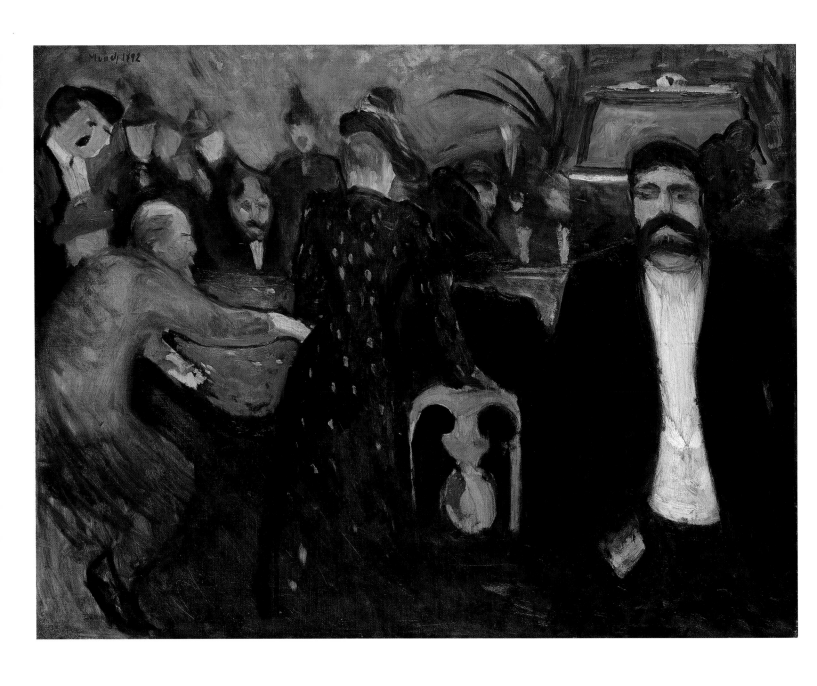

THE ROULETTE I
1892, oil on canvas, 72 x 92 cm
Private collection

It is strangely quiet inside the great halls – people stand closely packed around the tables. I only hear the turning of the roulette wheel and the voices of the croupiers: Faites le jeu messieurs. It is quiet here – but the cheeks of the men and women are bright with fever – their eyes glitter – their hands shake, as they clutch their wallets tightly.

N 22

When one walks up the Avenue de la Gare in Nice – the main street which leads to the train station – one catches sight of a poster that has been hung up on the wall of one of the biggest hotels in the town. It reads as follows: Keep away from Monaco – it is the ruin of families and businesses. This is followed by a list of those who have recently committed suicide after losing at the gaming tables.

The Parisian newspapers inform us (the local newspapers are paid thousands not to report these facts) that during the month of January there have been 30 suicides – 3 shot themselves just recently.

This may possibly stop several people from going in the first place – but nothing will help those who have already begun. Once you have entered the fairytale palace you become enchanted, meaning your return is inevitable.

It's two weeks since I first entered the perfumed halls of Monte Carlo, and since then I have returned each day.

How fearful I was that first time – I was quite faint from the hot perfumed air – I slipped on the polished floor. And as I approached the tables, everything I had read and heard about the catastrophes that could occur here, came back to me.

I place my small bet on the red – my heart is beating like a hammer – I am so dizzy, that I almost leave the table before the roulette wheel comes to a standstill. Then I see that my money has suddenly doubled – I have won – I place my bet and win again – I am so nervous that I leave

with my winnings. I dare not stay with all these people, who I thought looked mad – staring into space as they moved their lips – others seemed to stare coldly at me, but their gaze was quite empty. Their eyes were fixed upon the roulette wheel, their lips barely whispered.

The next day – I start working – when I'd worked for a while, I suddenly begin to think of Monte Carlo. If only I had continued playing, I thought – I could have won a fortune, and I thought about the money I had won – and whether I was perhaps one of those naturally lucky people. I can no longer work – I look at the clock – I look at the train timetable, and a little while later, there I am in the comfortable carriage that will swiftly transport me to that hellish casino.

And I have been there every day since – I have had sleepless nights. I have won and lost.

The little capital I had has all but disappeared – yesterday I lost a great deal of money – I didn't sleep last night. I lay there calculating my losses – they must have been be due to some vital mistake I had made. Today would be my lucky day. I leave.

I find myself sitting in that train carriage once again.

N 24

The same thing repeats itself each day – each morning I decide not to go. The morning passes – I don't even think about it – then the evening comes – I've organised everything for work – I shall start soon – the sudden thought that I might nevertheless make the journey to Monte Carlo strikes like lightning. There is no premeditation – it's simply a question of when the train leaves – the time – it is as if I have been struck down by a fever – the minutes seem like hours – the journey from Nice to Monte Carlo lasts an eternity – finally I find myself at the bottom of the steps leading up to the casino – I feel that strange prickling sensation in my chest once again – I enter the sultry, perfume-laden air. I sit down at

one of the green tables. I see the fortunes disappearing and passing in front of my very eyes – I see how the same passion makes everybody equal – there is no difference – countess or whore – they are just the same. They sit there with burning cheeks and glazed, red eyes. There is no longer any difference between them – there she is, the rich English lady – who was thrown out yesterday – she was found to be scooping up other people's winnings, 3 times running.

There she is – the whore, she sits radiantly at the table – and wins. How is it that happiness makes one beautiful? She is quite sure – confident of success, she places her money on the table – and wins – she glitters.

Yesterday I thought I was cured – I had lost – everything I had on me. I went out into the garden – followed the dark paths – shaded by palms and cactus – I was almost happy – for I felt I was cured – I was going to begin my work anew. I kept meeting guards – they were keeping an eye open for those who might want to kill themselves – or took care of removing the corpses as soon as possible.

I went in again to meet a friend. He was standing at one of the tables – hot and nervous. I'm mad – completely mad – I can't stop myself – he throws down money – he loses and loses again.

I borrowed a few francs from him – I placed my bet – and won again. Now I had the feeling that destiny was my friend – the money was pushed towards me – my pile became bigger and bigger. My trouser pockets – waistcoat pockets – every possible pocket was bursting with gold and silver.

Is it my imagination or is it reality ? – everybody seems to be talking about red and black – about Monte Carlo. Once I was entranced by a woman, and I began to think that everybody else looked like her – I seemed to hear everybody talking about her. In the railway carriage – in the train corridor I hear the words constantly repeated – rouge – noir – winning – losing – roulette.

I dream about it at night – if I overhear a conversation in the corridor it is about Monte Carlo – rouge – noir.

My cheeks are burning – I have an eye infection. Nevertheless – it is an intoxication – it's good to forget – all those other worries.

I awaken in the morning in a pool of sweat – and before the strip of light at the window has begun to herald the break of day, I hear talk of money in Monte Carlo.

N 6

I'm afraid something is wrong at home.

I began to hate him. He had no pity. My ears were ringing.

My sisters – my father.

"My father is dead?"

"Yes – I'm afraid so."

"Did you read it in Morgenbladet? Does it say Army doctor?"

"Yes."

"But have they spelled the name with c-h?"

"Yes. It says Lian Hauketo."

"Yes, then it is him," I say coldly.

How inexorable he was – I hated him. The occasion obviously warranted a letter to Kjelland – I took the letter – I opened it, and saw it was my brother's handwriting

"Please open it, Kjelland." I had become very calm.

"Yes, it's addressed to you." He handed me the two letters.

It was from my aunt – she prayed for God to comfort me. My father was no longer with us – he had met his salvation.

I packed my things and left. I wanted to be left alone. I went into a restaurant and read the letter over and over again. Inger had promised, on behalf of us all, that we should all meet in heaven, and be united with Mama and Sofie – his eyes had been radiant.

I pulled my hat down over my eyes. The waiters looked across at me. How large and gloomy this

restaurant was – nobody else but myself and a couple of waiters – two great billiard tables stood gaping in the corner.

I had to get out. I decided to walk down to the Café Régence to find the death notice in *Morgenbladet*. I walked down St. Honoré. Down by the Madeleine Church it became very busy – swarming with people – constant traffic – how silently the wheels rolled – one heard nothing but the regular clip-clopping of hooves on the asphalt.

I crossed the street carefully, to avoid being run over. How busy it was, and how cheerful people seemed. Some of them must also have experienced a death – at least a few amongst the thousands on the street.

I walked down the boulevard – past big shop windows. I noticed some ties, and stared at each of them in a daze.

I stopped at a newspaper kiosk – looked at some drawings in *Le Courier* – a lady in a slip, conversing with a man in a top hat.

I walked on – I gave a sudden start – I saw an old man a little further on – he looked just like my father – he walked in a slightly stooping way, with his hand on his stomach, and all the old people I saw seemed to resemble him. Close up, he didn't look a bit like my father.

There goes an old man with his son – they look alike – they have the same nose – the father is not so tall, a little stooped, and has a beard. The son holds his arm, and they are talking animatedly. They seem to be in complete agreement with one another – how trustingly the old man leans upon his son.

Avenue de l'Opéra – and the Café Régence, where I find the newspaper I have been looking for.

There it was.

I stared and stared at those lines in the newspaper, for I don't know how long. It seemed so strangely simple and natural – as if it were meant to be.

The funeral is on Thursday.

That was my father. He was always sitting by the bureau whenever I came home – with his pipe in the corner of his mouth, grey and stooped – in his old dressing gown. He smiled so pleasantly when one talked to him – smiled through a thick cloud of tobacco smoke. It was true – I would never see that smile again. I buried myself in the newspaper.

N 12

And then there was Jaeger – possibly the greatest sorrow. I almost hated Jaeger. I was convinced that he was right – but nevertheless.

I was visiting Goldstein.

"Now it's your turn. It's always painful when one has had a disagreement."

"Yes, but we were so very fond of one another – he was as soft as butter, you know – is your father still alive?"

"Yes."

I envied him that.

That Jaeger – he was as hard as nails – do you know what he said ? – Kill him.

My father – what a kind soul he was. I couldn't understand Jaeger. I could love him, but also hate him. For my father, that was the worst of it – the problem between Jaeger and me.

My father – just didn't understand – the problems I was having. I was unable to sit still – unable to be happy – unable to enjoy myself at home – when I knew she was together with somebody else.

And so I kept company with those who were suffering, like me. I could no longer put up with all that talk at home.

I keep remembering strange little episodes – and the worst of it is – I'm sure he himself forgot them immediately.

He once came home from Helgelandsmoen – he'd been away for some time – he brought out a bottle of wine – this is for you – let's drink it together.

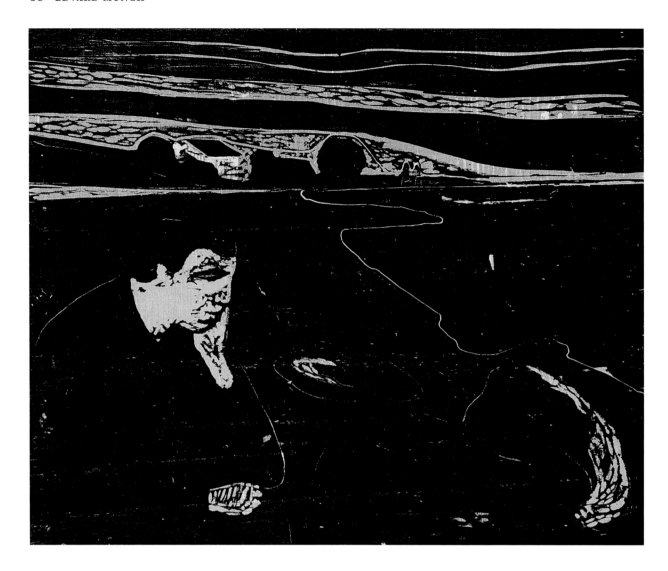

It was ordinary Champagne – I answered thoughtlessly – "I'm not sure that I like it." He was disappointed.

When I think of it now – why didn't I embrace him – take in those gentle eyes – the aged features – if only I could embrace him one more time.

I see him as he sat in the corner of the sofa by the window – in a cloud of blue tobacco smoke – the sun shone upon his grey hair. He raised his eyes when we spoke to him – with that gentle look.

N 16

So many small things came back to me – small episodes that preyed on my mind. Words that had wounded. I had been as cold as ice – whilst he was gentle, and looked for reconciliation. He was so gentle.

I was full of remorse for the great pain I had caused him – I suppose it had to come out.

That was what I had done.

It was mostly because of her – I was not myself.

EVENING/MELANCHOLY I
1896, woodcut, 383 x 455 cm
Munch Museum

I saw him sitting in the sofa, stooped, tired and grey – I saw his wonderful old head sinking lower – collapsing, as if searching for a resting place.

How hard and cold I had been towards him.

Tears sprang to my eyes.

I put the sheet in my mouth.

It was her.

Why hadn't I told him everything – he would have understood why I was so short-tempered and so nervous – so hard and cold so many times – why I couldn't stay at home, even when he had asked especially. The fact that I often came home late at night – I had to get out – out – to try and chase away my thoughts. I had to be out in order to try and forget her, and also to find her – in the places she had been.

How I wish there had been a time when we could have had a pleasant conversation – that I could have embraced that grey head in my arms.

When the time had finally felt right – death was waiting for you.

I was unable to share my thoughts with you.

N 18

I sit alone until I can no longer bear it. Then I go out to meet friends. When we're together, their laughter cuts through me like a knife, and I flee from them.

The dawning day is grey and dark when seen through tears.

He didn't understand my needs. I didn't understand the things he prized most highly.

God created us all.

Did you understand how I suffered? – did you understand why I was so hard? I was not only myself. She was in me – she was in my blood.

Those at home – my aunt, my brother and my sisters – believe that death is simply falling asleep – that my father still sees and hears. They believe that he is wandering in joyful happiness up there in heaven. And that they will meet him again in a while.

I have no choice but to give in to my sorrow, from the break of dawn until the grey evening light sets in.

I sit alone with a million thoughts – there are a million daggers ripping into my heart – and the wounds lie exposed.

The air lies grey and heavy over the rooftops – the light disappears so quickly. Silhouettes begin to take form through the window – one can make out chimneys and roofs. A thin layer of snow covers them. The red tongues of the fire in the stove flicker occasionally.

It is a town within a town – Kjærgård – the town of the dead. There are wide streets – side streets and boulevards.

The graves lie side by side – some tall, others low. There are chambers and palaces – quiet people live here – the dead. It is a highly populated town – there are many streets – and each block houses many people – whole families for many generations. The bones turn to dust, giving place to new.

What does it manner if one dies?

These streets swarm with people dashing about, and the bus is a moving mass of human insects. They all look happy or unconcerned.

Nobody cares.

N 63

ART IS CRYSTALLIZATION

AASGAARDSTRAND, CA. 1903

" ... HEAR THE BLOOD THROBBING"

Sensuality is many things. We prefer to think of it as a particularly optimistic source of energy for one who is sensual – a person who constantly reaches beyond himself or herself like a river overflowing its banks. Sensuality is abundance, sensuality is a kind of volume that lifts life into a fan of development. We say this and feel happy. Cheers.

Munch raised his glass, too – filled to the brim – but there is not the slightest reason to believe that he would have shared this idea of sensuality. Sensuality is something completely different for Munch. Sensuality is vulnerability, sensuality is being exposed, sensuality is the cause of fear.

To sense is not that the river overflows its banks, to sense is – for Munch – to receive. To take in. So, as the river overflows its banks out there among the happy ones, Munch is taking in water like a sinking ship. Sensuality is first and foremost receptivity, exaggerated susceptibility, a unprotected porous body without the strength to withstand external impressions, or – when the calamity has happened – keep reactions inside. The equilibrium is again broken. The boundaries quiver like soft breezes on the skin. "Suddenly I felt a chill" – and there does not have to be much more than a slight breath of air in St. Cloud in France before a feeling changes to the opposite, before dream is replaced by nightmare. Munch the thinker wants to make these two – the dream and the nightmare – dual aspects of the same thing: a kind of global cohesion where new life begins to grow from what is dying, but Munch the artist does not fall for this. On the contrary, he sticks to doubt and fear.

Fear is enormous – fear of life, which he believes he has inherited together with illness. And even so he manages to grasp it as a phenomenon. Because Munch is a kind of phenomenologist – of literary stamp. Neither his works nor his texts are primal screams from the deep. They are thought out with experiences as their centre, but they are still thought out, painted, and formulated. And just as he paints the same subjects again and again with rhetorical precision, likewise he writes them again and again with slight variations, and as he displays his great choreographic, dramaturgic talent in his painting, likewise he also writes his texts with this theatrical touch. We are in the theatre of the soul, there is movement and gesture, there is composition and sequence and it is always serious. "We are in endless battle ... one doesn't die, one is murdered by one's fellow human beings."

N 533

I lie at night and listen to my heart beating. I hear the blood roaring in my ears – it fills my head – it seethes under my skin and in the tips of my fingers and toes. My skin tingles.

How they buzz, those billions of worlds that stream along from the skin to the heart – rhythmically steered by the beating of the heart. Billions of worlds push forward. They wish to find a path out of their confinement. Yet they have to return over and over again. It gushes in the canals of my ear – it vibrates in my limbs – those billions of worlds.

What is little – what is large – what is time? One second between my heartbeats – and the worlds inside me have made their circumnavigation. The light from the furthest stars in the universe take billions of years to reach me.

In my cellular tissue the worlds are at work – and the inhabitants of those worlds – the starry stream in the cellular tissue – and its inhabitants – and its atoms. I shut my eyes in the darkness. It shines and sparkles inside me. The worlds give off their light – the atoms give off their light.

T 204

GRAVESTONES

It had been cold for a long time. Then suddenly it turned very mild and spring-like. I went up to the top of the hill and enjoyed the soft air and the sun.

The sun warmed, yet now and again a cool breath of wind blew – like the air from a burial chamber. The damp earth steamed – it smelt of rotten leaves – and how quiet it was around me. Then I seemed to feel how the damp earth with those rotting leaves fermented and was filled with life – even the naked branches. Soon they would germinate and come alive and the sun would shine upon the green leaves and the flowers, and the wind would bend them in the sultry summer weather.

I felt the greatest pleasure in knowing that I would be returned to this earth – this always fermenting earth – always to be shone upon by this living sun – alive. I would be at one with it – and out of my rotting corpse would grow plants and trees and grass and plants and flowers and the sun would warm them and I would be a part of them and nothing would perish – that is eternity.

I sat down on a bench. It was so quiet around me – yet there were a thousand sounds from this city of millions. From the immense wilderness of roofs, a prairie stretched as far as the eye could see, of roofs, towers, factory chimneys. The Pantheon shimmered in gold, and factories and railways sent clouds of smoke into the air. What a bustle on the Seine.

The rumble of a train – the scream of a child – they rose above the rest of the noise. Then a long screeching whistle from a locomotive – and yet another.

A cockerel crowed – it came from St. Cloud that lay beneath me. Another cockerel answered. I no longer saw the thousands of hazy roofs and spires. The cockerel that crowed – that smell of the steaming – rotting leaves. The sun that warmed me was so spring-like. I felt at home – it reminded me of a spring day at Vestre Aker. Me together with the one with the spring smile, the blonde hair and the blue eyes.

We sat on a bench at the top of the hill. In the distance the hazy blue fjord and the roofs of the city that glinted in the sunlight like silver – and down there the church, then the whole town with those dark, blue violet hillsides in the distance.

We sat quietly, and it was quiet all around us – and we heard the smallest sound from that sprawling town. The humming of a thousand lives in the quivering spring air, yet it was so strangely quiet.

I jumped up at the touch of a small breath of air – chilly, like that of a burial chapel – and I stood up and went home to my room with icy blood.

ST. CLOUD, 1889

Spanish Dancer – entrance 1 Fr. – I shall go in.

It was a long hall with galleries along both sides – people sat drinking at round tables underneath the galleries. In the middle of the room the gentlemen were crowded, top hat to top hat – amongst the ladies' hats!

Behind the top hats, a little lady wearing lilac-coloured tights and costume was balancing on a tightrope – in the middle of all that blue-grey, tobacco-laden air.

I sauntered amongst the standing clientele.

I was on the lookout for an attractive girl – no – yes, there was one that wasn't bad.

When she became aware of my gaze her facial expression changed to that of a frozen mask, and she stared emptily into space.

I found a chair – and collapsed into it – tired and listless.

Everyone clapped – the lilac-clad dancer curtsied, smiled and disappeared.

The group of singers from Romania performed their act. There was love and hate, longing and reunion – and lovely dreams – and that soft music melting together with the colours. All those colours – the background scenery with the green palm trees and steely blue water – the bright colours worn by the Romanian singers – in the blue-grey haze of the room.

The music and the colours captured my thoughts, which were carried away on the drifting clouds, borne off by the soft tones of the music, into another world of pleasant dreams.

I, too, wanted to create something – I felt it would be so easy – it would simply come to me, as if I were performing a piece of magic.

I would show them.

A strong, naked arm – a powerful brown neck – a broadly muscled chest – upon which a young woman is resting her head.

She shuts her eyes and listens to the words he is whispering into her long, loosely flowing hair.

Her lips are open, her mouth trembles.

I should paint that image just as I saw it before me, but in a blue haze.

Those two, at that moment, were no longer themselves, but simply a link in the chain that binds generation to generation.

People should understand the significance, the power of it, and they should remove their hats, as if they were in a church.

I wanted to create scores of pictures portraying this image.

There would be no more paintings of interiors. Paintings of people reading, and women knitting.

There would be paintings of real people who breathed, felt, suffered and loved.

I felt I had to do this – that it would be easy. The flesh would have volume, the colours would be alive.

There was an interval – the music stopped.

I was a little sad.

I remembered how many times I had had similar thoughts – and that once I had finished the painting – they had simply shaken their heads and smiled.

Once again I found myself out on the Boulevard des Italiens – with its white electric lights and yellow gas lamps – with those thousands of unknown faces that looked so ghostly in that electric light.

N 5

Good morning, Good morning – I wanted to get on with my work – Yes you, Munch. And he came out into the hall and gestured to me to

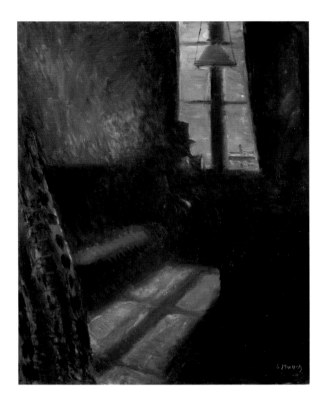

follow him – he held a paper in his hand.

It must be something important. Now, what could it be – is there a letter for me.

He said very quietly and strangely that there was something he needed to talk to me about – I have heard – he looked at the letter – Something seems to have happened – something to do with someone at home – here is the telegram.

It took some time for me to open the letter – my hands were shaking. I stare and stare as if in a haze, and at last I manage to decipher the contents.

It is nothing, I have been granted the loan. My father – aunt – my brothers and sisters – nothing has befallen them. I was exultant – I took a couple of quick steps across the floor.

Then I remembered what Hertzberg had said – so quietly that it seemed strange.

I froze immediately. Why was he so formal, why did he think something had happened, how did he come upon those thoughts.

NIGHT IN ST. CLOUD
1890, oil on canvas, 64.5 x 54 cm
Nasjonalgalleriet

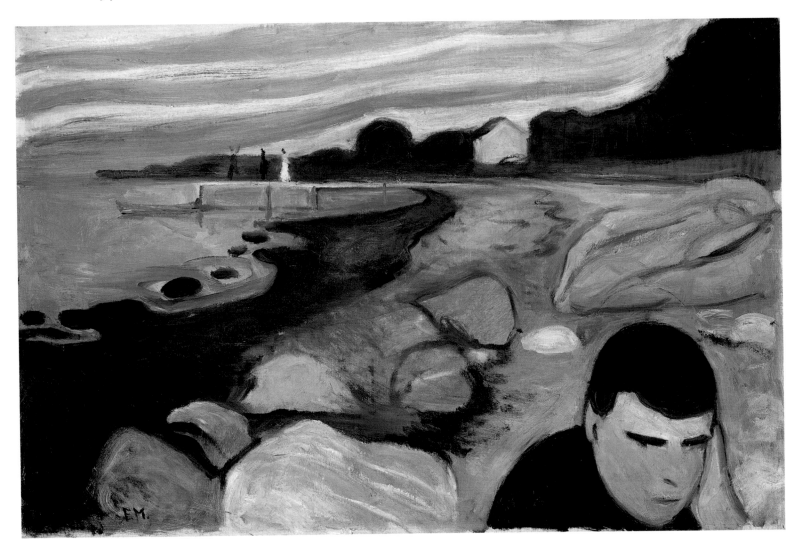

I looked at him – my blood turned to ice – I was quite sure something had happened – something dreadful. I saw it in his face.

You know something – it was completely quiet in the room.

N 664

ON THE BEACH: MELANCHOLY

I walked by the sea – the moonlight shone through dark clouds. The rocks rose above the water as mystically as sea beings. There were large white heads that grinned and laughed. Some were up on the beach, others down there in the water. The dark blue violet sea rose and fell. Sighing in between – the stones.

One evening I walked alone along the seashore. It sighed and sucked around the stones. Long grey clouds streaked the horizon. It looked as if everything was dead – as in another world. A landscape of death. Life began over there by the landing stage. There was a man and a woman – and there came another man. With oars over his shoulder. And the boat was tied up down there – ready to leave.

MELANCHOLY
1892, oil on canvas, 64 x 96 cm
Nasjonalgalleriet

She resembles her. I felt it as a stabbing pain in my chest – if only she were here now. I know for sure she is far away – but nevertheless I recognise her movements. That's the way she used to stand. With her arm upon her hip. God – heavenly God. Have pity on me – please don't let it be her.

There they are going down. She and he.... are going over to the island over there. In the pale summer night they will walk over there between the trees, arm in arm. The air is so soft. It must be wonderful to be in love now. The boat became smaller and smaller. The sound of the dipping oars could still be heard across the surface of the sea. He was alone – the waves rolled up towards him monotonously – and it sucked and sighed between the stones.

N 618

MY MADONNA

He sat with his arms about her waist. Her head was so close to his. How strange it was to have her eyes – her mouth – her breasts so close to him.

He was aware of every eyelash – and every greenish speckle in her eyes. The transparency of her hair – the pupils of her eyes, so large in the dusk.

He touched her mouth with his fingers. Her soft flesh moved under his touch – and her lips smiled – whilst he felt those large blue-grey eyes rest upon him.

He examined the brooch she wore on her breast – it shone with a red light. He touched it with his trembling fingers.

He laid his head upon her breast. He heard her heartbeat – he felt the blood coursing through her veins – and he felt two burning lips upon his neck. This sent a shiver through his body – he convulsively clasped her to him in his trembling sensual pleasure.

T 2730

Up in my studio I was working on two paintings. They were *Woman with the Venereal Child* and *The Red Sun*.

The woman bends over the child who is infected with the sins of her fathers. She lies in her mother's lap. The face of the mother who bends over her has become purplish from crying. There is a strong contrast in colour between the red, tearful, swollen face contorted into a grimace, and the ashen-white face of the child which contrasts strongly with the green background.

The child stares with huge deep eyes into the world it has involuntarily entered. Sick and frightened and questioning it looks out into the room – surprised at the realm of pain it has entered, and already with the question why. Why.

It was the old, familiar "Ghosts" phenomenon – and the accountability of the parents that I wanted to convey. But it was also about my life. My why. I came into the world as a sick being – in sick surroundings. My youth was spent in a sickbed, and life was a brightly lit window. With wonderful colours and wonderful joys. And death – I painted more than willingly out of doors – was part of this dance. The dance of life.

The other painting – the red sun. Purplish red, as if seen through a sooted glass, the sun shines upon the world. On a hill in the background, the cross is empty, and weeping women pray at the foot of the empty cross. The lover – the whore – the drunkard and the criminal all fill the landscape below – and towards the right hand side there is a steep slope going down to the sea. The people are falling and tumbling down that slope; filled with terror they clasp the edges of the steep slope.

In the midst of this chaos, a monk stands helplessly. He looks at everything around him with the same terrified eyes as the child – and asks why – what for.

T 2785

One evening I walk down a hillside path near
Kristiania – together with two comrades. It was a
time during which life had ripped open my soul.
The sun went down. The sea dipped quickly
under the horizon. It was as if a flaming sword of
blood cut across the firmament. The air turned to
blood – with cutting veins of flame. The hillsides
became a deep blue. The fjord – cut in a cold blue
– amongst yellow and red colours. That shrill,
bloody red. On the road and the fence. The faces
of my comrades became a garish yellow-white. I
felt a huge scream welling up inside me – and I
really did hear a huge scream. The colours in
nature – broke the lines in nature. The lines and

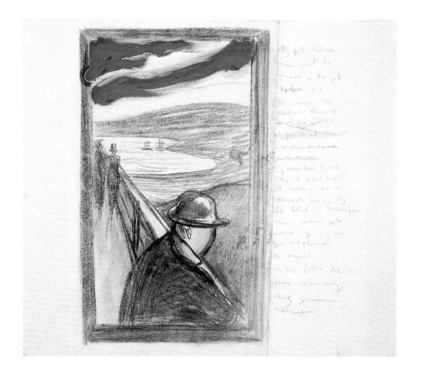

colours quivered with movement. These vibra-
tions of light caused not only the oscillation of my
eyes. My ears were also affected and began to
vibrate. So I actually heard a scream. Then I
painted *The Scream*.

T 2367

I was walking along the road with two friends –
then the sun set. The heavens suddenly turned a
bloody red and I felt a shiver of sadness. A clutch-
ing pain in my chest.

I stopped – leaned against the fence, for I was
deathly tired. Over the blue-black fjord and town
lay blood in tongues of flame.

My friends continued walking – and I was left
trembling in fear. And I felt a huge endless scream
course through nature.

T 2783

I was walking with two friends and the sun set
and the heavens suddenly turned to blood and my
friends continued walking. I stopped by the fence,
deathly tired. Over the cold blue fjord and city
was a flaming reddish yellow, and I felt a huge
scream course through nature.

N 72

One evening I was walking down a road – on the
one side lay the town and the fjord below me.

I was tired and ill – I stood gazing over the
fjord. The sun set – the colours of the sky were
red – like blood.

It felt as if a scream was coursing through
nature – I seemed to hear a scream.

I painted this image – painted the clouds like
real blood – the colours screamed.

This became the image *The Scream* in *The
Frieze of Life*.

One clear sunny day I heard music coming
down Karl Johan – it filled my soul with celebra-
tion. The spring – the light – the music – melted
together into a quivering happiness.

The music gave colour and the colours. I painted
the picture and let the colours quiver in time to the
rhythm of the music. I painted the colours I saw.

DESPAIR
1892, drawing (charcoal and gouache), 370 x 442 cm
Munch Museum

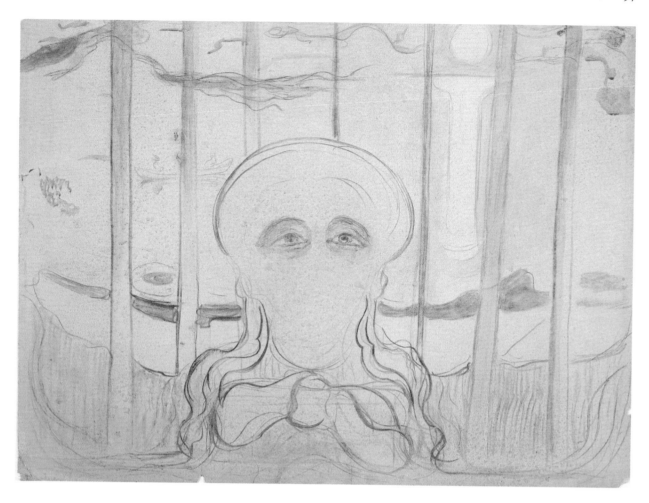

T 2785

THE PROFESSOR

The will can be identified in the protoplasm. The desire of the will is a display of power. It develops into a creature – a human. A human being's pores – see – feel – move – and hear and talk. The pores – the cells of the skin system – are the boundaries of the protoplasm. We may say that the human being's pores can see, feel – move – yet the desire of the human being was to see better, and so the two eyes developed. It wanted to hear better, and so the ears developed. It wanted to move about more freely – the feet – to touch more – the hands – etc.

The need to communicate became evident, and so the vocal cords developed, that strange organ.

Ladies and gentlemen – the sound of the voice – what power it has, making loud noise unnecessary.

In the vibration of sound, another power lies buried which one does not consider – we are talking about its melodious resonance, or whatever one wishes to call that strange power. It is the power of sympathy – or, in negative terms – the power of antipathy – at any rate the power of rhythm – a tiny sound vibration can, when it comes into contact with a similarly attuned sound instrument, produce resonance over long distances.

The vocal cords and the ear – a Marconi system. The vocal cords and the orifice of the mouth – the sending station – the eye being the receptor

MOOD/SUMMER NIGHT
1893, drawing, 500 x 647 mm
Munch Museum

station. Besides these sound waves, another Marconi telegraph works side by side with them – one that is not simply sent to the receptive eye – it can also be heard in the ear – it has the effect of arousing interference in the receptor station – it can bring life and it can kill – the glass – the light.

A gentleman enters and sits down at a table. A woman stands stiffly – cold and pale behind him – she speaks a tiny word – seemingly indifferent, the man immediately collapses, grabs a revolver and shoots himself.

She killed the man with one small word. It was not even the word that did it – it was the sound that did it. Perhaps it was neither the word nor the sound – it was the vibration of her vocal nerves – and the fact that this vibration came exactly at this point in time.

This little vibration came into contact exactly at this point in time with that tiny nerve point, and became etched into his body or his spine – and so he collapsed. He was – just as light is prepared and receptive when the right time comes – receptive to this small sound from the woman – the enemy. She wanted to take revenge. He had arrived wet with tears – prayers – the curse of his friends. She had simulated suicide in order to win him. He had watched over her all night long. Then last night he had slept safely in her arms – in hope – willing to sacrifice everything in order to save a human life. She waited for the right moment – just like a wasp, waiting to thrust its sting into the softest part of the human body. The man – the enemy. That which the light had made receptive. And that little voice – that little word – no – that little vibration went straight in – through the open flesh – to a tiny fibre in the human body. And as if struck by lightening he collapsed. His back bent over – the great mass of muscles contracted and twisted. The sinews tore and clenched and knotted themselves. His head sank to the table. He rocked his head from side to side. His arms twisted with the movements of the muscles and tendons. He wrung his hands and grasped at the air.

Down in a drawer – he held a revolver in his hand. He clasped it with both hands – squeezed it, pressed it. A shot. He stands up and looks around with open eyes – holding his left hand to his chest. Blood gushes from between his fingers. He stumbles a couple of steps and falls back upon the bed. His eyes still see for a moment. He looks towards the woman who is standing with the same staring ice-cold gaze she has had all evening, and she is looking at him. He is dead.

She had connected with that tiny nerve in the spinal cord – like the tiny living nerve in the body of an ox. With the instinct of a woman, she had, like the Marconi telegraph, discharged her electricity towards this tiny receptive nerve centre in the man's spinal cord.

FEBRUARY 1930

This fear of life has raged in me since the thought entered my mind. Just like the sickness I have had from the beginning of my life – both inherited. It feels as though an unjust curse has been following me.

Nevertheless, it often seems to me that I am dependent upon this fear of life – it is necessary to me – and that I would not want to be without it.

I often feel that my illnesses have also been necessary. In the periods without the fear of life, and without illness, I have felt like a ship sailing in a strong wind, but without a rudder – and I have asked myself where am I going? Where will I land.

2 JUNE 1930

Earlier in the spring I said: we are in endless battle. Humans are engaged in a never-ending hidden battle against one another – mostly subconsciously. Even with one's friends.

One does not die, one is murdered by one's fellow human beings. The poison gas of words – evil thoughts – which hit one's most vulnerable places like radio waves.

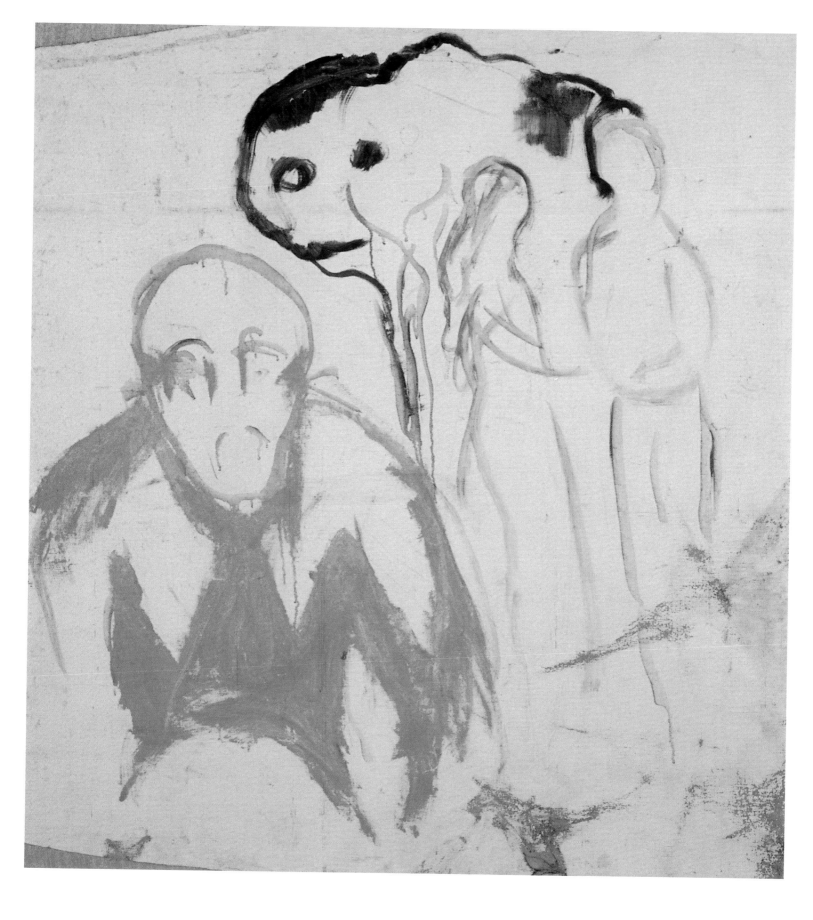

JEALOUSY
1930s, oil on canvas, 110 x 100 cm
Munch Museum

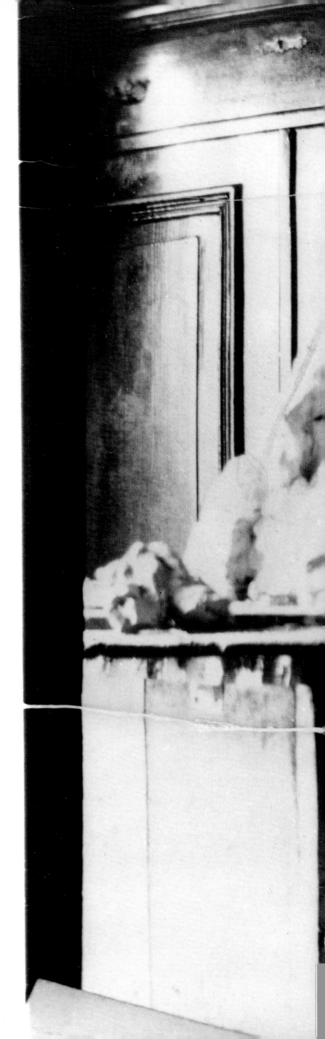

AN ARTWORK IS A CRYSTAL. A CRYSTAL HAS A SOUL AND A MIND, AND THE ARTWORK MUST ALSO HAVE THESE.
IT IS NOT ENOUGH FOR AN ARTWORK TO HAVE CORRECT ANGLES AND LINES.

EKELY, SKØIEN, 1929

"EVERYTHING IS LIFE"

Munch is alone in the world, surrounded by interdependence. Munch's ambivalent experience of life can be described as simply as this. On the one hand there is loneliness: "Two stars that are meant for each other just touch and vanish, each to its corner of the wide universe." There is also the significance Munch attached to hair, offering (as he saw it) a precarious link between man and woman. There is isolation in the sickroom, in bed, in the street, more or less everywhere. On the other hand there is the greater connection: cosmic visions, both in literary and popular scientific form, of the world, on which and in which everything works together. These two, loneliness and connection, are interrelated in every respect. This must make the experience of being excluded that much more unbearable.

Munch writes that everything is life, and that he has always believed this to be so. It is the vitalist view of the times: everything that exists is permeated by a fundamental life energy or force running through it at different stages. This energy runs through his pen, but as a concept it also has an evocative function for Munch. That everything is fundamentally connected is a good and comforting thought for someone unable to experience it as such. With all due respect for the obscurantism of the time, it is not without naivety that Munch expresses his notions about ethereal vibrations, rays and radio waves. On the other hand, these are clearly notions that – as always – are allowed to develop out of Munch's existential layers of growth. They become the answers to all manner of questions that lie, in a manner of speaking, some considerable distance away from where it all ends – with Marconi, the inventor of the wireless telegraph!

Munch's speculative contribution to the cheerless but comprehensive developments within the world of science is evidence that we are dealing with an artist who cannot involve himself in anything he has not personally experienced, just as he cannot paint anything he has not seen. We are also talking about a person whose fundamental interest in the world continues undiminished throughout his entire life.

Munch cannot be accused of being a researcher or a philosopher, but he is, in any case, a human being who seeks knowledge and attempts to combine what he believes he knows with what he believes he has experienced. He is an empiricist with an imagination, pursuing the smallest of observations as far as possible with the most ambitious of thoughts.

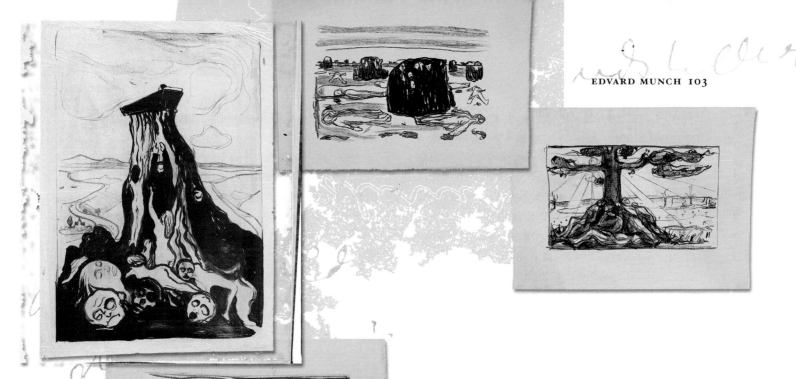

N 655 – 1

I stood on a high mountain and saw the whole
world spread at my feet – the world from thou-
sands of years back in time. I saw the small and
the large planets that adhered to the laws of
nature and moved in their predestined orbits. I
saw that little planet Earth as it moved on its
orbit around the sun. I saw where the change in
matter began – how the air corroded the hard
matter – and the transitional form between stone
and the atmosphere was created: the living –
human beings, animals and plants. After disinte-
gration desire was born. By virtue of this desire,
the human beings, the animals and the plants
mated. Obeying the law – man and woman made
love and – bore children.

I saw how humans multiplied – how they
gathered together in groups – and how they were
spread about the world. And when one mass had
bunched together – and met other masses – they
fought in order that the strongest might win –
like – the other living masses – the marshes for
example.

I saw the single individual – from the first
moment that light entered it – how its desire
slowly but surely developed. At what point – it
first began to feel? It screamed after nourishment
– it saw the sun and stretched its arms towards it.

The power of reproduction began – first as an unclear dream – incomprehensible desire – and finally complete desire. And it mated with another individual – bringing to life more fuel for the fire.

And I saw how an individual was born in those places where the masses had huddled together – another individual was born upon a freer earth – and both individuals had the same desire for destruction – for the combustion of life. In those places where the mass was thickest, the individual could not gather enough fuel and it became stunted – single individuals that collected together too closely were stunted – they were born with greater requirements – and became criminals. I saw one individual born of a stunted individual – and how the light first entered it and how it developed needs and requirements. Like the first time it saw the sun, and stretched its hands towards it – that individual was told it was bad – and it bowed its head and believed itself to be bad – and a condemnation was pronounced about that individual – because it was born with requirements – and because it was born stunted it was condemned to suffer for a long time.

You who are incomprehensible – you who are part of the protoplasm – you who are like a vast mystical head drawn upon the heavens. God – who cannot be comprehended – who cannot be imagined – the great secret – I know you are just.

I sin – have never been at one with the world – I stand here humbly – and I heard a voice inside me. Human being – nobody is evil – like the plant, stretch your leaves towards the sun when it shines. Human beings – be joyful when you can love one another – and be joyful when the time comes for you to die. Be joyful when the great wish comes true, and the individual has completed his little mission – donor of matter to the atmosphere and the earth.

T 2702

I thought to myself, nothing is small and nothing is large. There are whole worlds inside us. The small is part of the large and the large is part of the small. A drop of blood is a world with a sun at its centre, and planets and starry heavens are a drop of blood, a tiny part of a body. God is in us and we are in God. The primeval light is everywhere and the light is where life is – and everything is movement and light.

The crystals are born and are formed as a child in its mother's womb – and even in the hardest stone, the flame of life burns.

Death is the beginning of a new life. Crystallisation.

Death is the beginning of life.

We do not die – the world disappears from us.

Death is the love of life and pain is the friend of joy – and I became more and more angry with that rich woman.

I am like a sleepwalker who stands upon the eaves of a roof – and I do this safely in my thoughts and dreams. Don't wake me from my sleepwalking in a brutal manner – and don't clutch at me or I shall fall from the roof and break my neck.

The earth and the stones longed to mix with the air, and human beings and animals and trees were created and air turned into water and earth became air.

I dreamed at night. A coffin stood upon a mound – and in the middle of the coffin lay a young man beside the coffin stood a mother dressed in black, ringing a bell. And the mother's song entered the land of the crystals – and a file of men and women went down and repeated the song and entered the land of the crystals.

The background was immediately illuminated and a vast kingdom could be seen glowing with all the colours of the rainbow. Beams of light were broken by diamond-clear crystals both large and small – and some of them formed castles and others formed strange trees.

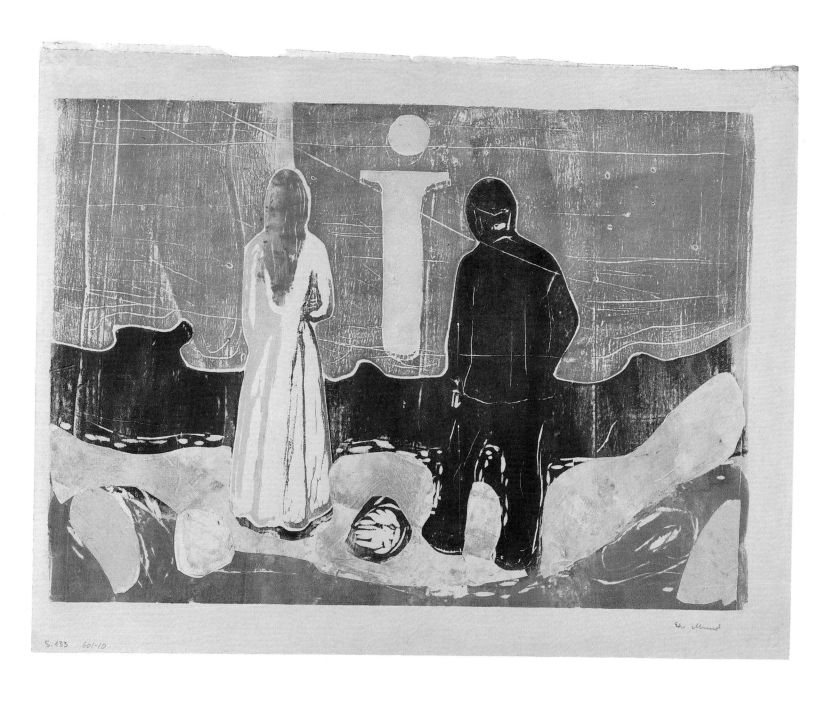

S.133 601·10

TWO PEOPLE/THE LONELY ONES
1899, woodcut, 394 x 552
Munch Museum

T 2601

Everything is in equilibrium.
Many encounter
great joy for the first time in death –
when the retina bursts
like a glass that shatters
and forms a star.

The mystical stare
of the madman. In these two
piercing eyes, many mirror images
are concentrated as
in a crystal. There is
something there that warns of
hate and death. There is a warm
pleasure that reminds one of
love – an essence
of her.
Like something everyone
has in common. A
scent of their common
woman. The gaze is
inquisitive, interested –
hateful and loving.

The destiny of man is like that of
the planets that revolve in space
and cross each others' orbits.
A pair of stars that are
meant for one another
hardly touch one another and
disappear each to its own
rim of the great universe.

Amongst the millions of
stars there are
but a few whose orbits come into contact
with one another. So that
they melt together
in flickering flames.
A man seldom meets
his ideal.

T 2785
ON THE WALL

I wanted to see an ox being slaughtered – and be tormented by the event. The butcher and I enter the byre.

The butcher bends over a fine well-nourished ox – fed to be slaughtered. He puts his arms around its neck and says "Cheri." He unties it and leads it down a passage to a room – the slaughtering room. It is led into the room with its head sticking half-way through the door, so that the back part of its body is in the slaughtering room, whilst its head is outside looking into the passage. The butcher takes a rope and pulls it through an iron ring in the floor – ties the end to the horns of the ox, and tightens it – until the ox falls to its knees and its head is pulled down to the floor. Its two large dark eyes look into space.

The butcher takes out a long-handled hammer. I hear a muffled blow. I meet the same large eyes that still stare into space. Blood runs from the head. The butcher takes an iron rod and pushes it into the hole in its head – twisting it around. Amidst the bloody mess of cerebral matter, the death rattle is heard – a tumble of hooves and the ox is lying on the ground.

The butcher takes a long-bladed knife – rises above the body of the ox and plunges it into the animal's heart. A thick stream of blood spurts out. The butcher takes a glass, catches the red jet in it and empties the blood-filled glass. The stomach is ripped open. The intestines – heart – kidneys are taken out. Its head is cut off. Its skin is flayed. The carcass is scraped inside and out – it is washed, rinsed and hung on the wall – like that well-known painting by Rembrandt. It seems to glow from the white and yellowish fat and tallow – the bright red and violet flesh. Bloody water drips. Wasn't that a fine piece of work, says the butcher, pointing to the cleanly washed and cleanly scraped inner carcass where the rings of the spinal column – like the trunk of a tree with its branches – lay like a finely executed artwork in red and white.

What is that, close to the spinal column that seems to be moving – a small white pulsing cord. Up and down – in rhythm. As rhythmically as a beating pulse.

It is simply the nervous system, says the butcher. Just the nerves twitching involuntarily. But nevertheless – life. Or perhaps it was the soul of the animal manifesting its final grip upon the strong body of the animal...... the last farewell.

T 2748

WHITSUN 1928

The spirit descended in the guise of a dove. The father, the son and the holy ghost. What is it that gives this Christian belief such power – even though for many it is difficult to believe in.

Even though one does not believe in God in the shape of a man with a long beard, Christ as the son of God who descended and became a man –

or the holy ghost that descended as a dove – there is nevertheless much truth in this belief. The power of God must be behind it all – directing it all. Let us say it is he who conducts the light waves – the power waves – the very heart of the matter.

The Son was transformed by this power into man – what great power must indeed have filled Christ. Divine power – the greatest power of genius – and the holy ghost. The greatest belief that is transmitted from the incomprehensible – from the divine power source to the human radio stations. To the inner human being. Which all human beings possess. Holy moments, when one's mind is made receptive to these wave lengths from the highest, most incomprehensible power station – to the receptive human instruments. He turns his thoughts heavenwards towards the kingdom of light – the inconceivable. He turns his receptive instrument in that direction – and the

SKETCHES
1930-31, drawing, 223 x 181 mm
Munch Museum

earth-bound powers seethe and burn in the living heart of our planet – lava and the blood of the earth. Earthly hell – where all thing earthly are recast.

T 2785

Spring, the harbinger
of winter.
Spring, the birth
of winter.
Birth, the messenger
of death.
The entrance of death into
life.

THE WORD BECAME FLESH

Is not Christ a spark of primeval light ? Primeval warmth – electricity. Divinity ... the power of the word. Has not a vast spark, a great spark from the kingdom – the kingdom of crystallisation – struck the soul of Christ – in other words, the wound of divinity. The power became condensed in him, and a concentrated discharge carried forth his words.

Air waves. Waves – rings in the air, which have, in the course of 2000 years, spread themselves over the planet Earth.

DO SPIRITS EXIST?

We see what we see – because it is in the nature of our eyes to do so. What are we but a collection of energy in movement – a light that burns. With a wick – inner warmth. The outer flame – is still an invisible flickering.

Had we possessed different, stronger eyes – we would – like X-rays – be able to see our wicks – our skeleton. Had we possessed other eyes, we could have seen our outer, flickering aura – and we would have had a different shape. There is no reason why other creatures with lighter, more solvent molecules, may not move around like us. The souls of our loved ones – e.g. spirits.

WARNEMÜNDE
14 JUNE 1908

The host at this establishment has such a dreadful voice – when he starts to thunder, the milk turns sour. I regret that his white-haired wife, from one morning to the next, is exposed to this Marconian discharge.

4 MAY 1929

I have recently been puzzling over the following: what we see and feel is dependent upon the instruments of sight and hearing and feelings that we have. The nature of our powers of sight, hearing and feelings reach only so far. If we possessed other, more finely tuned organs – or organs that were adapted in a different way – we would see and feel differently.

A tree is not a trunk with branches and roots, in reality it has a different form, almost round – encased in a spherical casing. On the other hand, I also believe that in reality, the world is not round, but also has a differently (?) shaped centre (let us think in terms of a core with many branches).

In the same manner, the earth has another shape than round. It is surrounded by atmosphere and ether – there is a part of the earth – which may have the shape of a sphere.

(similar sketch to the one on the previous page)

It is the same way with us. We have a casing around us, so let us say we have a spherical shape. Because of this, we do not live on Earth, but move around in Earth.

(compare to my drawing of 1909 in my diary of humans in their circles – and their peripheries. The periphery cuts into the ether vibrations and the earthly vibrations)

For the last few days I have been dipping into Plato. It was just as great a revelation as Kierkegaard. To my surprise, he writes the strangest things about Earth (I read them today).

He tells that in reality, we do not walk upon Earth, but live in a depression in Earth – rather

MAN AND HIS THREE SOURCES OF ENERGY
1930–35, drawing, 647 x 500 mm
Munch Museum

like the animals on the sea bed. He talks about relativity – and believes that air forms the mass of the earth, but that we feel it to be light because of our senses.

15 APRIL 1929

(As noted 20 years ago)

Everything is light and movement. Just as the stone and the crystal have life and will, so do humans. The human will – or soul – can be saved, even though the human body may be damaged.

The idea of human will. Religion is about preserving this idea.

16 APRIL 1929

In my earlier paintings and graphic works, the predominant wavy lines denoted and hinted at ether vibrations – with the feeling of a connection between the bodies. (*Separation* and *Two People* – the hair was transformed into wavy lines and was the connection between the lovers).

At that time wireless telegraphy had not been invented.

JANUARY 1930

Today I read in the paper about the latest discoveries – or conclusions. "Matter is ether vibrations".

My whole adult life, I have been talking to friends and also noting in my diary that everything is in motion – that life can be found even in stone.

I have pointed out that the quality of matter (and, for example its hardness) is decided by the quality of movement (speed or type).

I have also maintained, for many years, that the Earth is a living creature. A round ball, everyone claims. How do we know that it is round, or that the planets are round. The ancient Greeks (I think it was Plato) believed that the Earth was the nucleus of a body. It has several spheres – the closest being the ether sphere. What shape do these spheres have? We can hardly see the round forms of the planets with the eyes we have.

But what about the radiation ? Everything is supposedly round.

The human being with its radiation, and all of life.

FEBRUARY 1930

Today I heard a lecture on the radio about light waves and matter. The lecturer pointed out the latest conclusions, the drift of which was that light consists of waves, and is therefore also matter. This is exactly what I wrote in my diary 20 – 30 years ago. I wrote that everything is in motion, and that the fire of life may be found even in a stone. That it is simply a question of different kinds of movement.

The lecturer pointed out that the electrons in atoms must be perceived as movement He also mentioned electrical discharge. (Everything is fire, fire is movement.)

The variety of movement determines the form and variety of the matter.

JUNE 1939
PRODUCING LIFE

Today there was a discussion in the newspaper about manufacturing life. The materialist Bruckmand believes that this might be accomplished. From another perspective, Brøgger claims that the spark of life cannot be manufactured. That there is in fact, something about "living life" that cannot be produced.

10 years ago, and 20–40 years ago, I noted in my diary that everything is alive. Even in "dead mass" life may be found. There are star systems in an atom, and animal life may also occur there, as on Earth. So, nothing is dead, and matter is alive. There is life in all things, "God" in all things, and we are "God". If life is manufactured from matter, in other words, "dead nature" – this would simply mean that life is disposable, and that one can transform life from matter into something else. I believe that if one could manufacture an eye from matter, then this would mean that the embryo was already present in matter.

T 2748

SEPTEMBER 1932

We have suffered death during birth. We are left with the strangest experience: the real birth which is called death. Born to what ?

T 2748

(1927–1928)

Everything is motion – everything lives in stone – in crystal – in air, in mankind. (Already in my notes from 20 years ago.)

In the Earth – and the planets – and the atoms and their planets. The Earth – is it a weak-willed sphere that rotates around the sun ? The Earth has that beautiful round shape – that shoots out greenness in the spring. It gives nourishment to humans and to animals. It shoots out flames from volcanoes. The Earth moves in its orbit in the large space around the sun – just as mankind moves upon the surface of the Earth.

The Earth is a living atom that has its own will and own mind. It breathes, and its breath casts itself like clouds over itself. It breathes, and storms chase across the Earth. The seething lava is its blood.

Should not the Earth have its own mind and will, when it proudly rotates in space around the sun ? Should not the sun have its own will and mind, when it sends forth that vast mass of light into space, when it pursues its orbit around the heavens ? Those thousands of heavenly bodies.

I read through my notes from the last 40 years. Another age has arrived.

Once upon a time was an age of Realism. That was the time when believing in no god was the order of the day, and also represented a belief. Many died and lived by this belief, and found comfort and safety in it. For belief is belief. Discoveries had been made that were prosaic and practical. The railway – steam ships – hydro-electricity. Darwin understood that short-sighted prosaic truth that an individual develops and is

improved upon. But discoveries were also being made about pure, (?) invisible, alternative types of energy. Electricity – the telephone.

I thought about the ideas I had been working on. The planets in space and the atoms.

Electricity was an invisible source of energy, which materialised through its very energy – but it was earth-bound. It had to move through wires. The wireless transfer of electricity had arrived. Wave lengths were transmitted through solid matter – transmitted through space.

Thoughts could be transferred through space. X-rays that passed through the body were discovered. The radio.

N 67

The flame of culture dies and is reborn. An ignited spark – burns and is extinguished in order to be re-kindled – live – die, somewhere else. A flickering inflammable spark.

The flame is ignited and is extinguished in the kingdoms of the East. It is re-kindled in Israel – Egypt – Greece and Rome. And in Europe.

Greece – Rome – Europe – America. Greece gave its spirit to Rome after bleeding to death from reciprocal battles.

This is the probably the way matters will run in Europe. It will bleed to death and give its flame to America, in order to be reborn and die – and be born anew in the kingdoms of the East?

When will it happen? The united states of Europe would seem to be the only way to keep the flame alive.

Kunskabens Træ
paa
GODT og ONDT

KYSSET
TO BRÆNDENDE LÆBER MOT MINE
HIMMELEN OG JORDEN FORSVANDT
OG TO SORTE ØINE SAA IND I0
MINE -

JORDENS MULD LÆNGTET EFTER LUFTEN
LUFT BLEV VAND OG JORD OG JORD BLEV LUFT
 JEG DRØMTE OM NATTEN:
EN KISTE STOD PAA EN HØI I DEN LAA EN MØK
STOD OG RINGTE PAA EN STOR KLOKKE
MOREN SANG GAK NU IN I KRYSTALLERNES
LAND. EN RÆKKE MAND OG KVINNER GIK NEDENUNDER
OG GJENTOK. GAK NU IN I KRYSTALLENES LAND
HIMMELEN SPALTEDES OG LYSTE _ ET STORT
KRYSTALRIKE SAAES SPILLENDE I ALLE
REGNBUENS FARVER NOD DIAMANTKLARE
KRYSTALLER STORE OG SMAA. NOGLE DAN-
NEDE SLOTTE ANRE TRAR

LUFTEN TÆREDE PAA JORDEN
JORDEN SVEDEDE SLIM DET BLEV
MENESKER DYR OG PLANTER
VANDET DANPEDE OG BLEV SKYER
SKYERNE FALDT NED SOM REGN
MENSKER OG DYR OG TRÆER ER
FLAMMER DER SIIGER OP A JORDEN

T 2547

THE TREE OF KNOWLEDGE

Top left

THE TREE OF KNOWLEDGE
FOR
BETTER OR WORSE.

Top right

THE KISS

TWO BURNING LIPS AGAINST MINE
HEAVEN AND EARTH DISAPPEARED
AND TWO DARK EYES LOOKED INTO
MINE.

Bottom left

THE MOULD OF THE EARTH LONGED FOR AIR
AIR BECAME WATER AND EARTH AND EARTH
BECAME AIR
I DREAMED AT NIGHT:
A COFFIN STOOD UPON A MOUND – IN IT LAY A
CORPSE. A MOTHER STOOD RINGING A GREAT BELL
THE MOTHER'S SONG REACHED THE LAND
OF THE CRYSTALS. A FILE OF MEN AND WOMEN
WENT DOWN
AND REPEATED THE SONG. IT REACHED THE LAND
OF CRYSTALS
THE HEAVENS SPLIT AND WERE ILLUMINATED –
A VAST KINGDOM OF CRYSTALS COULD BE SEEN
GLOWING BRIGHTLY IN ALL THE COLOURS OF THE
RAINBOW AGAINST DIAMOND-CLEAR
LARGE AND SMALL CRYSTALS. SOME FORMED
CASTLES, OTHERS FORMED TREES.

Bottom left

THE AIR CONSUMED THE EARTH
THE EARTH SWEATED SLIME AND
MANKIND, ANIMAL AND PLANTS WERE CREATED
THE WATER EVAPORATED AND BECAME CLOUDS

THE CLOUDS FELL AS RAIN
MANKIND AND ANIMALS AND TREES ARE
FLAMES THAT RISE FROM THE EARTH

IT WAS DARK AND GREY
THE BOY WHO HELD HER HAND
COULD NOT DESCEND THE STAIRCASE
FAST ENOUGH
WHY ARE YOU WALKING
SO SLOWLY? HE ASKED
SHE STOPPED AND BREATHED DEEPLY
AT EACH FOOTSTEP
OUTSIDE THE DOOR
HE WAS BLINDED BY THE LIGHT
SHE WAS WEARING A PALE LILAC HAT
THE LONG RIBBONS FLUTTERED UP AT
EACH BREATH OF WIND
THE AIR WAS SO STRANGELY
SULTRY WITH A COOL BREATH OF WIND
THE GRASS SHOT UP BETWEEN
THE COBBLESTONES – BRIGHT GREEN GRASS
IT WAS SPRING

THE EARTH WAS AFLAME

Top left, next page

THE EARTH WAS AFLAME
AGAINST THE PERIPHERIES OF THE UNIVERSE
THE FLAMES WERE EXTINGUISHED AND BECAME
ASH AGAIN
I SAW THOSE EYES – BLUE AND SHINY
DARK WITH THAT BURNING GAZE
QUESTIONING
SEEKING
YEARNING

JORDEN slog flammer mot universets pereferier
FLAMMERNE SLUKNET TIL ASKE IGJEN
OINE JEG SAA - BLÅ OG BLANKE
MØRKE MED GLØDFYLDTE BLINK

spørgende
søgende
higende
villende
søgte de ul mot purpurien
løste fra jorden mennesketårn

forst falde tilbake
blande om aske med modergrund
HVORFOR S HVORTILS
VILLENDE MAARENDE STEG DE OG FALDT
GNISTER OG GLØD I NATTENS MØRKE

GUD ER I ALT
ALT ER I OS (Gud)

BRØDRE I LIVETS VÆLDIGE LEG !
LEGEN ER VILLET, VOVET OG GJORT
FOR ATTER AT VILLE OG VOVE OG DØ

GLÆDEN ER SORGENS VEW

FORAARET HØSTENS BUDBRINGER

DØDEN ER LIVETS FØDSEL

FONTÆNEN - DEN GALES OPTEG - NELSER

EN ROVFUGL HAR SAT SIG
FAST I MIT INDRE. DENS KLØR -
HAR HUGGET SIG FAST I MIT
HJÆRTE. DETS NÆB HAR
BORET SIG IND I MIT BRYST
OG DENS VINGESLAG
HAR FORMØRKET MIN
FORSTAND

WANTING

YOU SOUGHT THE PERIPHERY

CUT LOOSE FROM THE EARTH – CHILD OF MAN

IN ORDER TO FALL BACK

AND MIX YOUR ASHES WITH MOTHER EARTH

WHY? TO WHAT PURPOSE?

WANTING, NEEDING, THEY ROSE AND FELL

SPARKS AND EMBERS IN THE DARK OF THE NIGHT

GOD IS IN EVERYTHING

EVERYTHING IS IN US (GOD)

BROTHERS IN THAT GREAT GAME OF LIFE!

THE GAME IS DESIRED, RISKED AND DONE

IN ORDER TO DESIRE, RISK AND DIE ONCE AGAIN

THE EARTH FLAMED UP AGAINST

THE PERIPHERIES OF THE UNIVERSE – THE FLAMES

DIED DOWN AND BECAME ASH AGAIN –

THOSE EYES I SAW – BLUE AND SHINY, DARK

WITH A BURNING GAZE – QUESTIONING,

SEEKING, YEARNING, WANTING, THEY SOUGHT

THE PERIPHERY – CUT LOOSE FROM

EARTH – CHILD OF MAN – IN ORDER TO

FALL BACK – TO MIX ITS ASHES

WITH MOTHER EARTH –

WHY? – TO WHAT PURPOSE? WANTING

AND NEEDING, THEY ROSE AND FELL

SPARKS AND EMBERS IN THE DARK OF NIGHT

SPARKS FROM EARTH!

GOD IS IN EVERYTHING EVERYTHING IS IN US

BROTHERS IN THAT GREAT GAME OF LIFE –

THE GAME IS OVER, DESIRED, RISKED AND DONE

– IN ORDER TO BE REBORN AND DIE

WE DO NOT DIE

THE WORLD FADES AWAY

NOTHING IS SMALL. NOTHING IS LARGE.

Top right

JOY IS THE FRIEND OF SORROW

SPRING IS THE MESSENGER OF AUTUMN

DEATH IS THE BIRTH OF LIFE

Bottom left
The fountain
Notes of a madman
A BIRD OF PREY IS CLINGING

TO MY INNER BEING. ITS CLAWS

HAVE RIPPED INTO MY

HEART. ITS BEAK HAS

DRIVEN ITSELF INTO MY CHEST

AND THE BEATING OF ITS WINGS

HAS DARKENED MY

SANITY.

Next page

THE BLOOD ROARED INSIDE HIM. A HELLISH

CONCOCTION BREWED FROM THE WINE-LIKE

BLOOD OF THE PLANT –

MIXED TOGETHER WITH

THE FEMALE VAMPIRE'S POISON.

THERE WAS A BOILING

BREW IN THE MACHINERY OF THE BRAIN

THE CELLULAR TISSUE OF THE BRAIN EXPANDED.

UPON THIS PAR-BOILED, BLOWN-OUT CELLULAR

TISSUE, THE DECEITFUL SCRIPTURES

OF THE DEVIL WERE ENGRAVED

AS UPON A PHONOGRAPH

THAT CELLULAR TISSUE WAS STRETCHED LIKE AN

OVERBLOWN BALLOON. AND COLLAPSED LIKE A

CRUMPLED LEAF BEFORE THE CYCLE OF BOILING

AND EXPANSION RECOMMENCED

AND THE CHOIR OF DEVILS SCREAMED. A CREMATION

OF PLANT CORPSES. THE TOBACCO SENT

ITS ANAESTHETISING AND POISONOUS ASH INTO

THE PASSAGES

AND LABYRINTHS OF THE SKULL

HE SAW A CROWD OF STARING FACES

TURNED TOWARDS HIM

HE LAY BROKEN ON THE STREET

HE HELD A BLOOD-RED ARM IN THE AIR.

BLODET FOSSEDE I HAM, ET HELVETES
BRYG BRYGGET AE AF PLANTENS BLOD VINEN_BLAN-
DET SIG MED KVINNEWAMPYRENS GIFT - DET VAR ET KOGHEDT
BRYG I HJ∅RNENS MASKINERI

HJERNENS CELLEV∅V UDVIDEDES, PAA DET OP-
KOKTE UDBL∅STE CELLEV∅V BLEV SKREVET SOM
I EN FONOGRAF EN DJ∅VLEBL∅NDET SKRIET

CELLEV∅VET DER VAR UDSPILET SOM EN TILDET
YDERSTE SP∅NDT BALLON - FALDT SAMMEN SOM ET
KR∅LLET BLAD FOR ATTER AT KOKES OG UDSPILLES
OG SKRIKE SOM I ET DJ∅VLEKOR - EN LICBR∅N-
DING AL PLANTENS KADAVRE - TOBAKKEN SENDTE
SIN BEDVENDE OC FORPESTEDE ASKE IN I GRANI-
ETS GANCE OG LABYRINTER

HAN SAA EN MASSE STIRRENDE ANSIKTER
MOT SIG

HAN LAA KNUST PAA GADEN
HAN HOLDT EN BL∅DR∅D ARM I V∅RET

DEN GALES OPTEGNLSER —

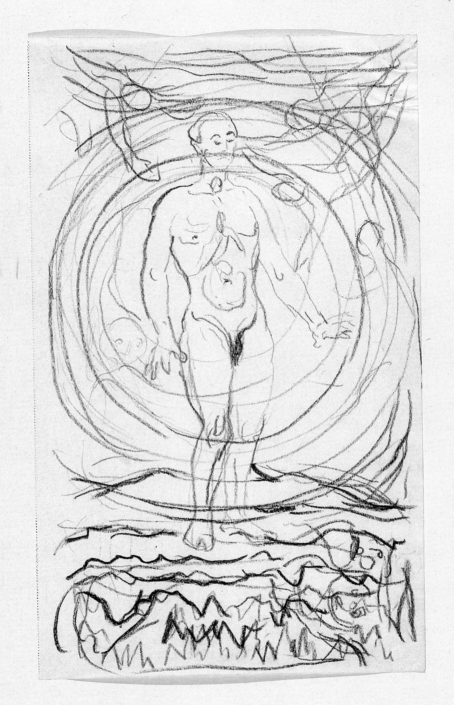

MENNESKET OG DETS CIRKLER
OVENTIL CAAR PEREFERIEN
OP I ØTHER SVINGNINGER —
OG NEDENTIL I JORDSVINGNINGER

THE PAUSE WHEN THE WHOLE WORLD
STOPPED TURNING
THIS FACE CONVEYS ALL EARTHLY
BEAUTY
YOUR LIPS, AS CARMINE-RED AS
RIPENING FRUIT, GLIDE
APART, AS IF IN PAIN
A KIND OF SMILE
NOW LIFE IS SHAKING HANDS
WITH DEATH
THE CHAIN THAT BINDS TOGETHER
THE THOUSAND GENERATIONS OF DEAD
WITH THE THOUSAND GENERATIONS YET TO BE
BORN
HAS BEEN TIED

Previous page
Notes of a madman
MANKIND AND HIS CIRCLES
THE PERIPHERY RISES ABOVE
IN ETHEREAL VIBRATIONS
AND DOWN BELOW, THE VIBRATIONS OF THE
EARTH.

Opposite page
THE EARTH LOVED THE AIR. THE AIR
CONSUMED IT AND THE EARTH BECAME
AIR AND THE AIR BECAME EARTH
THE TREES STRETCHED THEIR BRANCHES
HEAVENWARDS AND CONSUMED THE AIR
THE TREES BROKE AWAY FROM
THE EARTH AND BECAME
HUMAN BEINGS
EVERYTHING IS ALIVE AND IN MOTION
EVEN AT THE CENTRE OF THE EARTH
THERE ARE SPARKS OF LIFE

THOUSANDS OF CENTURIES PASSED AND PAIN
WAS BORN. A LITTLE HOPE
A LITTLE SMILE. THEN HOPE DISAPPEARED
THE SMILE DIED
AND GENERATIONS TRAMPLED UPON

GENERATIONS
THERE WAS A STEEP HILL WITH
GREEN GRASS AND AT THE TOP
CLOSEST TO HEAVEN, WAS THE WOOD –
COWS AND SHEEP GRAZED
THE GRASS AND THE SOUND OF TINKLING BELLS
COULD BE HEARD
THE SKY ABOVE WAS BLUE
WITH WHITE CLOUDS
THE GRASS IN THE VALLEY WAS SO
GREEN
DOWN BELOW PEOPLE WERE WALKING AND
CALLING TO ONE ANOTHER

Page 109
MANKIND WITH ITS THREE CENTRES OF ENERGY –
ETHER VIBRATIONS
THE BRAIN
THE HEART
THE INSTINCTS
EARTH VIBRATIONS

Page 120
NOTHING IS SMALL, NOTHING IS LARGE
WE CARRY WORLDS INSIDE US. THE SMALL IS PART OF
THE LARGE AND THE LARGE OF THE SMALL
A DROP OF BLOOD IS AN ENTIRE WORLD WITH
ITS OWN SUN AND PLANETS.
THE SEA IS BUT A DROP OF WATER FROM A TINY PART
OF THE BODY
GOD IS IN US AND WE ARE IN GOD
THE PRIMEVAL LIGHT IS EVERYWHERE AND IT
FALLS WHEREVER THERE IS LIFE
EVERYTHING IS MOTION AND LIGHT
CRYSTALS ARE BORN AND FORMED
JUST AS CHILDREN IN THEIR MOTHER'S WOMB.
THE FIRE OF LIFE BURNS EVEN IN THE HARDEST STONE
DEATH IS THE BEGINNING OF LIFE.
THE BEGINNING OF NEW CRYSTALLISATION
WE DO NOT DIE, THE WORLD FADES AWAY
DEATH IS THE LOVE-MAKING OF LIFE. PAIN IS THE
FRIEND OF JOY.

JORDEN ELSKEDE LUFTEN LUFTEN
TØREDE PAA DEN OG JORDEN BLEV
LUFT OG LUFTEN BLEV JORD
TRÆERNE STRAKTE SINE GRENE
MOD HIMLEN OG AAD LUFT
TRÆERNE LØSNEDE SIG FRA
JORDEN OG DET BLEV MEN-
NESKER.

ALT ER LIV OG BEVÆGELSE
SELV'T JORDENS INDRE ER
LIVETS GNISTER

AARTUSINDER GIK DER
FØDTES EN SMERTE LIDT HAAB
LIDT SMIL OG HAABET FOR-
SVANDT SMILET DØDE HEN
OG SLÆGTER TRAMPET PAA
SLÆGTER

INTET ER LIZET INTET ER STORT. —

I OS ER VERDENER. DET SMAA DELER SIG I DET

STORE DET STORE I DET SMAA. —

EN BLODDRAAPE EN VERDEN MED SOLCENTRER OG
KLODER. HAVET EN DRAAPE EN LIDEN DEL AV ET
LEGEME —

GUD ER I OS OG VI ER I GUD.
OR LYSET ER OVERALT OG GAAR HVOR LIV ER — ALT
ER BEVÆGELSE OG LYS —
KRYSTALLER FØDES OG FORMES SOM BARN I MODERS
LIV. SELV I DEN HAARDE STEN BRÆNDER LIVETS ILD
DØDEN ER BEGYNDELSEN TIL LIVET — TIL NY
KRYSTALISATION
VI DØR IKKE, VERDEN DØR FRA OS
DØDEN ER LIVETS ELSKOV SMERTEN ER
CLÆDENS VEN —
TIL EN KVINNE
JEC ER SOM EN SØVNGJÆNGER
DER GAAR PAA MØNEN AF ET TAG VÆK MIC IKKE BRU-
TALT OP ELLER JEC FALDER NED OG
KNUSES

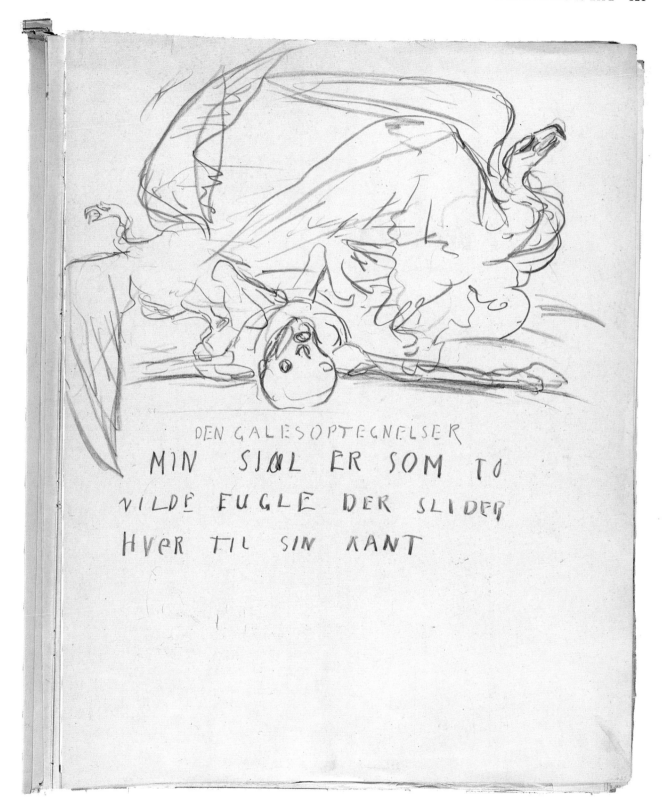

DEN GALESOPTEGNELSER

MIN SJØL ER SOM TO
VILDE FUGLE DER SLIDER
HVER TIL SIN KANT

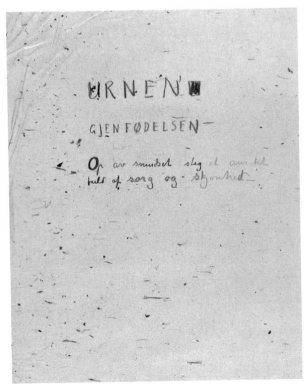

To a woman

I AM LIKE A SLEEPWALKER

WALKING UPON THE EAVES OF A ROOF. DO NOT

WAKE ME BRUTALLY

OR I SHALL FALL DOWN AND BE CRUSHED

Previous page
Notes of a madman

MY SOUL IS LIKE TWO

WILD BIRDS THAT ARE STRUGGLING

AWAY FROM ONE ANOTHER

Top left

WHEN YOU LEFT ME AND JOURNEYED ACROSS

THE SEA, IT WAS AS

IF FINE THREADS STILL UNITED US,

AND THEY WERE TEARING AT THE WOUND

Bottom left
The urn
Rebirth

A FACE ROSE FROM THE FILTH

FULL OF GRIEF AND BEAUTY.

Opposite page

I WALKED ALONG THE ROAD

WITH TWO FRIENDS.

THE SUN SET

THE SKY SUDDENLY TURNED

TO BLOOD AND I FELT NATURE

UTTER A HUGE SCREAM

I SEE ALL HUMAN BEINGS

BEHIND THEIR MASKS

THOSE SMILING, CALM FACES

PALE CORPSES, RESTLESSLY HURRYING

ALONG THE WINDING PATH,

WHICH LEADS TO

THE GRAVE

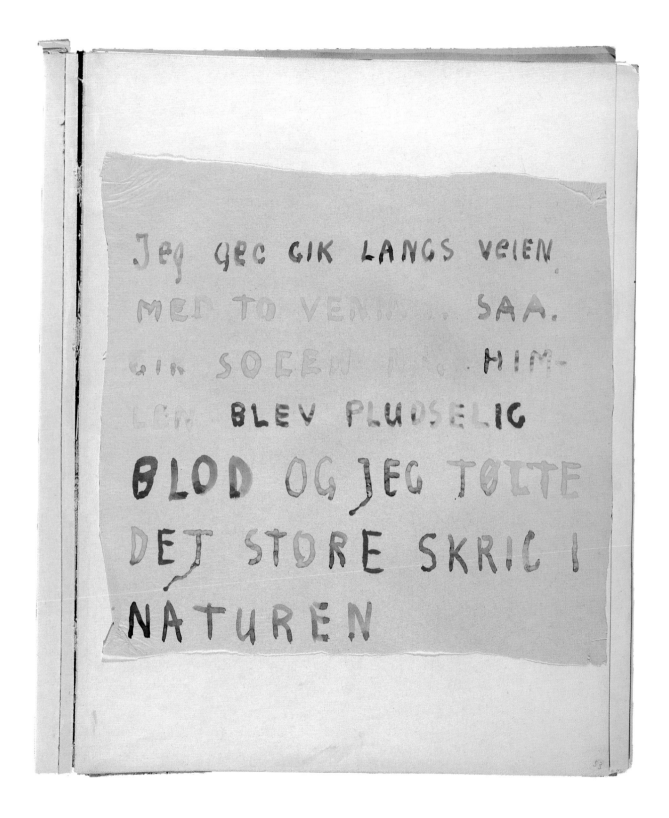

DA VI STOD MOD HVER-
ANDRE OG DINE ØINE
SA IND I MINE
ØINE DA FØLTE JEG
SOM USYNLIGE
TRAADE GIK FKA
DINE ØINE IND I
MINE ØINE OG
BANDT VORE HJER-
TER SAMMEN

MENNESKESKIØBNER
ER SOM KLODERNE
DE MØDES I VER-
DENSRUMMET FOR
ATTER I FO SVIV-
DE FAA GAAR OP I
HINANDEN I LYSEN-
DE FLAMME

FLOWERS WILL RISE UP
FROM MY ROTTING CORPSE –
AND I SHALL BE
IN THEM. ETERNITY

THE MYSTICAL GAZE OF THE MADMAN
IN THESE TWO BURNING EYES
MANY MIRROR IMAGES
ARE CONCENTRATED
AS IN A CRYSTAL. THE GAZE IS
SEARCHING, INTERESTED
HATEFUL AND LOVING.
THE ESSENCE
OF HER
WHICH THEY ALL SHARE.

Top left
WHEN WE STOOD CLOSE
TOGETHER AND YOUR EYES
LOOKED INTO MY
EYES, I FELT THAT
INVISIBLE
THREADS PASSED FROM
YOUR EYES INTO
MY EYES AND
BOUND OUR HEARTS
TOGETHER

Bottom left
HUMAN DESTINIES
ARE LIKE THE PLANETS
WHICH MEET IN SPACE
ONLY TO DISAPPEAR
ONCE MORE BEFORE
MELTING TOGETHER IN
BURNING FLAMES

Opposite page
Notes of a madman
THE HARD MASS OF THE STONE IS ALSO ALIVE

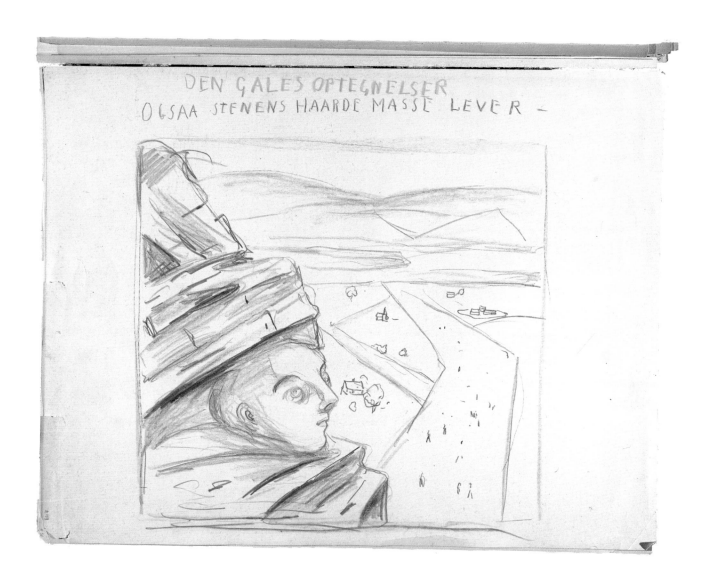

JEG FØLTE VOR KJÆR-
LIGHED LIGGE på
JORDEN SOM EN
ASKEHOP

Above

**I FELT OUR LOVE LAY
UPON THE EARTH LIKE A
PILE OF ASHES**

Opposite page

**THE MOONLIGHT GLIDES ACROSS YOUR FACE
WHICH CONTAINS ALL THE BEAUTY
AND PAIN OF THIS EARTHLY KINGDOM
YOUR LIPS ARE LIKE TWO RUBY RED
AND AS BLOOD-FILLED AS THAT
CARMINE-RED FRUIT
THEY GLIDE APART AS IF IN PAIN –
A KIND OF SMILE –
THE CHAIN THAT BINDS GENERATION
TO GENERATION IS NOW TIED –
LIKE A BODY IT SLIPPED ...
OUT UPON A GREAT OCEAN – BORN UPON LONG
WAVES WHICH
CHANGE COLOUR FROM DEEP VIOLET TO
BLOOD RED.**

Mennesket glider over det ansigt
der falde ud af jordringens skjønhet - og smerte.

Disse læber er som to nervøse røde orme
og blødfylde som den kammerats frugt
- De glider pa hinanden som i smerte
et ligs smil ——————— Thi
Nu knyrler kjeden der banden slagter
til slagter ——————

Som et - legeme glider in ... ut ...
et... stilt liv — ... lang ... bølger ... skibe
... ... dybnatt ... Klodernes

ART IS THE OPPOSITE OF NATURE –
I DO NOT PAINT FROM NATURE, BUT I TAKE FROM ITS BOUNTIFUL
PLATTER

KRISTIANIA, 1903–1904

THE NATURE OF ART, AND THAT OF THE ARTIST

"I do not paint from nature, but I take from its bountiful platter". Munch has many ways of describing art's relationship to nature. What links them is the duality affecting all of his work – that his works are both of him, and outside and independent of him. This was how Munch linked himself to the world – by transferring his works to it. He insisted that both were possible at one and the same time. Therefore, he moves through the following notes from his introverted, confessional starting point to his ideas about a more collective art, flat art, decorative art, art in the public sphere.

Even though Munch's view of his age can often be paranoid, it is acute. Opposition to his pictures incited him to resistance, and that compulsion for repetition he so clearly yielded to has undoubtedly played a part in clarifying his thinking. There may be scorn, hate and envy in relation to the established world of art, and there may be an unbecoming attempt at self-righteousness and constant moaning, but he knows precisely what he wants and what he does. Being exposed creates outlines; one can see him for who he is: Munch.

However great the intimacy is between art and artist, Munch has a fully developed general knowledge of the function of art in society. Using his usual telegraphic metaphors, he says a country's artists are sensitive phonographic apparatuses that pick up society's radiation. By this he points out the importance of transgressions of the privacy which was so important to him – also in the private sphere.

It may well be that Munch ended his life as a painter of the simple life. But he knew sophistication – make no mistake of that. For many years he was fully conversant with the discussions of his time, and he found it natural to not only paint the pictures he thought he ought to paint, but also to defend them afterwards as his art and the art of art. This overriding aim is found throughout; regardless of his peculiarity and stubbornness.

N 57
WARNEMÜNDE, 1907–1908

Art and Nature

Art is the opposite of nature.

An artwork comes directly from man's inner being.

Art is an image, translated into form, which comes into existence through man's nerves. Heart. Brain. Eye.

Art is man's need for crystallisation.

Nature is the vast eternal kingdom which nourishes art.

Nature is not only that which is visible to the eye. It is also the inner images of the mind. The images upon the reverse of the eye.

KRISTIANIA, 1890

I do not paint what I see. But what I saw.

T 2785

Impressionism is a great woodpile firing nature's cauldron. A new country in the kingdom of art.

Interpreting strong emotions whilst working directly from nature – or nature seen in terms of strong emotions, is terribly nerve-wracking work. Recognizing, during the space of a few hours, the fairly indifferent nature that one is part of. And consequently, during those same few hours, allowing it to be transformed through the transparency of the eye – the chambers of the brain – the heart – and the nerves, glowing in their passion. The burning furnace of the mind attacks the nervous system ferociously (van Gogh – partly myself).

Realism – Naturalism had loosened up. Zola – Maupassant. The aftermath from Voltaire – Rousseau – Darwin in England. Georg Brandes –

Bjørnson – Alexander Kielland and also Ibsen, who at that time was perceived as a Realist.

Nature all the way. Truth to the last. It was not necessary to choose a motif. I preferred to paint from the window. The same motifs. In sunshine – rain – summer and winter A copse of birch trees. First draw in the mass – then dissect it and draw the tall trunks – dissect it and draw the branches that grew from the trunk Then all the twigs ... until the smallest were collected into masses. Every twig was to be drawn. Every small mark upon the trunk. Yet there were always more to be found. I sweated and worked.

One does not paint
from nature
one takes from it
or serves oneself from its
bountiful platter.

STYLE AND IMPRESSIONISM

Man's need for crystallisation lies within the realm of art. The elements dissolve in nature only to renew themselves. Whilst Impressionism performs a feat of strength by portraying this act of dissolving, it seeks also to hold on to a style and form.

T 157
ABOUT STYLE

In nature there are two firmly established lines – two main lines. The horizontal, resting line and the vertical – the plumb line. Around these, the living lines move – the explosive lines of life.

In ancient art, these two established main lines are employed the most. In Michelangelo's style, they can be seen to be in motion. These lines of life have the greatest possibilities of development – of breaking up the two main lines.

In pine woods, one is very aware of those main lines in living nature – the perpendicular and the vertical. The branches form the explosive lines of movement – like soaring Gothic arches.

N 59

When the clouds at sunset affect one's senses in such a way that they seem to be a bloody blanket – it is surely not enough to paint ordinary clouds. One acts directly – and paints the immediate impression. The image paints the blood of the clouds.

The effect a painting has depends upon what it conveys. He wants an extract from nature. The square root of nature.

Art disengaged itself from both Impressionism (Manet) and from nature – the mind developed past the elementary. It found its form in Symbolism. Each school of thought develops its own form.

In the pale nights, the forms of nature have fantastical shapes. Stones lie like trolls down by the beach. They move. It is simply a reflex caused by the rocking ocean. It makes the stones appear to be trolls.

What ruins modern art – are those great exhibitions – those great market places. The fact that paintings are expected to look good upon a wall – to decorate it. It is not done for the sake of the painting – not in order to convey anything. To think that I went to Paris 7 years ago with a burning desire to exhibit at the Salon. I thought I would be moved by the experience, but felt only disgust. There they hang – resplendent in those prominent surroundings.

Bougeraux receives a medal. Soap pictures, which interest the bourgeoisie, like the labels on cigarette packets. Bonnats, iron, stone figures.

N 29

All in all, art represents the need of one human being to communicate with another.

By whatever means – each as good as another.

In painting, as in literature, one often confuses the means with the end. Nature is the means, not the end. If one can achieve something by changing nature, one must do it.

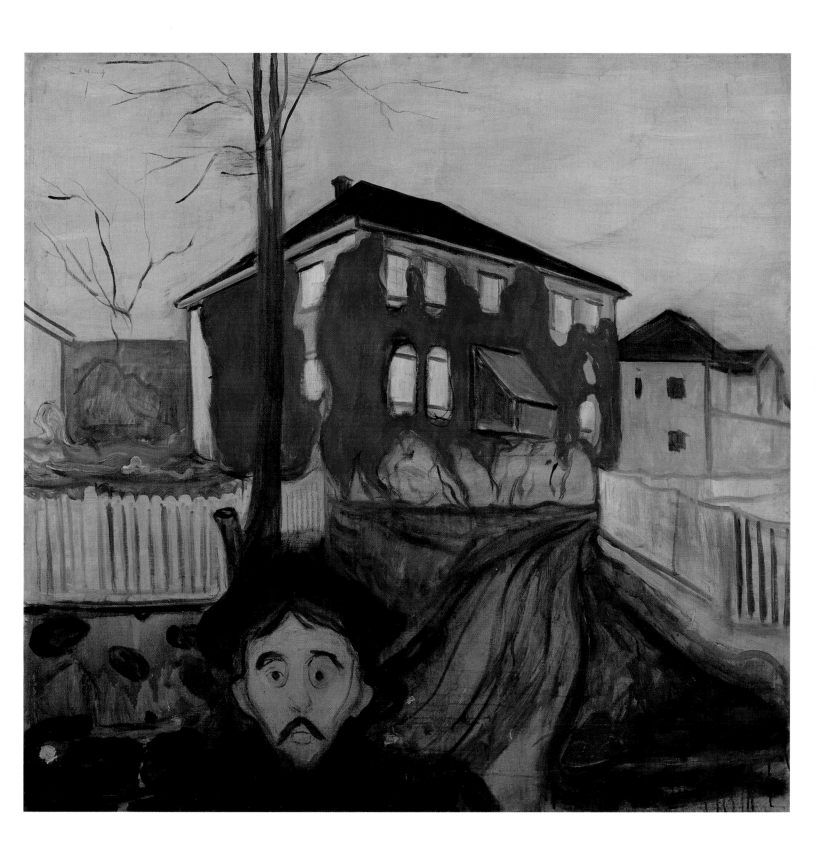

RED VIRGINIA CREEPER
1898–1900, oil on canvas, 119.5 x 121 cm
Munch Museum

In having stated that it would have been a crime for me to have married, and in order to understand and clarify this, I offer the following information: my grandmother died of tuberculosis – my mother died of tuberculosis – as did her sister, Hansine.

My aunt who stayed with us has apparently also had tuberculosis. She suffered all her life from colds, spitting of blood and bronchitis. My sister, Sofie, died of tuberculosis. We other children were plagued by heavy colds our entire childhood. I was born sick, was christened at home, and my father believed I would not survive. I was almost entirely unable to attend school. I was constantly ill with colds and rheumatic fever. I spat blood, and had high blood pressure. My brother had a weak chest, and died of pneumonia. My grandfather, the vicar of the parish, died of skeletal tuberculosis. I believe that my father inherited his morbid disposition and anxiety. And we children all developed these tendencies.

I am of the opinion, therefore, that my art is not sick, as Scharfenberg and many others believe. These are people who know nothing of the nature of art, and are not familiar with art history.

When I paint sickness and suffering it is, on the contrary, a healthy release.

It is a healthy reaction from which one can learn and carry on living.

How did I come to paint friezes and wall paintings?

Through my art I have tried to explain my life and its meaning.

I have also intended to help others to clarify their lives.

I have always worked best with the paintings that relate to me.

I arranged them side by side, and noticed that the content matter of individual paintings connected them with each other.

When they were set up side by side, I was

In an strongly emotonal state of mind, a landscape will have a particular effect on one. By portraying this landscape, one will produce a painting which is affected by one's own mood. This mood is the main thing. Nature is simply the means.

Whether or not the painting looks like that landscape is beside the point. Explaining a picture is impossible. The very reason it has been painted is because it cannot be explained in any other way. One can simply give a slight inkling of the direction one has been working towards.

I do not believe in any other art than that which is forced out by the human need to open one's heart.

All art – literature as well as music – must be generated from the blood of one's heart.

Art is one's heart-blood.

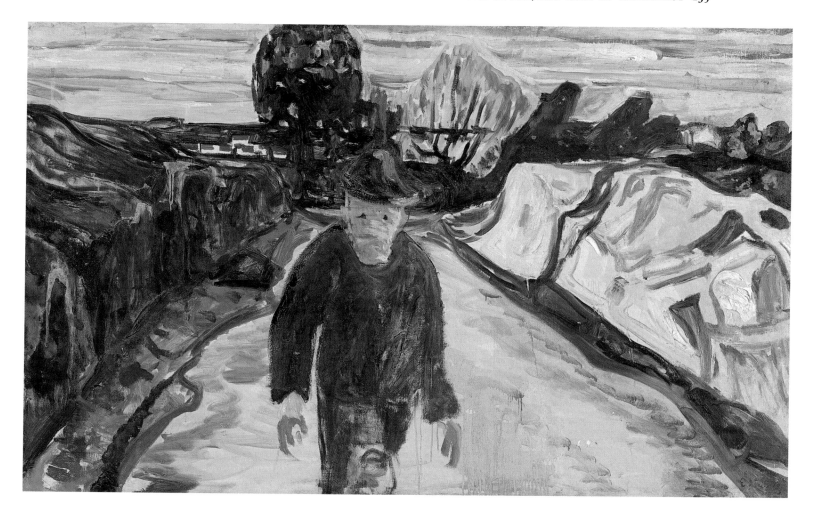

immediately aware of the resonance between them, and they took on a different meaning than they had individually. It became a symphony.

That's how I began to paint friezes.

6 AUGUST 1932

DEAR GRISEBACH

We once talked (Warnemünde 1906–07) about Determinism. I claimed that many inherited burdens were difficult to completely eradicate. (A curse upon an entire family, as in the tragedies of Sophocles.) You claimed that Determinism had very little meaning.

My art must be seen in the light of my enormous inherited burden. Tuberculosis on my mother's side of the family, and the psychological illness on my father's side. (My grandfather died of skeletal tuberculosis)

My art is a self-confession. Through it, I seek to clarify my relationship with the world. This could also be called egotism. However, I have always thought and felt that my art might be able to help others to clarify their own search for truth.

ELGERSBURG, 1905

What is art?

Art emerges from joy and pain. Mostly from pain.

It grows from human life.

Is art a description of this life – of its motion.

THE MURDERER
1910, oil on canvas, 94.5 x 154 cm
Munch Museum

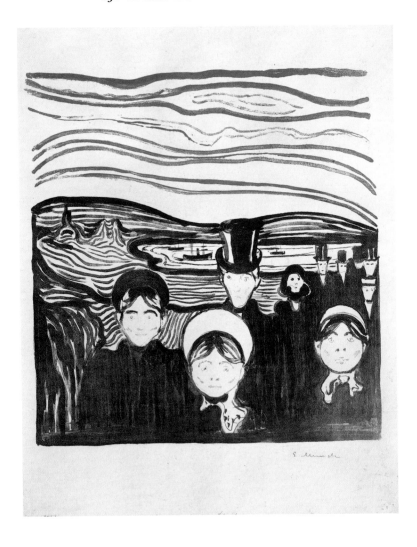

Should it show the various pleasures, the various sorrows?

Or should one simply see flowers, whose character, type and vibration are determined by joy and pain.

T 2742

MUSIC AND PAINTING

Are colours aware of their music, and is music aware of its colours?

(Poetry and words are reproductions of music and the impressions of colours).

What we hear are wavelengths, received by the eardrum.

What we see are light waves that affect the retina.

Poetry is the perception of waves by the eye and ear, filtered through the brain.

Painting is the perception of the brain, filtered through the eye.

Art is the opposite of nature.

Art is sovereign in its own kingdom.

Art governs nature and discards that which it does not control.

Art is an autonomous kingdom which is also part of the kingdom of nature.

Art helps itself to the vast kingdom of nature and conquers it – secretes superfluous

art, as in the desire for crystallisation.

Needs form – boundaries.

Nature is art's first aid.

T 157

Henrik Lund lived with his family on the floor below me at the Palace Hotel. He wanted to draw me. Most unwillingly, I agreed.

He stands 2 metres from his easel. He screws up his eyes – measures out with charcoal sticks, and starts to draw. The camera of his eyes darts about. Squinting and measuring as he goes, he finishes the picture. It was very good.

Why exactly must you stand and draw 2 metres from the easel?

"One usually sees people from about that distance," he replies.

"You are talking in the same terms as a photographer – yes, exactly those terms," I answer. "Yet perhaps one can see people more clearly in another situation, simply by accident. Perhaps one has a stronger impression of somebody at a distance of 10 centimetres."

"Munch," he says.

"Now I'm going to paint you," I say.

"Well, where shall I stand then?" he says.

"It will not be necessary. I saw you as I walked through your room. Remember, you were sitting

over there. I passed by your face at a distance of 10 centimetres."

The next day I painted the picture. It was unnaturally large – as he had been so close to me – and his wife in a flaming red dress, who had sat further away, was quite small. The colour of his face was apple-green against the strong vermilion.

T 2785

Art and people
Hogarth painted
vice and Bohemians in
London. He was himself
a wealthy citizen who died happily
in the bosom of his family.

Raphael, that painter
of beauty and purity
died of syphilis.

Shakespeare died
a gentleman of independent means.

A Hogarth and a
Shakespeare.
The result of a kind of
British hypocrisy

Is it vice's
desire for
purity. Or
purity's desire
to be soiled.

Is the artist a
lily that is thrown
upon a pile of rubbish
Does it grow best there
like a diamond
secreted by
the mussel.

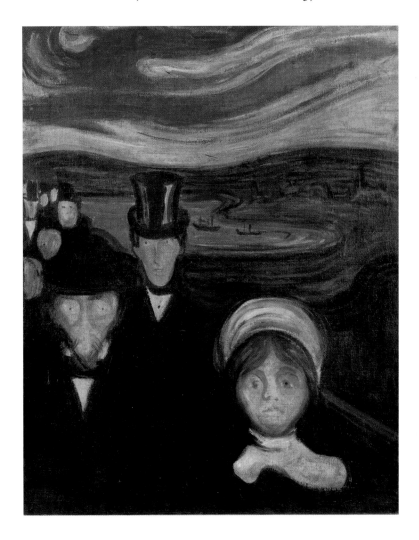

N 41
COLOURS

Hope is pale green
eternally and ever beautiful.
Brown is steadfastness
fleeing your peace of mind
patient and strong
destiny is heaven's work

Yellow is the cheek of deceit
faithless and crafty by nature.
tell me, where can they be found.

ANXIETY
1894, oil on canvas, 94 x 73 cm
Munch Museum

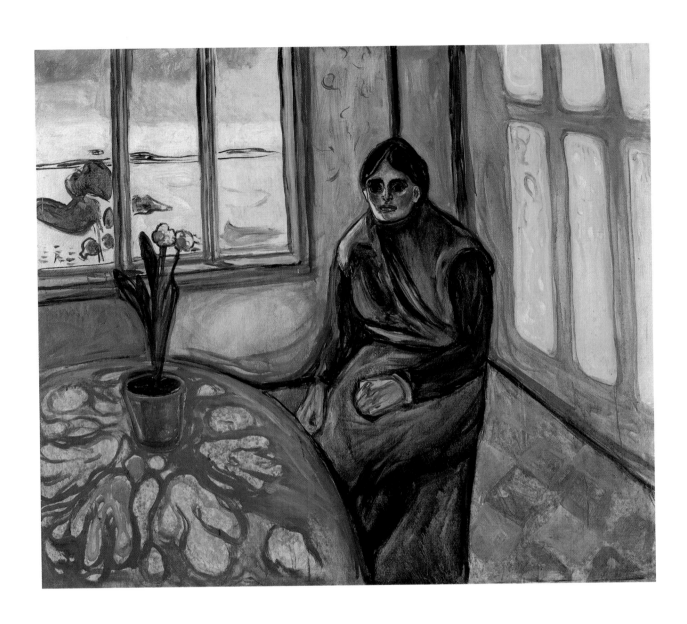

MELANCHOLY, LAURA
1899, oil on canvas, 110 x 126 cm
Munch Museum

Joy is sky blue
a pleasure to see above.
The grave is always black
the source is gone forever. Shut your eyes
and enjoy life's play of colour.

N 170

Artists of this country.
Poets – those sensitive
phonographs – they have
the great and painful ability
to record the emanations
– sent out
by society.
This gives the poets power –
a condensed extract.
If an artist is chased away from his
country – that country also chases away
– a fully charged electric force.

N 305

I would like to suggest that the question of photo-graphic portraiture versus the painted portrait be taken up for debate.

Photography and the Portrait. The second condition for a portrait is that it does not look like the sitter. The first condition is that it is art. I would ask him to look for a photographer. Then a true likeness is allowable. I would add – that it is quite difficult for an artist to avoid creating a likeness and I would ask him to consult a photographer. I can admire and understand Dix whose artistic aim is to seek a likeness. That mechanical production method executed by a careful hand, can give good results. Nevertheless, I admire Dix, whose artistic aim is to seek, and to gain pleasure from seeking that perfect likeness.

They always answer – no, I want a work of art. Well then – go and find yourself in a work of art. But they don't. They want the painter to see as if he were a camera. They want you to see the sitter as the sitter knows himself to be – as he himself

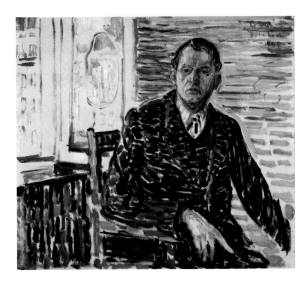

has been seen – in a thousand secret moments – in a variety of life's stirring situations – as his tailor has seen him – and wanted him to be – as his lover has seen him (as his mother has seen him) and as his many cousins have seen him. He shall be as the people have seen him on the balcony – if he is a well-known public figure. Not simply as the artist sees him. Not simply that immediate impression which is, on the whole, the first condition of art production. What would one say if an unfortunate painter wanted to paint a flock of geese – and they suddenly started screaming and refused to be painted in that particular way. Or if a painter is sitting beside a red house in a landscape – and in the midst of his work painting it he hears it shout through its door I don't look like that – my angles and colours are much finer. That doesn't look like me.

The edition of the art magazine (*Kunstbladet*) about photography is interesting – and contributes to a solution.

Each in its own place – photography in its own domain – art in its own domain – and only as an aid for art.

SELF-PORTRAIT
1909, oil on canvas, 100 x 110 cm
Rasmus Meyer Collections

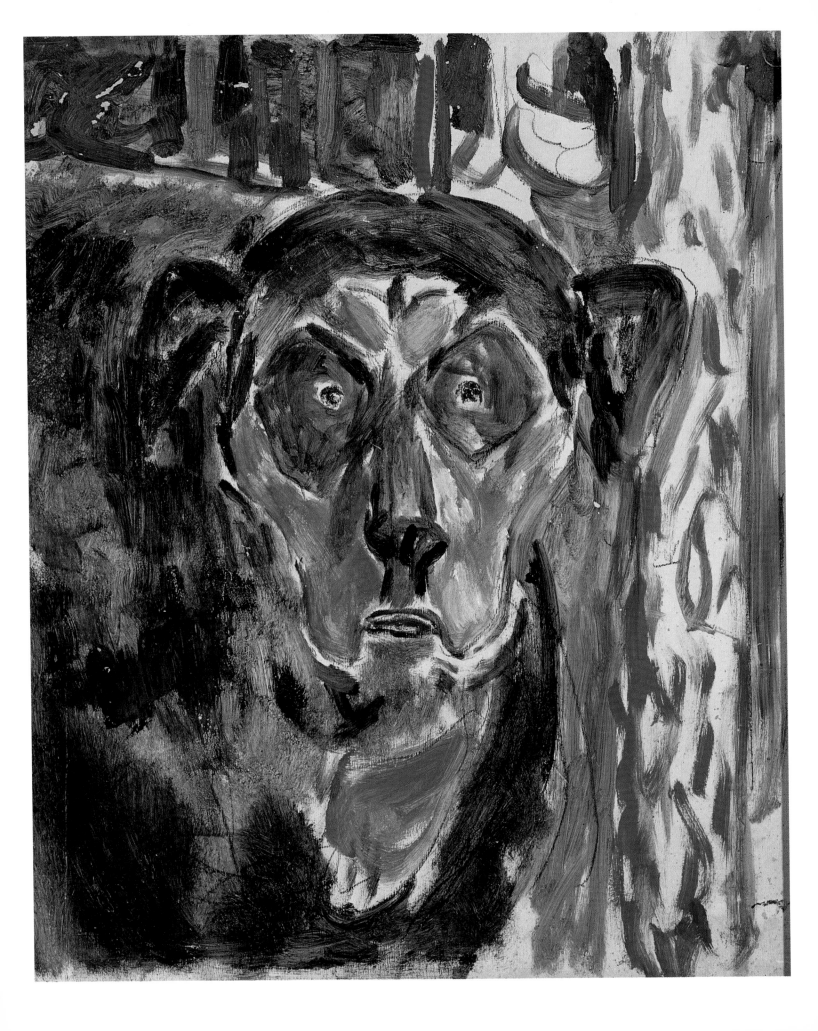

It was also good to be able to say: Impressionism is not a main station, or a final destination – the train carries on.

N 176

The Academies of Art are nothing but great painting factories – those with talent are fed in at one end, and they come out as mechanical painting machines. What we lack is courage. To set up our ideals – create styles based upon our contemporary beliefs – feelings – even Klinger must come to terms with a Pieta in order to become a great man. The test of a great painter lies in the painting of a Pieta.

Who is the greatest painter in France – Messonier. He was the one who best understood the desires of the bourgeoisie.

The art of our time is the art of the great Salons – the Academies – the art of winning medals. Naturalism – Impressionism – Symbolism – these are all schools of thought – they have become the means by which one can express the only important aspect of painting – the human aspect.

Honesty is a badge which is sadly misused these days. Any number of holier-than-thou honourable realists walk around in the belief that they have accomplished something, simply because they tell you for the hundredth time that a field is green and a red-painted house is painted red. Anybody who perceives colours can become a painter; it's simply a question of whether or not one has felt anything and whether one has the courage to recount the things one has felt.

T 2601

ART AND MONEY

Ours is a time of markets – a time of bazaars. It characterizes the time we live in.

The great Salons are simply market places. Where art is put up for sale for the bourgeoisie who are so eager to buy.

Contemporary art is under the thumb of the worst band of capitalists – the bourgeoisie.

Art is better understood by half-mad aristocrats and kings. When the Salon is finally abolished, or is given the place it should have – the Art Bazaar – perhaps it will make way for better conditions for the exhibition of art.

As circumstances are now, these art bazaars show the kind of art products which are actually worthy of being shown in such conditions.

Painting Christmas cards is a vile occupation for an artist. It is like a musician creating works for the organ-grinder.

The newspapers write. They wonder why these gentlemen don't make paintings – why is that – a little …. That is not art. Cut-outs. Lithographs. Etching.

Apropos. Our gallery is starting to fill up with enlarged Christmas cards. As if this work had a retrospective influence – for the painter – the gallery is filled with numbers of enormous metre-long Christmas cards. From floor to ceiling.

Is art influenced too much by business?

Our painters would rather paint a bad painting than do without a bottle of Champagne or a horse and carriage.

N 39

We aspire to more than a simple photographic reproduction of nature. We do not aspire to painting pretty pictures to adorn the wall of a sitting-room. We want to try, even though we sometimes fail, to lay the groundwork for art that is a gift to mankind. Art that is stirring and moving. Art that is created from one's heart-blood.

But the artisans are starting to rule. Those who work to achieve something from their heart-blood are to be crushed. And so mediocrity and boredom are doomed to reign. The State Autumn Exhibition (Høstutstillingen) seems more and more of a great desert – where the public have nothing to protest about, and nothing to be moved by.

HEAD OF A DOG
1930s, oil on canvas, 46 x 38 cm
Munch Museum

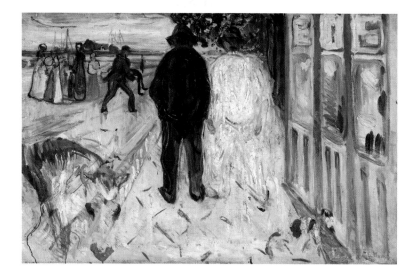

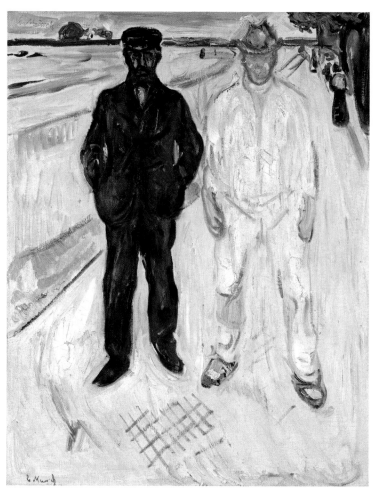

Those who see something that they will succeed in producing in the future, those who have something they would never abandon, who would let their work be destroyed rather than give up that something, those who are at the heart of the matter (who would sacrifice everything rather than lose sight of what they feel to be the essential in art, that which cannot be taught), they shall be suppressed.

And those immigrant artists – those who have sacrificed no blood in the battle ...? but arrived when all was cleared and prepared. Those young foreigners treat us quite brutally. Like the innovative painters of ten years ago we must now mount our attack against the timid bourgeoisie, against the cowards of the art world.

Those who fought at the forefront are discriminated against, even though they have the greatest advantage and have committed the greatest errors – that was the most characteristic result of Norwegian art at that time. They were kept at bay for fear of opposition.

Glørsen painted a good painting. Later he tried to emulate Werenskjold's style.

His style withered, as his talent cannot be compared to those "green branches" as one art critic calls the young set. Dry branches are to be thrown in the fire.

Eilif Petersen can be thankful for those ideas – he would have rejected the very ideas that inspire the painters he turns down. He possesses such talent, that when he mixes it with a tiny amount of Impressionism, it becomes just modern enough to satisfy the public.

Small paintings in gold frames have been for sale for such a long time – to adorn the walls of the bourgeoisie – that one has come to believe that painting is quite a mundane occupation.

Just like making shoes – a factory. I have never given a thought to the sale of a painting.

People simply don't understand that one paints to experiment, and to develop and improve.

THE DROWNED BOY
1908, oil on canvas, 85 x 130 cm
Munch Museum

MASON AND MECHANIC
1908, oil on canvas, 90 x 69.5 cm
Munch Museum

It never crossed my mind to wish for a mansion with an old garden where one might sit in the sun and eat apples. I have better things to do.

N 122

Let the body die, but save the soul.

The first *Scream* (now in the Thielska Gallery) – *The Kiss / by the window – the cypress tree outside* (belonging to Mustad) – The first *On the Beach* (*A Melancholy Man on the Beach* or *the Yellow Boat*). All these belonged to *The Frieze of Life*. They were painted in 1891 in Nice.

Kiss and *Vampire* and *Man and Woman on the Beach* were executed in pencil and the painting *Kiss* was made in several versions from 1884. *Ash* was executed as a drawing in 1884. At the same time, another version with partly Impressionist and partly psychological (psychoanalytical) notes was made. I had thought of illustrating it with lithographs in a larger work.

I started off as an Impressionist, but after the violent soul-searching and conflicts of life which I experienced during the Bohemian era, Impressionism lacked the expressiveness I needed in my work. I had to seek out the impressions that moved my inner being. My acquaintance with Hans Jæger helped me. (To paint one's own life.)

My first break with Impressionism was during my work with *The Sick Child*. I sought out expressiveness (Expressionism). I was having difficulty attaining the kind of expression and atmosphere I wanted, and it was still unfinished after about 20 revisions. (Later I often repeated the same motif, if it gave me the possibility of achieving the expression or atmosphere I wanted.)

Spring was painted just after 1887 (exhibited in 1889). I had finally bidden farewell to Impressionism or Realism.

During my first visit to Paris, I made a couple of experiments with pure Pointillism. I used only dots of colour. *Karl Johan*. The Art Gallery in Bergen. This represented a short return to Impressionism. The painting from *Rue Lafayette*

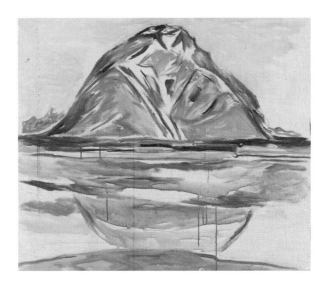

was really just a well-known motif in French painting – but then I was in Paris.

I had been using those short brush strokes in one direction for a long time, in Norway. *The Frieze of Life* took up more and more of my time, and I was also supported by the current trends within the fields of painting and literature. Symbolism. The simplification of line (which developed into the Jugend Style), iron constructions. The forerunners of those secretive rays, ether vibrations and waves.

During my first visit to Paris in 1884 I was very interested in Velázquez. (Why has nobody noticed the relationship between my large portrait figures and the work of Velázquez?)

It the same way, nobody has remarked upon the fact that already as a young artist, I was extremely interested in Couture's study of a shepherd, that was shown in our gallery. I found the thinly painted transparent ground and the strong, living contours very interesting. I was inspired by the same masters as Manet: Velázquez and Couture!

NOVEMBER 1929

A pronouncement has been made upon my paintings: They are different and are painted in different styles.

MOUNTAIN MOTIF
ca. 1925, oil on canvas, 68 x 80 cm
Munch Museum

I work in such a different way to so many others (especially those who have discovered the safe little format, preferably shown in a heavy gold frame, which is the most financially rewarding). I believe that each painting is individual, and is trying to achieve something of its own. (Quite the opposite view to those who believe that each painting is a collective expression of one's creative ability.)

Each of my paintings is different. Many are failures – many are unfinished. But each should have a specific task. In all their diversity, and more or less successfully, they should strive for the same aim. The top of the pyramid. They are all stones in this building.

T 2748

The Sick Child was the breakthrough. That painting contains the ideas I later developed, with the subsequent art movements. If one examines this painting carefully, one will find small traces of Pointillism – (symbolic time – Jugendstil) – Expressionism and form.

Around the face – the face and the circle around it – you will find that a Pointillist manner of painting has been used (I painted the coloured dots with a pointed brush) – you will find, in the lines of the mother's bowed back, traces of Jugend style. The conception of the painting is Expressionist. The constructed composition is built up in a Cubist manner.

T 195

They say that *Amor and Psyche* was a return to Pointillism. This is not true, although the colours might remind one of earlier works. I did not use dots, but inch-thick, metre-long lines that are painted horizontally, vertically and diagonally – a kind of pre-Cubism.

At the beginning of the century, I wanted to break up the plane and the wavy lines, which I felt had become mannered. In Warnemünde I copied *The Sick Child* (the version shown in the

gallery). This is painted in the same way, as the gallery painting shows. By this, I mean it is not so exaggerated. There is just a little area of dotted paint around the face. I did it to create greater depth and fuller forms in the painting.

N 38
SEHR VEREHRTER

I prefer not to write about my art. It easily becomes a rule, a programme. All rules are bound to be broken – just like all those institutions and societies. They hang around one's ankles like heavy chains.

All rules are doomed to death in advance. Like chains around one's ankles.

The ground is unsteady, and the condemned man's eyes are clouded by mist on the way to the scaffold – then he notices a bud – the bud of a flower. His mind hangs on to the sight and clutches tightly to it.

How strange that yellow flower is – how odd that bud is.

A good painting with 10 holes is better than 10 bad paintings without holes.

A good painting with a badly prepared grounding is better than 10 bad paintings with well prepared grounding.

Good paintings never disappear.

A brilliant thought never dies.

A charcoal mark on a wall can be a more valuable work of art than any number of enormous paintings in costly frames.

Most of Leonardo da Vinci's paintings are destroyed – yet they live on nevertheless – a brilliant thought never dies.

The war.

Death throes.

A praying man.

A charcoal drawing on a wall can be a greater work of art than the most perfectly executed painting.

Many painters work so carefully and conscientiously with the grounding of a canvas – and with

the execution of the painting – in order to preserve it for posterity – that the painting loses its fire.

It also happens that the painting is so boring and so bad, that it ends up in a dark loft.

Although a pale Expressionist painting may lose its colour with the passing of time – it will keep its soul and its tension – even if there is hardly a line left, it will at least die in beauty.

At least it will have given new inspiration to painters with other intentions.

JUNE 1930

It is better to paint a good, unfinished painting than finish a bad one.

Many believe that a painting is finished when as many details as possible have been completed.

A single line can be a finished work of art.

A painting must be done with a sense of purpose and feeling.

It does not help to paint in this way, and then add unfelt, weak-willed things.

A painting must not be false or unfelt. Yet a painting may also be wrong and false if it is done with feeling – and self-consciously.

An Impressionist, Liebermann, said the following about me: That Munch is crafty – he pretends to be incapable.

I replied, "Liebermann pretends to be capable of more than he actually is. He calls it Realism."

20 FEBRUARY 1931

Do not tread upon my spiritual corns.

T 2761

The truth of the matter is that one sees with different eyes at different times. One sees differently in the morning than in the evening.

The way one sees is also dependent upon one's emotional state of mind.

This is why a motif can be looked at in so many ways, and this is what makes art so interesting.

If one enters a sitting-room in the morning, having come out of a dark bedroom, everything one sees has a bluish hue. Even the deepest shadows float in this pale air.

After a while, one's eyes become accustomed to the light, the shadows deepen and everything becomes sharper. If one wishes to paint that first pale blue morning atmosphere that made such an impression, one cannot simply sit down, stare at each object and paint them exactly as one sees them. They must be painted as they are supposed to be, as they were when the motif made such a vivid impression. If one is not able to paint from memory, one must use a model, yet this will also be false.

The "detail painters" call this untruthful painting – they believe that the only truth in painting is to reproduce the table and the chair with photographic precision, as it appears to be at that very moment.

They say that trying to recreate an atmosphere or mood is untruthful painting.

When one is out on a drinking spree, one sees things differently. Drawings become hazy, and everything seems more chaotic. It is a well-known fact that one sees things in a strange way.

It seems obvious that one must then draw or paint in a strange way. If one sees double, one must, for example, draw two noses.

And if one sees a crooked glass, one must paint it crooked.

The same thing applies if one wishes to convey that which one has felt in an erotic moment when one is still heated and warm from love. Such a moment represents a motif that cannot be painted exactly as one sees it at that very moment – one must wait until one has cooled down. It is acceptable that the first image one has seen is quite different from the second. One experiences things differently when one is warm than when one is cold.

It is this fact, and this alone, that gives art a deeper meaning. It is the human aspect – life, which one must try to convey. Not dead nature (still life).

Actually, a chair can be just as interesting as a person. But the chair must be seen by a human. In

some way or another, it must have made an impression upon him, and he must try to convey this through his work, so that those who look at the painting will feel that impression.

It is not the way the chair is painted, it is the impression the chair has made upon the painter.

That exponent of "detail painting" – Wentzel – has parodied the prevailing view of painting as a mere craft form, in the following words: A chair is a chair and there is only one way to paint it.

Followers of this doctrine have nothing but disdain for those painters who try to convey a mood in their work. They cannot understand that a chair can be seen in a thousand different ways.

A chair is simply itself, with that particular colour – so it must be painted in that way only.

One may admire their competence – one may say it is impossible to paint better – so they might just as well stop painting – they cannot improve upon their efforts.

But one is left cold. One's pulse does not beat any faster. One's inner being is never moved by their work. They do not manage to give one an impression that one keeps, that one takes out and looks at over and over again in one's mind.

One forgets the picture the moment one walks away from it.

N 79

An art critic arrives in Paris. He suddenly discovers America. By this I mean Impressionism, and good Impressionist art. Unfortunately it has been around for such a long time that something quite new is beginning to emerge.

He dances around the calf that is already overcooked.

He gets quite a fright when he discovers that all around him a completely new kind of art is being made – causing scandal – conflict and ardent discussion, just as Impressionism had done a long time ago. He is alone. What else can he do but declare that art is dead. Finis artistes.

A new architecture emerges, with simple angles and spaces. Those small pictures are no longer necessary.

The great piles of ornaments, plants and those small pictures of running deer. Horizons and church spires. The superficiality of that charming couple, kissing in the moonlight.

But those large spaces still need life and colour. One contacts a painter, and he covers the whole surface of the wall.

But not all the new wall paintings can be measured against those of the Renaissance.

Once again, art becomes the property of the people – we all own the work of art.

The work of a painter need not disappear like a tiny patch in a home – only viewed by a couple of people.

For me, there is something very attractive about walking about in a completely unknown city. Without Baedeker's travel guide or map, I enjoy this new mystery. Wandering, as if partly in a dream, absorbing all the new impressions.

I arrived in Basle one morning, and disembarked from the train. I had several hours before the train left again, and I had the opportunity to absorb as many impressions as possible. What a find Basle was. Those wonderful, newly discovered impressions of beauty. The wonderful construction of the town with its enormous spaces, all those streets and alleys – their colours and forms – old and new.

I stopped suddenly at the sight of facades covered with fresco paintings. Not decorations, but art – and then I looked at the fresco paintings by Pellegrini and other artists from Basle. The fresco paintings that most impressed me were those done by Pellegrini on a corner building.

Wasn't the time ripe for this kind of art?

It is said that there used to be religion in art. There is always religion amongst people. New forms and different art.

One must give one's entire soul to the painting of an entire wall – otherwise it will simply be a decoration.

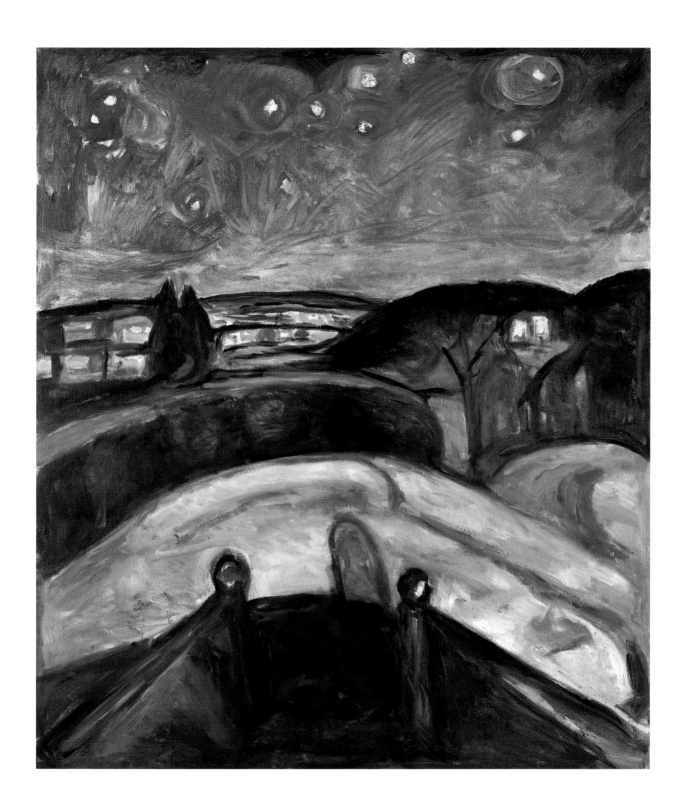

STARRY NIGHT
1923–24, oil on canvas, 139 x 119 cm
Munch Museum

N 163

They are always talking about the art of decoration. From its earliest days, art has always been ornamentation – they say. That is the same as saying that poetry is just the same as light reading.

Right from the beginning, art's function has been partly to decorate and partly to communicate. To recount something – that was a religious revelation.

Stories were told of kings and heroes, grand tales were told (also a kind of drawing), and the histories of countries were written down. Palaces were built – walls and pillars were decorated. The walls were painted. The columns were ornamented with leaf-patterns.

N 41

I have noticed a coldness amongst the younger brigade of artists from all the Nordic countries, also here in Oslo. But the big exhibition in Berlin and the following exhibition in Oslo have heralded an apparent reversal of this trend. I can imagine that my paintings and prints would meet a lot of resistance in Sweden, in particular.

There can be no other country in the world where objectivity, the small format, sleek execution and wealth of detail have made such inroads. I can understand the reason for this sudden change – and change will always come. However, I don't think that kind of art will last much longer. The small format may last a while longer, but many other things will change. The small format with the large, decorative frame has become the art of art dealers. It is bourgeois, and has its roots in the aftermath of the French Revolution – and the triumph of the bourgeoisie. The age of the workers has arrived. Perhaps art will once again become collective property, as in former times. In public buildings and on the street ?

Frescoes ?

N 43

When you write about *The Frieze of Life* and the different images that are mentioned in symbolic or literary terms, you must remember that they also had a co-ordinating artistic function. These paintings were steps towards later wall paintings and to the Aula paintings.

I was trying to simplify. That is actually what I have always tried to do. It can be seen in that construction of iron (now concrete), the Eiffel Tower. It can be seen in that taut curved line that later relaxed into Jugendstil. The bowed line also relates to the discovery of and belief in new energies in the air. Radio waves, and the new communication methods between people. (The difference is that I symbolised the connection between the separated entities by the use of long waving hair – it also occurs in *The Frieze of Life*.) The long hair is a kind of telephone cord.

Perhaps the contemporary, simple style of clothing adopted by women has been influenced by the attempts of artists to simplify their painting. Just as in Functionalism.

It is a question of simplification, although the idea had been proposed much earlier, by amongst others, van de Velde.

Do you see the similarity between *The Dance of Life* and the development of rhythm and movement in dance during the past 20 years? Or in *The Frieze of Life* ? Can you not see the likeness between the groupings and movements, the lines and contours of *The Frieze of Life*, and contemporary youth ?

Apropos. I must soon make a decision regarding my plans for *The Frieze of Life*, and the other large friezes. I am aware that I can expect little sale, and I have prepared myself in case I am forced to terminate my work. I can carry on for one more year, then I shall have to roll all the canvases together. I can always take photographs and make drawings of my plans. I also have a dream about creating an entire park installation with wall paintings.

Yours humbly,
Edvard Munch

23 OCTOBER 1933

During his short life, Van Gogh did not allow his flame to go out. Fire and embers were his brushes during the few years of his life, whilst he burned out for his art. I have thought, and wished, that in the long term, with more money at my disposal than he had – to follow in his footsteps. Not to let my flame to die out, and with burning brush, to paint to the very end.

I was aware of the fact that my torch flamed up, then was almost extinguished, and I gazed around in darkness and fear. I had lost my way. Who was I? Had I lost my way for good?

But I managed to rekindle my torch, and drag myself from the undergrowth. I fell and I ran. I sought my way on broken limbs. Where was the path? And sick as I was, I dragged myself along with my crackling, flaring torch, whilst everyone watched me. Look at him, they said. He's looking for gold. He's looking for gold! He's burying treasure. He's hiding his gold in the earth. Let's find it and hunt him down – and they insulted him and mocked him. That miser – gold-digger.

Then he said stop. I'm aiming for a distant, higher target, he said. Those fools think I'm wearing myself out for the sake of money. I've had enough. I stop – I dress in clean clothes – polish my shoes – put carpets on my floor. Welcome in. You will not be forced to accept the gold I'm searching for. I invite you for a cup of tea, served with little cakes.

That will be 10 crowns, please!

THE FLOWER OF PAIN, SUNFLOWER MOTIF
1902–03, oil on canvas, 110 x 60 cm
Munch Museum

T 2749

HERE AT HOME I AM ELBOWED OUT, AND I FEEL ONLY
ANTAGONISM, AND THE COLD BREATH OF ENVY. THERE IS
NO POSITIVE ATMOSPHERE TO CARRY ME FORWARD, TO
MOTIVATE MY WORK. IT WOULD HAVE BEEN BETTER TO
FEEL A STORM AROUND ME, AS I DID BEFORE — AT LEAST
THAT ACTIVATED MY ENERGY.

1933

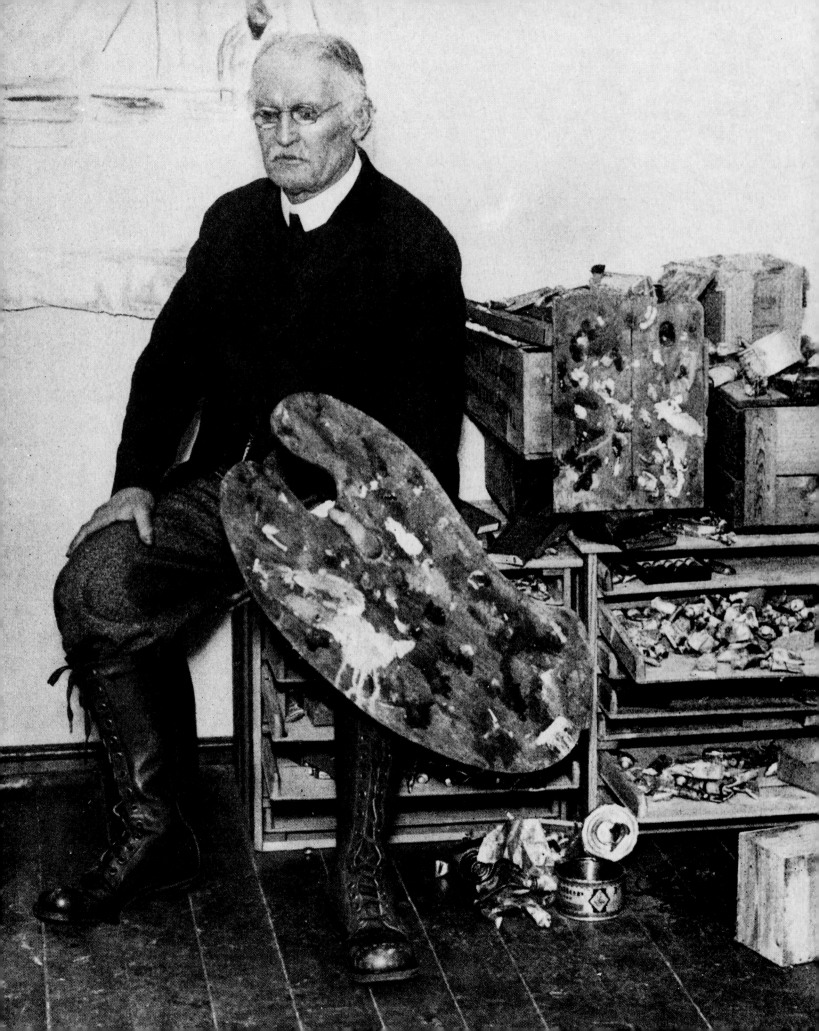

MUNCH AND OTHER PEOPLE

"Hell is other people," said Sartre. Munch would have agreed. The world is waiting out there, free of the torments of the inner life. Then everything becomes different than expected. Munch feels far from welcome in the Norwegian society he returns to, and lives on various farms and in different houses along the Oslo fjord, ending up at Ekely. He is constantly at odds with his surroundings. There is a past, which is not easy to forget. It towers like a monument over the artist's lack of recognition among his fellow Norwegians. There is a present, in which the barometer of envy is quite stable – especially in Munch's own version. There is a future, in which the tax authorities would show more and more interest in this rather well-to-do artist. Munch proved correct in his predictions on the last point, in any case.

Attention from those out there has always had the same effect on Munch. It releases long descriptions of self – a kind of dialogue without a partner, as Munch does not talk only to himself. His writings are like his pictures in that they operate with, or imply the existence of, a second person present throughout – either standing in front of the picture, or listening to what has been written. These are words from a man who does not appear to have many people to talk with, but who still needs language in order to communicate his innermost thoughts to others.

Then there is, naturally, the resentment: fury at the city authorities for favouring his colleague Vigeland, fury at being attacked for his University Aula decorations, and frustration towards the everlasting tax authorities. Munch never understood why he could not get a tax deduction on everything when he had to pay tax on everything he earned. He really thought that everything that went towards the upkeep of E. Munch ought to be exempted. He never understood that it did not function this way, for those out there.

He sits at Ekely and writes much of this. He does not just write it, he writes at it. A great deal more than this selection suggests. Monomania lurks just round the corner, if one does not choose to see it for what it also is – persistence, one of his most dominant characteristics. This he definitely had.

N 284

I worked on the Aula paintings for 4 years. I built several huts and outdoor studios at the various places where I lived. I ordered the best canvas from Holland and used Windsor & Newton colours. I experimented, and the canvases were taken up and down hundreds of times.

It was very expensive. Just to make a comparison, the University paid 10,000 crowns to have the paintings transported, cleaned and varnished. I received 80,000 crowns. My expenses had been over half that amount. In addition, the expenses I had incurred, and paid myself, were at the pre-war rate, whilst my artist's fee was paid at the post-war rate.

It was quite depressing to work on the paintings, not knowing whether they would be accepted or not. They were accepted after 4 years, when they were finally hung.

I had to cover all the expenses from my own pocket.

My urge to work was somewhat dampened by the general consensus that it was unreasonable of me to use my own money, scraped together during the years, to continue my studies of monumental art that I had experimented with for so long. So many people gave me the feeling that my need to develop and profit from the experience I had gained whilst working on the Aula paintings (perhaps the greatest monumental work of art in Europe) was a waste of time.

It was difficult for my poor brain to understand the view that I should not be allowed to use a couple of hundred thousand crowns of my own earnings to create the most important work of my

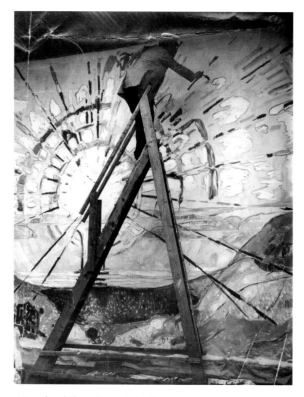

Munch while painting The Sun, *Kragerø, 1911*

life. *The Frieze of Life*, which was indeed my life's work, was half finished ten years before Vigeland's fountain, which was based on more or less the same idea (and which would cost the city authorities 30 million crowns).

N 286

I had been working on *The Frieze of Life* for almost 20 years, when in 1910, in Kragerø, I was asked to submit a proposal to the competition for the decoration of the Aula in Oslo.

I had great reservations, and after several urgent requests, I submitted two proposals: *History* and *Towards the Light*.

I was busy with *The Frieze of Life*. It was completely subjective, and I had personal motives for working upon it. Self-experienced motives.

I had to work in a more objective way with the Aula paintings, and with a particular motif. It would have to be executed on a different level than *The Frieze of Life* which would, for me, always be my most important business.

But it took time.

After having made many unsuccessful sketches, I suddenly saw an old white-bearded man bending down to pick up a piece of wood he had dropped. A little red cap. A blue and white jacket. Worn-out, yellow working trousers, just as the jacket, patched in many different colours.

There was something venerable about the old man. The bushy eyebrows, from beneath which two piercing eyes cast their lightning gaze – and that long grey beard. Now I have my picture, I said to myself, and I managed to get Børre to model for me. I drew him under the tree. This won first prize. I was to work on it for the competition.

Little by little the other things fell into place. The sea and the islets – and the cliffs.

I saw the sun rise over the cliffs. I painted the sun. After that came the mother with her children.

I built my first outdoor studio. I built three wooden walls against the side of my house in Kragerø. I painted the large-format pictures there. I had images to inspire my work with the Aula painting right at my doorstep – the sun, the story. I needed the proper setting in which to paint the mother.

I left Kragerø – and bought Nedre Ramme at Hvidsten. I found the inspiration for *Alma Mater* there.

N 287

At Nedre Ramme, I could set up the models for *Alma Mater* and the children bathing on the beach, with the fjord against the blue hazy hills in the background. I painted the preparatory sketches in full scale – the first two were 5 x 11 1/2 m. I painted 4 suns in almost the same size.

I felt at ease with the large scale, and was not exhausted by painting such enormous pictures. To a certain degree I painted them from right to left, just as I was used to doing with an ordinary easel painting, and used the best quality colours.

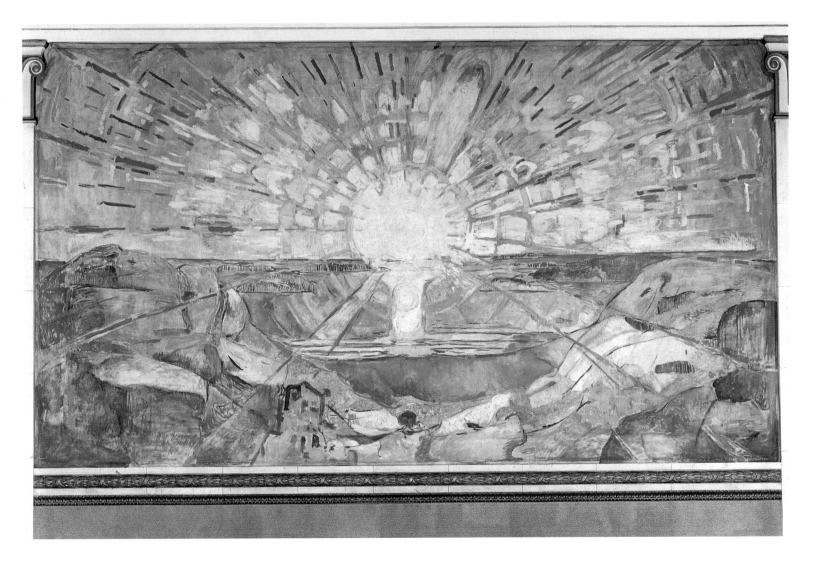

I was not tired at all by the time the paintings were hung – and I could have painted *Alma Mater* yet again, if I had been given financial support by an interested party. But no such supporters were to be found, even though I could have painted another version and borne the cost myself. *Alma Mater* was originally conceived of with several more children bathing. The painting as it hangs in the Aula seems a little empty on the left-hand side. I also wish that this painting had the same harmonious and calm atmosphere as *History*.

When I moved to Oslo I looked for a larger piece of land, where I could build the outdoor studios that I had thought about whilst I was in Kragerø, and which I used in the places I lived in later. In my opinion, a piece of land was already a studio, and could be used as such by simply building up four walls, with a simple roof to stop the rain from falling on the walls. The sky became the roof, and the earth became the floor.

Finally I found the perfect place for the outdoor studio I had been looking for at Ekely. I carried on with the Aula paintings there, as well as the developing *Frieze of Life* and a couple of other large monumental works.

I had to keep on the house at Nedre Ramme,

THE SUN
1911–16, oil on canvas, 455 x 780
Aula, University of Oslo

Munch in his outdoor studio, Ekely, ca. 1925

because I was working on several large paintings there, and it was also the backdrop for *Alma Mater*. It was really only a stony beach with a few trees.

Other than the studio, I hardly used the old villa that was also part of the property.

Because of these two properties, which in fact I bought as cheaply as possible in order to be able to work with the monumental paintings I wanted to develop, public opinion proclaimed that I collected small villas.

Rumour had it that during the last 20 years I had collected 6–10 villas.

N 288

Until I was 40 years old, people were not interested in my work, and paintings were thrust upon people for a mere crust of bread. When it became apparent that they were valuable, I was not allowed to keep my extremely necessary sketches. Everything was to be sold, in order to maintain a reasonable income.

To paint *Alma Mater* with her bathing children, I occupied 100 metres of Norway's long coastline. This caused great envy. It should only be used for bathing. One does not live by bread alone, but by all that passes from the mouth of God. As does all good art.

As long as I have painted in this country, I have had to fight every inch of the way with clenched fists for my art. I have also painted the central male figure, "the worker", with clenched fists.

In Hvidsten, I have for 15 years worked on the unfinished Aula painting in addition to the painting of the bathers. In Åsgårdstrand I have worked for 20 years on *The Frieze of Life*. This is what they call letting the house stand empty. For five years I have been ill, and unable to travel there. It is not possible to let others use this place instead of me. The house is in the middle of a garden which is rented out by somebody else. How can I let just anyone into the place where I have all my sketches, and where I create my paintings?

I suppose there are not so many years left for me to annoy my fellow countrymen with my work.

I have been plagued by the same pestering attitude from my neighbours, building authorities and all kinds of others, ever since I moved to Ekely. Why does he need 10 acres of land? Why does he need all those huts?

It depends upon how highly one values art, and in particular my art – and in reality it is not valued that highly.

I needed to have a piece of land as big as this, in order to put up these cheap wooden constructions with partly open roofs, that make it possible for me to work on and complete my many large paintings as economically as possible.

Why don't you paint small paintings that can be sold, like everybody else, asks my milkman.

Look after your cows, I said. You know something about that.

I also needed so much land because of the fire laws that dictate the distance between the buildings. In addition, the building authorities also have their own requirements regarding the distance between the buildings.

It is impossible for people to imagine the world as anything else but a market place. That's why I'm no longer allowed to paint sketches. Everything must be for sale.

People have villas, and go on trips to the countryside and the mountains. I have 3 neglected, shabby houses, that I use to work in, and people find this strange. I think Rodin had 30 studios in Paris.

Although people think it too much that a couple of old shacks are sacrificed in the name of art, they also understand that my paintings from Aasgaardstrand and Kragerø are a good advertisement for those places.

T 2797
THE BRICK STUDIO

In the big studio I have been working on the development of *The Frieze of Life*. This includes a number of sketches that I have used as research material for the Freia paintings – in the main hall at Freia (Chocolate Factory). For this, I received 80,000 crowns, and of this I had to pay 25,000 crowns in tax. I'm working on sketches and studies for portraits of a lady from Bergen and Frølich, the factory owner – 2 portraits.

For the Frølich portrait, and the portrait of the lady in Bergen, including many sketches, I am to be paid 5,000 crowns, from which I also have to pay tax. Here in the studio is a study for the portrait of Prime Minister Blehr. Last spring I received 5,000 crowns for the finished portrait.

In the cellar there are many more or less finished paintings and studies. They have all been used in the development of finished portraits – with the exception of a few portraits which I have used in my printmaking.

There are some studies for the winter paintings from Kragerø in the studio. One of these paintings was sold to a museum in Zurich for 6,000 crowns. This sum is also taxed.

In the cellar are a number of primary studies for the Freia paintings, and for the painting *The*

Dance of Life, which Stenersen bought. I paid tax on this sale.

The studio complex in the northern part of the garden consists of a north and a south studio. These are separated by a large open courtyard which I have made into two open-air studios. In the north studio I have 8 large studies for the Aula paintings. There are also about 40 large rolled-up sketches for the Aula paintings in there, together with a few other smaller sketches and paintings. All finished pictures are very highly taxed when sold.

There are sketches of Møller's portrait – the finished portrait is sold, and I have paid my tax.

A covered passageway connects the two large studio buildings, and this is used to store several studies for the Aula paintings, in full scale. In the first open-air studio, on two walls, I have hung up the large works in the daylight. I have been working on them for about 8 years.

Along the walls of the covered passageway hang large works that I have been painting over the course of several years. These are paintings that make up *The Frieze of Life*, and others. I have been working on the large painting of bathing men for the last 20 years.

In the south studio I have stored unfinished paintings – *Summer Nights* – part of the frieze, portraits of Ibsen and Bjørnson – a study for the large A. painting – Nietzsche in the Thielska Gallery – and a portrait sketch of Chief Administrator Løchen. For this and Thiel's portrait I have received a fee for which I have paid tax. I have some engravings there, too. Some of these I have sorted out and painted, in order to be sold. In this room, as in the open-air studio, there are preparatory studies for sculptural works. A number of more or less unfinished sketches are also kept here, together with a study for a woman's portrait. The finished portrait is sold and the tax on it has been paid.

In these studios I keep the large packing cases that have transported my work around the world,

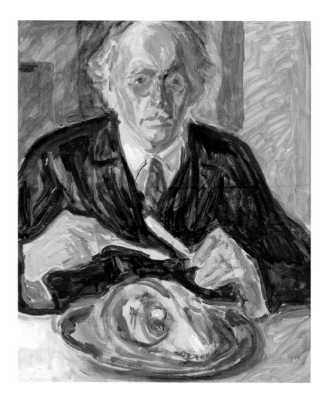

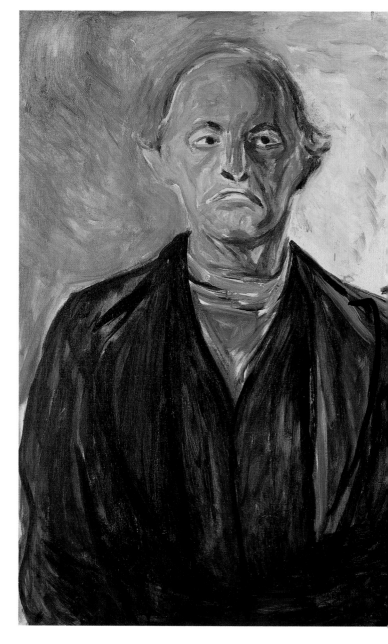

and promoted Norway. In this way I have gained the recognition that helps to sell my paintings – and have provided the tax authorities with money. I store the packing cases with their contents. You must remember that I am among those who pay the highest taxes in Norway.

One must also respect the fact that I have a complicated production process, and that the business is expensive to run. Last year the tax authorities demanded the pathetic sum of 1,000 crowns.

Do the tax authorities now expect to be able to demand tax for a painting before it is finished or sold? Isn't it enough with the enormous tax one has to pay on the painting when it is finished and sold?

In the southern open-air studio, I keep the unfinished sketches for the City Hall decoration. How can one expect me to finish them, when for years I have been disturbed in every imaginable way. By Vestre Aker borough, and not least by the tax authorities. Perhaps one expects me to pay tax on these paintings before they are even sold.

Not only do they want to tax the cow and the milk, but also the foetus of the calf in its mother's womb.

What will happen to the composer who is always erasing and re-writing, and has many manuscripts and scores – or a poet who does the same – or a tenor who is often singing, or a philosopher who often philosophises? Perhaps the

SELF-PORTRAIT WITH COD'S HEAD
ca. 1940, oil on canvas, 55 x 45.5 cm
Munch Museum

SELF-PORTRAIT BY THE WINDOW
ca. 1940, oil on canvas, 84 x 108 cm
Munch Museum

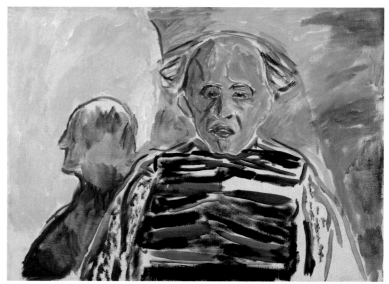

for my printmaking. I have installed a kitchen here, and a large etching press. I also keep a large store of printing paper here, plus copies of many of the 500 prints that I have made over the years.

The cellar is also used for printmaking. I have installed a big lithography press in one room, and the lithography stones are kept in the other two rooms. I also keep printmaking paper here.

On the wall of my room on the ground floor, I have put up the large sketches for the Aula paintings – sketches for the coloured lithographs. I also store quite a few other smaller works here, in various stages of completion.

In the cellar I also keep half-finished paintings and studies, together with some prints.

In my room on the ground floor I have the preparatory studies for the portraits of Mrs Stenersen and Mrs Ridderstad. 4–5 studies. I received my fee for these paintings this year, and paid tax on the amount. Studies for the portrait of Mrs Thomas Olsen are kept in the same place. For this painting I received 6,000 crowns, and tax has been paid on the amount.

On the ground floor I also keep a picture of two groups – men and women. It is the preparatory study for a painting I sold to Stenersen. The

manuscripts will be taxed, or the voice of the tenor – or perhaps they will tax the philosopher's brain. I expect they will also want to tax the tenor's lungs – as he sings even when he's not giving a concert.

In the main building there are two floors, the second of which I use for the preparatory studies

SELF-PORTRAIT WITH STRIPED PULLOVER
1940–44, oil on canvas, 57.5 x 78.5 cm
Munch Museum

preparatory studies for the Freia decorations are also here. Also a portrait study of Rolf Stenersen, which he paid for, and I paid tax for.

I also keep studies for the portrait of a woman in black here.

N 135

THE PROPERTIES

P.S.

There has been talk of Nedre Ramme being state property – this is an unfortunate thing to say. It might be helpful for me to give a short explanation of the use I have made of my two properties – Ekely and Nedre Ramme – as well as the little cabin in Aasgaardstrand. The rumour that has been spreading for the last 20 years – that I own 6–8 villas and am a hopeless snob – has vexed me enormously, and caused me great harm. It has caused untold damage to my relationship with the tax authorities, and to my family, who have heard tales of this wealthy man from whom they might expect financial support.

I bought Nedre Ramme after leaving Kragerø, where I had had been working on the motif for *History*. I needed the space to finish the Aula pictures, and I also found the motif and surroundings for *Alma Mater* there, so that both the paintings shared the same earthy character. I kept the property at Nedre Ramme, because I was constantly re-working *Alma Mater*, which I was always hoping to improve. The shabby little cabin in Aasgaardstrand is the place where I worked on *The Frieze of Life*, and it has a connection to an even earlier period in my painting. Ekely is the place where I work and store all the large paintings and studies for wall paintings that are nearing completion or are half-finished in the studios. The main building houses the two presses for engraving and lithography.

N 136

The fairy tale about my 20 villas, and how one can build a large studio for 400 crowns – and a

little about how the Aula paintings came into existence:

At one point in my life I found myself on the beach in Kragerø. I found it to be a fine place, and so I stayed for 2 or 3 years, if not longer. It was the loveliest of all Norwegian towns – a real haven for the seamen who ended up ashore there.

The towns along the coast from Larvik to Trondheim are truly delightful.

They lie, shimmering like red and white crystals, at the edges of the fjords. Real havens for the seamen who come home after the storms and their toil at sea. Something about these towns reminds me of the gulfs of Italy. I lived on the hillside overlooking the surrounding islands – overlooking the skerries with their white foam.

I received a kind of commission for the Aula paintings – no, I suppose it could not be called a commission.

I had to work on them for 5 years, without any assurance that they would be accepted. Only when I pronounced them finished did I finally receive my fee, and the paintings were accepted. I painted those large canvases out here. Because of the way I painted, they had to be done on canvas. I did not want to discard the colour palette I had developed, and the colours for fresco painting were quite different, even though they were used by Michelangelo before oil paint had been invented.

How then to paint them here?

I built 3 walls around the southern wall of the house. A narrow roof ran around the edge – about 1 1/2 metres in depth, to protect the paintings from the rain. Other than this, the sky was the ceiling. The studio cost 400 crowns, and functioned perfectly – both summer and winter. The house was occupied by a painter.

These days one would call it "Functional". It was the very first Functional style building to be put up in this country – in 1912.

MODEL IN FRONT OF THE VERANDA
1942, oil on canvas, 117 x 95.5 cm
Munch Museum

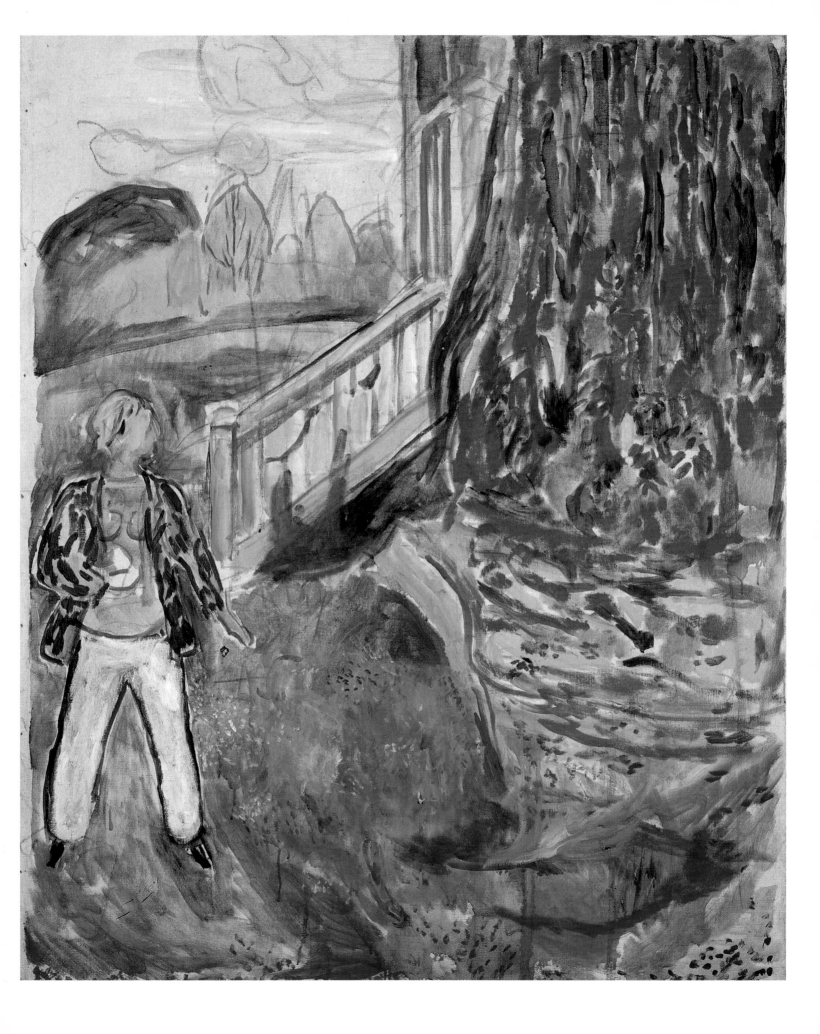

N 143
TAX AND E. MUNCH

It is impossible for me – and with the years it has become even more impossible – to satisfy the complicated claims made by the tax authorities. Even with the help of the best lawyers.

I have gradually built up quite a complicated and costly business around my artistic practice, which includes large decorative works (like *The Frieze of Life*, and the once-planned decoration of the City Hall – and the continuing work with the Aula paintings) and my printmaking production, for which I need the two large presses.

Now I shall probably have to reduce my production greatly, if they carry on with these tax claims.

These are the facts: this large apparatus allows me to work in quite a different way – it also allows me to sell my work. If I get rid of my studios, and work in a smaller room, both the production of the work and the sale of the work will become much more difficult. I have built up this apparatus during the past 20 years, and time has shown that it allows me to work a great deal and sell a great deal. On an average, I have paid around 14,000 crowns each year in tax. There have been fewer sales during the last few years. This is because I have almost stopped working, and this has its reasons – I have been greatly disturbed by all kinds of people the borough of Vestre Aker has caused me difficulty, and my ongoing battle with the tax authorities has also contributed to this situation.

N 144

It is therefore necessary to ask the tax committee whether it is able to take a flexible position with regard to my tax returns.

The most difficult aspect of the matter is the expense of the equipment and studio space that are necessary for my production, and the simple running costs of this apparatus seem to cause the most opposition. I don't think they realise that this is a matter of necessity.

I believe that the tax committee would benefit from allowing me to keep the equipment and studio space I need in order to work.

A couple of years ago I was forced to abandon the work I had started with the City Hall decorations, and that took its toll.

It will be useful to have these questions answered, when I allow myself to be taxed by the borough of Vestre Aker, as I was before.

N 47

I never promised to paint the Aula paintings in the fresco technique. At that time it would have been impossible.

As long as one has competent assistants, the technique of fresco is quite easy.

My paintings have been neither repaired nor restored – irresponsible gossip.

The paintings are executed in exactly the same way as all my other easel paintings that are shown in galleries.

I, just as many other notable painters (e.g. Cezanne), often work on my paintings over a long period. During the four years I worked on them, they hung in my outdoor studio, exposed to wind, rain and snow.

The paintings have not faded.

N 49

Today's stories and lies

Wenn ich schlief kamen
die Schweine und fragten
von meiner Loobeern

Nygård-Nilsen says the following in his book about monumental art:

That I had promised to execute the Aula paintings in the fresco technique. That is untrue. It was quite unnecessary, as the areas to be decorated, and the room as such, were better suited to a work executed in oils. Furthermore, I wanted to paint the pictures in the technique I was best acquainted with.

He claims that the paintings had to be taken down after a few years, in order to be restored. This is untrue. The Aula paintings were taken down to be cleaned of soot, varnished and insulated. The paintings and colours have never been in such good condition as now.

He claims they are painted in a turpentine technique.

Mr Nygård-Nilsen knows nothing of any technique, least of all mine.

The paintings are executed in exactly the same way as all my other paintings, including those in the Nationalgalleriet.

I have no intention of explaining to Mr Nilsen that I also use turpentine if I feel it necessary, or about the particular manner in which I utilise it.

This is all part of a tactic to promote the status of the fresco technique. It is a perfectly acceptable technique in its place, but it will never compare to the technique of oil painting, which has been studied and improved on since the Renaissance. The technique of El Greco, Titian and Tintoretto. The latest fresco techniques always have something dry and cold about them. Fresco can never have the same dramatic impact as oil paint.

N 51

Propaganda supporting the technique of fresco has been circulating for a long time now, in the form of speeches, written articles and correspondence. Some people claim it is the only true form of decorative art. My Aula paintings, if indeed they are mentioned at all, are given a modest mention, as being a worthy, if stumbling, beginning to the monumental art form – unfortunately they are painted in oils. The Freia paintings are completely boycotted.

It is true that the wonderful technique of fresco is making a reappearance, and is a valuable companion to oil painting. However, the technique of oil painting has been developed over hundreds of years, and the technique of fresco will never manage to attain the same strong, lush, glowing colours.

Then there is the question of durability. The article mumbles about the fact that my Aula paintings had to be taken down to be restored. Already damaged. This has nothing to do with the truth of the matter.

I shall quote some of the statements made in that long article.

After a few words of praise and rebuke for the Aula paintings, the following strange claims are made, in an effort to prove the weakness of my oil painting technique, and in an effort to harm my reputation: After many years of struggle, the Aula paintings were finally accepted in 1916. A few years ago the paintings had to be taken down in order to be restored.

This is quite untrue. No fresco painting would survive as well as these oil paintings. They are painted on the best quality Block Bryssel wide canvas, which has been quite impossible to get hold of since the war. They are painted with Windsor and Newton's excellent easel-quality paints, and the paintings are sealed and protected from damage.

The paintings were taken down so that the accumulated soot from the heating system could be cleaned from their surface. They were varnished, and stretched onto frames. This is the usual procedure with every oil painting.

They wish to find evidence of my slovenly, negligent technique, and to show that oil painting is decorative art.

Then the following statement is made:

The four champions at the forefront of fresco (Fresco Supporters) are Sørensen – Revold – Per Krohg and Rolfsen.

Then further down, the following strange statement:

Sørensen paints very little fresco himself (he has painted just one little painting in fresco) but he allows his friends to utilise the technique.

Yet nevertheless he is a Fresco Supporter – or more correctly Top Supporter of the Fresco Supporters, and he is given permission to use the

unfortunate technique of oil painting in his decorative art. Actually, he has only been working with decorative art in recent years.

My fresco paintings should be seen in good light conditions. One should look at *History* on the morning of a sunny day, when the light falls on it. I looked at the paintings recently. They have never glowed so brightly. It was if they had been painted yesterday. They are shown to their best advantage now that the Aula has been renovated, and the heavy square panes in the roof have been removed.

N 56

Krohg wrote a negative piece about the Aula paintings. History cannot be recounted by a fisherman, he said. Actually, I often see an old seaman sitting by the paintings – he looks as if he's been out in many a high sea. Anyway! Weren't some of the Gospels in the Bible recounted by fishermen? Krohg thought the feet were too big. This was in fact done on purpose – the foreshortening that Krohg talks about was also done on purpose. The exaggerated size of the feet gave the man greater presence and height.

Munch walking at Skøyen, Oslo, 1935.

I think it was also Krohg who said that Alma Mater was not tall enough, and that it was unnatural that she was clothed, whilst the children were naked. He also thought she had too many children. Krohg would rather have had a beautiful Helen, wrapped in her many togas. Apparently he would have preferred Alma Mater to have been breast-feeding her child whilst she bathed. Regarding the number of children, they did not necessarily all belong to her. She could be taking care of somebody else's children, too. If everything should be so Greek, and the togas draped so perfectly, then the public should also be clad in togas, or else naked.

Those who sit closest to the sun are bathed in all the colours that are reflected upon the surrounding panels, and the brightness can be shocking. The sun often burns. My good friend Sinding and his wife were sitting in the line of fire at the first concert (in the Aula), or perhaps it was the opening. They jumped up aghast. The colours were too much for us, he said.

Wagner's music was also hard for people to accept, in the beginning.

In actual fact, the seaman in the painting *History* is a symbol. They are on a different level than the simple motifs in themselves, just like the woman in *Alma Mater* and the bathers in the sun.

Professor Brøgger, as a scientist, came with the following weighty pronouncement against *History*: "There are no oak trees by the coast," he said!!! Heavens above. The old tree that I painted grew by the coast, but it has now rotted away. But this very summer I walked through a wood of a thousand oaks, by the beach in Kragerø.

He said the same thing about the colours I had used.

Blue stones! I can tell you they don't exist, he said.

I have seen many blue stones. I can also tell you that in different kinds of light, a horse can be red, yellow, white and blue.

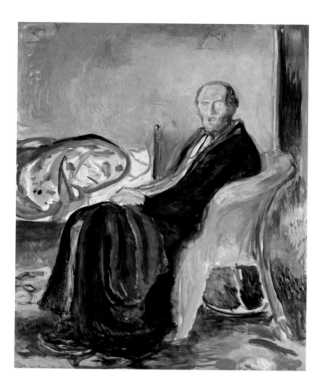

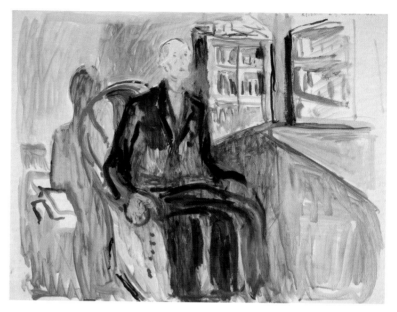

Then there was old Professor Dietrichson. He said he would have to vote against it, even though he was blind.

A blind professor may tell stories, but not judge a painting.

These are indeed weighty reasons. *History* was not accepted, and Schibsted's famous yellow tapestries were hung up.

I told Brøgger that the rays of the sun had not reached him – as they had reached the reclining figures in the painting.

Vigeland, my rival, spread rumours that I had torn up his dreadful dragon-style art. I was supposed to have crept out of a hole in the wall in the dead of night.

N 326

I now live very quietly at Ramme, and make occasional trips to Ekely and other places.

I have much to reflect upon. A complete change in my life, or an entirely different way of working. It is a step backwards, and that is often the

hardest step to take. It is obvious that the situation requires me to prepare myself for a modest life, also with regard to my painting. By this I mean: I will need to stop work on the large commissions. Partly roll up – the canvases. Nevertheless, it seems I am unable to stop working on the 7th *Alma Mater*. I have set it up here in Ramme, and I carry on working with the studies for it here.

I'm working with the formation of different groups of figures. I have always thought that *Alma Mater* might be my finest work. I enjoy painting those groups of naked children and girls. That is life itself!

In other ways, I have to take stock of my financial position so I don't fall into the trench of economic ruin ahead of me. They have harried me with the most amazing lies about my fortune and my many properties. Ekely! – what a brilliant financial operation that was. A property worth millions – I protested. But it never worked. I was exhausted by all that money nonsense, and even allowed myself to be deceived by all that talk. Now, when I really need money, it seems that it is very hard to come by. The whole property at

SELF-PORTRAIT WITH INFLUENZA
1919, oil on canvas, 150 x 131 cm
Nasjonalgalleriet

SELF-PORTRAIT AT 2.15 A.M.
1940–44, gouache, 515 x 645 mm
Munch Museum

Ekely, with all my studios and the house, will not fetch more than 100,000 crowns. Everything will be pulled down, and I shall be without a home.

I am quite sure I cannot expect to sell much work now. I could sell a little, but nothing much to speak of. Nevertheless, I am glad that I held back with the sale of my paintings and prints. The market would have been flooded by now.

I have no objections to working a little less. I must tighten my belt in many ways – cancel my electric lighting – give my gardener notice – and save money in many other ways.

I was just starting work on a series of large monumental paintings, having finished the commission at the University. I shall roll most of them up.

T 2734
21 JANUARY

Once again, in the Kristiania magazine I have been misrepresented regarding the great amount of work I sell from the galleries. From 1884-1909 I sold work for the total sum of 20,000 crowns. Half of that amount per year was used to buy paints – canvas – studio expenses and models' fees. On the other hand, many people came into possession of my paintings in all kinds of ways. I exchanged one for a pair of shoes (*Karl Johan Street*, subsequently sold to Germany) for 80-20-5 crowns. I exchanged another for a dinner at the Grand, and received 2 crowns for the portrait of Jensen. Ulby paid best – he gave me 40 Chateaubriands for a painting. The painting I received 5 crowns for was sold to a stranger, who later sold it to a gallery in Bergen for 1,500 crowns. I received 60 crowns for the painting *Girl by the Bedside* – the last version was sold later to a gallery for 2,500 crowns.

Approximately 12 of these paintings are in the same gallery. A couple of paintings have been sold to a gallery in Copenhagen.

As well as taking up gallery space, so that I am unable to sell other work, these gallery owners naturally complain over the fact that I take the liberty of selling my own work directly. They are also very keen to explain to the public that my early work is the best, and that I, like a crab, progress forward in a backward manner – thereby denying me the possibility of direct sale. And the public scream about the gallery prices. They do not scream when small works of mine bring 1,500 – 2,000 crowns, especially when they have acquired them for almost nothing. I am denied the right to all kinds of commissions. Meanwhile, I have received portrait commissions from Stockholm – Copenhagen – Berlin – and even Chemnitz. I have received portrait commissions from abroad for 20 years, but I am no longer able to accept these, due to failing health.

As long as the camera cannot be used in Hell or in Heaven, painters need have no fear of competition.

JUNE 1930
REFLECTIONS ABOUT PEOPLE

Whilst I was working and earning money – there was a great uproar about the fact that I was tormented by money problems. It disturbed my work. I found it embarrassing to have money, whilst others starved. It gave me a lot of administrative work. I was forced to run a business. All of these things bothered me, and I found it a great strain.

They carried on complaining about me. He doesn't sell, even though he has lots of valuable paintings. Why won't he sell?

First, the money bothered me, and second, I needed to have the paintings. I have never painted in order to sell; I usually paint to experiment and improve my work.

They want me to donate my paintings to a museum in Oslo. I have also thought about this, but I wouldn't know how to go about it. On the other hand, it is important to keep as many paintings as possible. The best ones are of course the easiest to sell – and they should be in a museum.

My paintings are best seen hanging together – they lose something when exhibited together with the work of others.

People envy me, and they are constantly screaming about all the property I own.

I have a little cabin on rented land in Aasgaardstrand. I also have a permanent studio there.

This place is important to me – it is there I work on *The Frieze of Life* and on other ongoing motifs.

Then there is Ramme. This is a neglected old house in an overgrown garden, surrounded mostly by rocky landscape and cliffs. This is where I work on the motifs for *Alma Mater*, which I painted here and continue to work on, as well as other important motifs.

I bought Ekely cheaply, at a time when I needed to construct the simple, inexpensive wooden shacks I needed in order to be able to work with the large Aula paintings.

I needed a large piece of land, otherwise I would not have been given permission to put them up. I only have these properties in order to be able to carry out my work.

It is also very important for me to be able to paint in peace and quiet. I cannot live in a hotel, and dislike being surrounded by other people.

This is a weakness. The result of it is that I have a serious eye condition.

They call me "master", and praise my paintings, yet they envy me, and will not leave me alone and give me the peace I so badly need to be able to work.

The sword of Damocles hangs over my head. I am tormented, both by my eye condition, and the dangerous congestion I have been experiencing. The past 5 weeks have been the first time I have been able to rest for 15 years. And I have been able to forget the sword of Damocles.

People can think what they will.

My two studio properties and the cabin I own have become 10 villas (pleasure palaces) in their eyes.

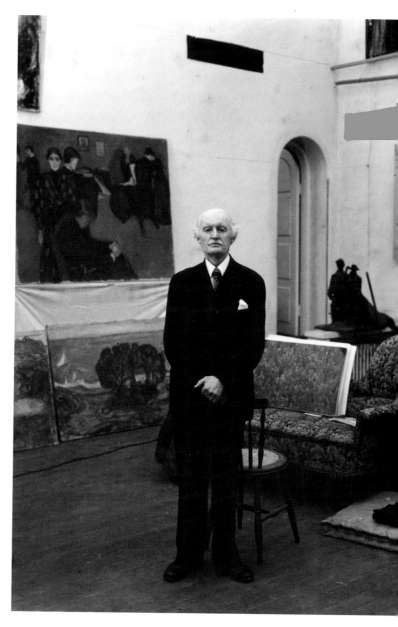

Munch in his winter studio, 75 years old, 1938.

For the past 15 years my relatives have been asking me whether I really own 10 villas.

They started to pay attention when I answered the following: Only 10 villas – I own all the villas along the Oslo fjord, and I only keep them to be able to eat the berries in their gardens and annoy people. Neither do I have a fortune of 2 million,

with an annual income of 100,000 crowns – I have 20 million, and earn 500,000 crowns a year.

When I have an exhibition, people go round and add up the sum I have sold for. 20,000 – 10,000 and 50,000. But they could also see my paintings hanging for years in Gallery Blomqvist, and finally being sold for under 2,000 crowns.

The tax assessment arrives – this is where people have been able to see the size of my income – but they are no longer interested, because they can see that I have had no income for the last few years – on the contrary, I have used up 70,000 of the small amount of capital I have accumulated. There are only 150,000 crowns left of this. People cannot understand that in my situation the current good economic prospects do not apply, but that here in Germany it is not easy to sell.

N 545

WHY I WAS FORCED TO MOVE FROM VESTRE AKER

Over the course of many years, I have been pestered and bullied by many people from the district of Vestre Aker, as well as the other citizens of Oslo. I have had to stop working because of these terrible disturbances. I have had to turn down large commissions. For the past 7 years it has been impossible to walk the streets of Ekely.

I have also had great problems with my relatives. They have made great difficulties for me. Because of all this pestering from aggressive people, I lost the sight in my only good eye, at I time when I needed absolute rest. It became worse and worse.

I have not complained about my tax payments for 17 years, but have chosen to pay more than necessary, rather than start a round of protests. For example, without being consulted, I allowed my tax to be raised, for no other reason than the fact that my income allowed room for it. This caused great protests from the tax authorities, who were sceptical to my calculations, and this gave me a lot of trouble.

I felt that many of these disturbances were directly related to a kind of persecution that

certain parties had decided to pursue against me, and this made my departure all the more necessary.

I was so tormented by the aggressive behaviour of the press, my relations and the people of Oslo and Vestre Aker borough – that I developed a grave effusion of blood in my best eye. I was threatened by this recurrent condition and blindness. Now my other eye is also endangered.

I felt it was absolutely necessary to find a place away from all this, and considered moving abroad.

Instead, I chose Nedre Ramme, Hvidsten, where I had lived for many years, and where I was working on the Aula paintings to the very last. I have produced several other large works here. The place has always been arranged with both living accommodation and studio facilities – there are 3 studios and one outdoor studio, and 10 acres of land. I thought it possible to make

MAN WITH SNOWY TREES
1909 or later, drawing, 293 x 224 mm
Munch Museum

this my home, and I arranged everything in this way. I repaired the shabby house, bought stoves, installed electric lights and an oven, and got a dog. I employed a handyman, and later on I bought a car.

In short: Ekely and Vestre Aker had become unendurable. When I took up residence at Nedre Ramme, it was because I had been hounded from Vestre Aker, and I hoped to find peace there.

During the last few years I have stopped painting, and have turned down a number of large commissions, like the City Hall decorations. I lost the courage to tackle them. I have stopped painting because they have threatened to tax my paintings.

The fact is, I have no place to work.

During this time of difficulty, I was receiving the most flattering and honourable invitations to hold exhibitions. They came from every corner of the world, and were mediated through the Ministry. I tried to follow these invitations up as best I could, although I was extremely debilitated during this period.

N 44

The reason I have so many paintings is because I'm used to surrounding myself with them when I paint.

Most of them are large studies. I paint my preparatory studies in full size. I have framed them, so as not to lose them. I'm sure the painters of old had thousands of studies and drawings rolled up.

It was also useful when it came to exhibitions. They were completely necessary to me.

Of the two properties I own, Nedre Ramme is a derelict house that I use as a studio, with a strip of rocky coastline and a few trees. I didn't buy it to use as a house with a garden, but I found it cheaper to buy an old house to use as a studio than to build one.

Rodin had 20 studios in Paris.

Ah well. They have vexed me, and caused me harm. The result is that I am tired of working, and tired of being hounded.

I travel around the country, collecting

impressions. At least I am left in peace, something I did not experience in the 20 years I lived at Ekely.

N 179

After 20 years of strife and misery, a kind fate came to my rescue in Germany. A welcoming door was opened for me. That was in 1902. Linde and others bought my paintings.

I travelled back home. During the summer they had prepared their cowardly piece of villainy against me. The pack hatched out their plan in Drøbak. The pack consisted of Bødtker (Gunnar Heiberg's hunting hound) and all the rest of the women and men who surrounded Krohg. But of course, first and foremost, the spider himself.

They attacked me over and over again. The Norwegian newspapers echoed the attacks. I was unable to cope with these "knife-in-the-back" tactics. I had used up my energy defending my art from its enemy.

These are the tactics: Blows from behind and below.

N 45

In *The Sick Child* and *Spring* I was quite obviously influenced by my own experiences at home as a child. These paintings are about my childhood and my home. Those who really knew the situation in my home would be able to corroborate the fact that any outside influence is out of the question, other than providing some assistance during the birth of the idea. One could also say that the child was influenced by the midwife.

That was the time of pillows, the sickbed, bedtime, duvet-time. What of it.

I don't expect any of those painters had experienced the agony of the deathbed at close hand as I had done a child. It was natural for me to use this experience as a motif for *The Sick Child*. I was not the only one to experience these things – my whole family was there, too.

Krohg was always the one to sit upon his throne and pity his models.

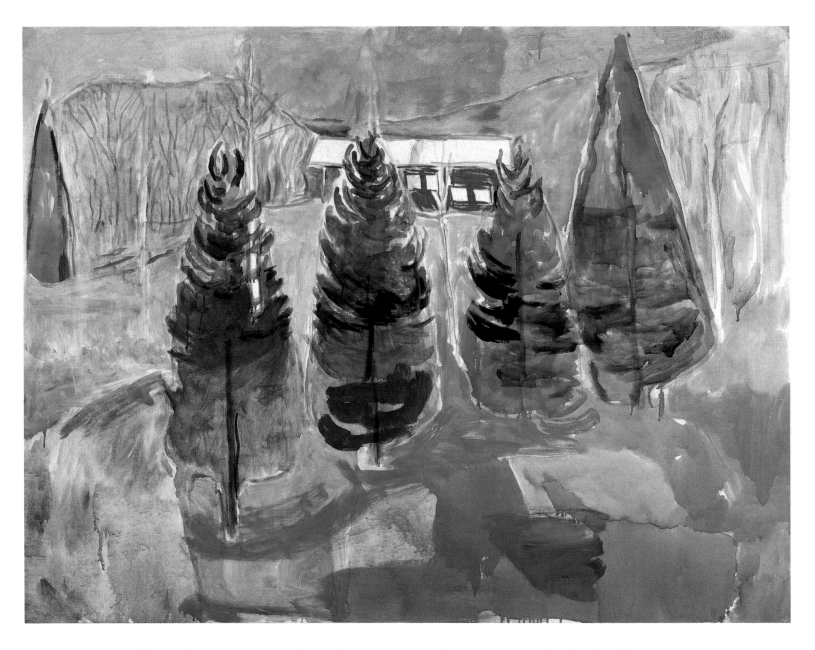

His art did not grow from self-experience, but sympathy.

There is a direct link from *Spring* to the Aula paintings. The Aula paintings depict people who are drawn towards the shining sun, a bright light in a time of darkness.

Spring depicts the yearning for light and warmth and life, as felt by a terminally ill patient.

The Sun in the Aula series is the sun through the window in *Spring*. It is Osvald's sun.

(In *Spring* there are some similarities to Krohg's work – small areas of tight brush strokes, and the shape of the mother, but taken as a whole, with its nervous composition and use of colour, it is quite the opposite.)

I, and all my family, starting with my mother, have sat in the very chair I used in *Spring*. We sat there winter in and winter out, yearning for

RED HOUSE AND SPRUCES
1927, oil on canvas, 100 x 130 cm
Munch Museum

the sun. Until death took them, one by one.

I, and all my family, starting with my father, paced the floor in the grip of mad depression.

All these things have made up the foundation stones of my art. It seemed to me to be a great injustice, right from my childhood days, and these things brought about my need for rebellion in my art.

In addition came my fear of eternal damnation in the fires of Hell, as impressed upon us as children.

N 76

Spring – the sick girl and her mother by the open window in the streaming light – represented my farewell to Impressionism and Realism. With this painting I broke new ground. It was a breakthrough in my art production. Most of my later work has been directly influenced by this painting.

N 78

No painting in Norway has created such an uproar.

When I entered the room at the exhibition opening, people were tightly clustered round my painting. I could hear screams and laughter.

I finally went out into the street, and there stood the young naturalistic painter, together with his mentor, Wentzel. He was a celebrated artist. He was at the height of his career, and several of his excellent paintings from that period are in our museum.

Humbug painter! he screamed in my face.

It is an excellent painting – I congratulate you, said Ludvig Meier, who was one of the very few that had anything positive to say about it.

Aftenposten enjoyed throwing vile insults at me.

This newspaper is the enemy of art, yet it fills a kind of public need. A waste collector is, of course, useful too. Aftenposten has always had, and still has, its Jonas Rask. He is someone who has dabbled a bit with painting – and has mediocre exam results in written Norwegian. Jonas Rask was kicked out by Thaulow – Christian Krohg and others. These were heavyweights of the art world – and Thaulow was known to be a gentleman. He was also the son of a rich apothecary. Aftenposten feared him.

But this counted for nothing. New Jonas Rasks were appointed in his place – and this will always be the case. Now it's Haug.

Why chase after him? Perhaps it's not his fault that he has been appointed. The crude masses who fill Aftenposten's coffers with gold demand such opinions.

If one succeeds in removing him, the mass of readers will demand yet another of the same mould. They can make demands. It is they who pay for the newspaper.

These readers need newly-slaughtered young painters for breakfast – a kind of marmalade for their toast.

It is good that someone can provoke the men in power, but woe unto the source of the provocation.

T 2749
21 JUNE 1933

A German told me that Germany is no longer receptive to my art. This is also true of Norway. I have said it myself. I am quite finished with my early paintings. My painting has developed, and I work on. At the time it was created, my early work was not understood, just as the work I create now is not understood. They are simply not able to understand that a painter's work continues to develop, even when he is older.

I have the same enemies now as I had before – and the worst thing is that half that cry yes! no! My half-friends smile. They are the collective flock – the so-called young set. Collectively they gain power, and their values prevail. I have always been in opposition to them. There have been many sets – the Realist set, the Impressionist set, the Danish set and now the Cubist set, with a national flavour.

JENSEN HJELL

The painter Macke (who was killed two years later in the war) said the following to me at the large, important exhibition Sonderbund in Cologne in 1912: We carry you on our shoulders.

SELF-PORTRAIT DURING EYE DISEASE II
1930, oil on canvas, 80 x 64 cm
Munch Museum

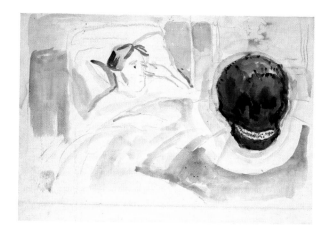

In 1930 Munch has severe haemorrhaging in one of his eyes for the first time. Though shocked, he takes up his brush and represents his change of sight in a series of watercolours. Munch draws the actual haemorrhage as a big, black bird and thereby creates a link between one of his recurring symbols of dread and a physical correlate, i.e. the damage to his field of vision caused by the effusion of blood.

**ARTIST WITH SKULL – VISION
FROM THE INFECTED EYE**
*1930, watercolour, gouache and coloured crayon, 650 x 502 mm
Munch Museum*

STUDY OF THE ARTIST'S DISEASED RETINA
*1930-31, watercolour, 502 x 650 mm
Munch Museum*

The Germans have indeed carried me on their shoulders. Here at home I am elbowed out, and I feel only antagonism, and the cold breath of envy. There is no positive atmosphere to carry me forward, to motivate my work. It would have been better to feel a storm around me, as I did before – at least that activated my energy.

N 545

As a matter of fact, I have almost been made homeless, and feel hunted down, due to the incredibly aggressive and inconsiderate attitude of so many people. I have had to move from place to place in order to find some peace. The constant threat of tax claims for my studio work has killed my will and desire to work.

In short – because of my housing and studio situation, I have been quite unable to work for the last few years – I am unemployed.

I have been hounded by aggression and turmoil, so that I can in fact claim to have no place to live.

I have said it before – I live in railway carriages and in my car.

Because of ill health, I was unable to leave Ekely almost all last year.

I still feel homeless, and am searching for somewhere I can work peacefully. Somewhere I can settle down, now that I am so weak.

Six years ago I was afflicted with a serious eye condition in my best eye. It was rendered useless, and I was under constant threat of a renewed attack.

My other eye was afflicted in March 1938. Now I am threatened by total blindness.

The only solution for me was to leave Ekely and Oslo. Unfortunately, as it turned out, not only was the eider duck's nest destroyed – its wings were also cut off.

T 2744

KIERKEGAARD LIVED DURING FAUST'S LIFETIME
DON JUAN – MOZART – DON JUAN
THAT WAS THE MAN WHO SEDUCED
THE INNOCENT GIRL.

I HAVE LIVED IN A PERIOD OF TRANSITION
MOVING TOWARDS THE EMANCIPATION OF WOMEN.
WHEN IT BECAME THE WOMAN'S TURN
TO SEDUCE, ENTICE AND DECEIVE THE MAN
– CARMEN'S TIME.
DURING THIS PERIOD OF EMANCIPATION,
THE MAN BECAME THE WEAKER PART.

27 FEBRUARY 1929

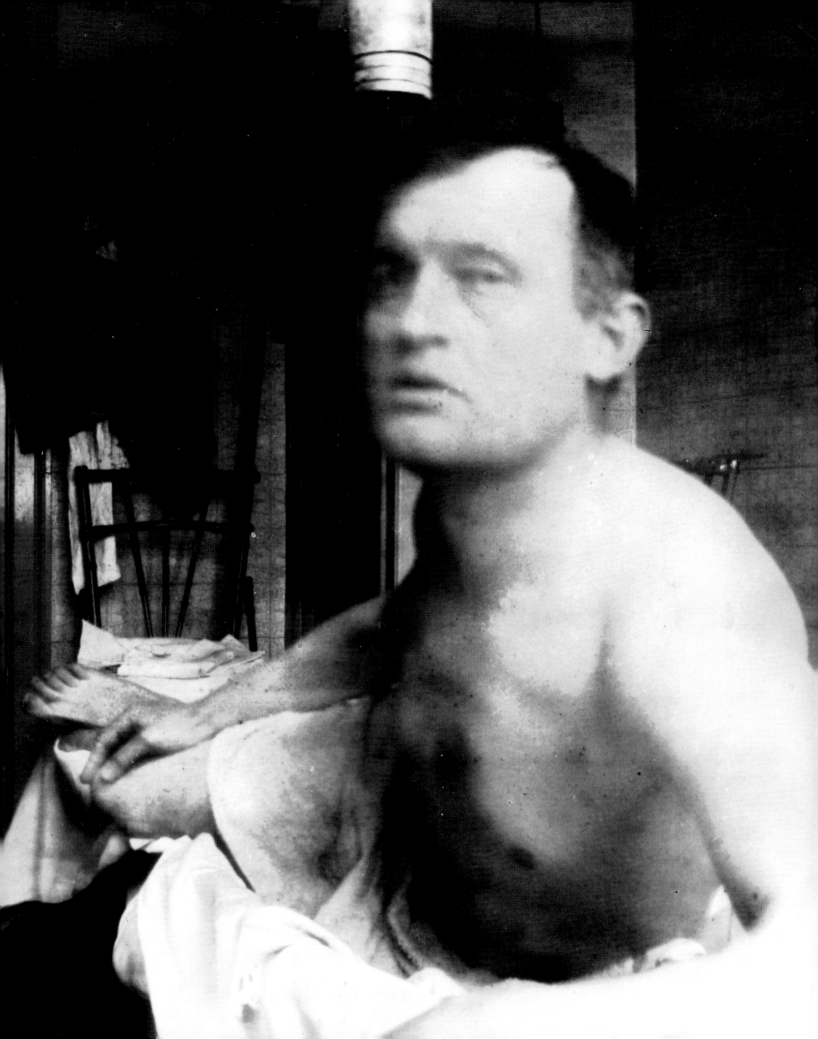

MUNCH AND THE OTHER

"Munch and woman" has almost become a trademark. This was the essence of what Munch struggled with – the great revolution of the period, which Munch refers to as emancipation, and certainly the essence of the Munchian iconography: Madonna, Vampire, women on the bridge, on the beach, on the bed, women all over the place. This "all over" was also true of Munch's life, although it was not until his relationship with Tulla Larsen, a wealthy, independent Norwegian woman, that this female presence became serious. And then it did become serious and decisive.

There had been more than enough flippant relationships. Tulla Larsen wanted to marry Munch here and now – here, being Kristiania, Berlin, Florence, and now being about 1899. Munch does not want to marry. In fact, he is close to doing so, but just barely avoids it. His own explanation is that he does not want his own sad fate to be passed on to any children. There are almost certainly other explanations, but we do not know what they are; perhaps Munch himself hardly knows them. There is probably love. There is certainly intense jealously towards those friends who have brought Tulla and Munch together (Munch is sure that he is inheriting something second-hand). Tulla Larsen and Munch travel round Europe together or on each other's tail. These years are the most intense years in Munch's celebration of the destruction of the whole world. And the destruction became manifest when Tulla and Munch met after a couple of years' separation. The meeting culminates in a shooting episode in which Munch mutilates a finger – an almost symbolic amputation of the artist's hand and of the art he still thinks is the most important aspect of life. His paintings entitled *Death of Marat* become the visual interpretation of the event, while the literary attempt introducing Munch's alter ego Brandt, which can be read in what follows, has more the character of an act of revenge on those involved.

In simple terms, there can be no shadow of a doubt that Munch had a problem with "woman". Whatever this might mean. But it is easy to exaggerate the point. Munch's pictures of women also show tenderness, love, and devotion. The vampire image ought not to be allowed to fill the whole picture. I believe – and this can only be a supposition, though one based on what one can see in and infer from Munch's work – that Munch's problem with "the other" predominates his problem with "woman." But this can be difficult to understand in an age such as ours that wishes to identify "the other."

Munch's relationship to "woman" echoes his much greater efforts at relating to the world. The reason why "woman" can sometimes also be a liberating factor is, of course, that there are difficulties which are even greater than this, believe it or not.

T 2783

Invisible hands pass fine threads from your big, dark eyes, through the pupils of my eyes, binding them to my heart.

When you left me – I felt those threads tugging my heart, even though you were far away over the sea. It felt as if my heart was an open sore, and that those fine threads were ripping it apart.

T 2782

The moonlight glides across your face, which contains all the beauty and pain of this earthly kingdom. It is as if death is beckoning life and a chain binds the thousands of generations who are dead to the thousands of generations to come.

You lie back, and I see upon your face – a face filled with earthly beauty – the thousands of generations who are dead, and the thousands to come. Death is beckoning to life. The chain that binds the thousand generations who are dead to the thousands to come is being tied.

A chain binds them together.

Your lips are like ruby-red snakes. Your lips are as ripe with blood as that carmine-red fruit – they open, as if they belonged to a corpse.

Your sensuous lips – blood-filled like that carmine-red fruit (they glide apart as in a grimace of pain – the smile of a corpse.)

We left the sultry, flower-filled wood – out into the pale luminosity of the night.

N 645

Your face captures all the tenderness in the world – your eyes are as dark as the green-blue sea – they suck me in. A painfully tender smile hovers upon your lips – as if you wish to beg my forgiveness for something. Your lips are sensuous – like

two blood-red snakes. The soft glow of the lamp imbues your face with piety – your hair is pulled back from your pure brow.

You have the profile of a Madonna – your lips part as if you are in pain.

Fearfully, I ask whether you are in distress – but you just answer that you care for me.

T 2784

At last, spring arrived. When the sun came out, it shone for longer and longer.

But the cold and snow from the North would not loosen their grip. They would not leave the frozen earth – they had been in possession of it for many months. The big, dark cloud masses gathered threateningly behind the hills to the north of Frognersæter. The dark winter clouds pulled back a little whilst the sun burned – but returned with a vengeance during the afternoon and evening. They covered the sky. The fairytale clouds, south winds and Italian sun lit up the southern skies. Castle-like clouds that heralded the sun. They lay there, patiently waiting to pour their warmth upon the frozen earth – building up their strength to chase away the winter clouds.

In the middle of the day, when the sun was high in the sky, they spread their white angel wings across the shiny blueness of the sky. A breath of warmth from Italy made me feel weak – and strangely sad. The snow melted. The streams gushed with water. Shiny beads of water dripped from the roofs. The earth became soft. The spring came. But each afternoon the hateful, spiteful winter clouds gathered their strength. Their great blue-black fists clenched themselves together, attacking the heavens with renewed force. Those angel clouds from the south were driven back.

THE YELLOW HOUSE

The yellow painted wooden house – two floors and a veranda at the front. Tasteless. With ugly wooden carvings – in that stupid "dragon" style.

It was painted in that sentimental yellow colour that seemed sad when seen against the dark backdrop of the woods.

He had two small room up on the first floor. Painted the same sentimental yellow – sad and tasteless.

But it had a view over the fjord, with the tops of the pine trees in the foreground and the skerries beyond, which was beautiful. Sadly beautiful.

He paced the floor of those two rooms – to and fro – to and fro. Then he took a long walk, then he paced the floor once again until it was time for bed. How he hated his bed. His instrument of torture – he lay there in order to sleep – only to start up, wide awake.

Was it morning ? He looked at the clock – he had only slept for one hour.

Then back to tossing and turning in bed. All through the long hours of the night, with all their myriad of unpleasant thoughts, until – finally it was morning.

Then he paced the floor once again – until the next sleepless night.

He was shy – he did not wish to see anyone. The other boarders ate their meals together downstairs. They included an depressive – an epileptic, and all the others. The landlady with the lame leg slept on the floor below him.

He waited for spring and summer – hoping they would help to cure his bronchitis – improve his sleeping habits, and bring him better health.

When the dark snow-clouds from the north gathered their forces, bringing snow, rain and wind for days at a time – he became ill. He became so tired that he was hardly able to walk.

He met the consumptive merchant – he lived in the neighbouring villa.

"I have a cold," he said. "I've had to stay in bed for 5 days. I've been spitting blood all day long. And I can't eat, I just vomit if I do."

"How much do you weigh?"

"I only weigh 110 – like a child."

"Just wait until spring comes."

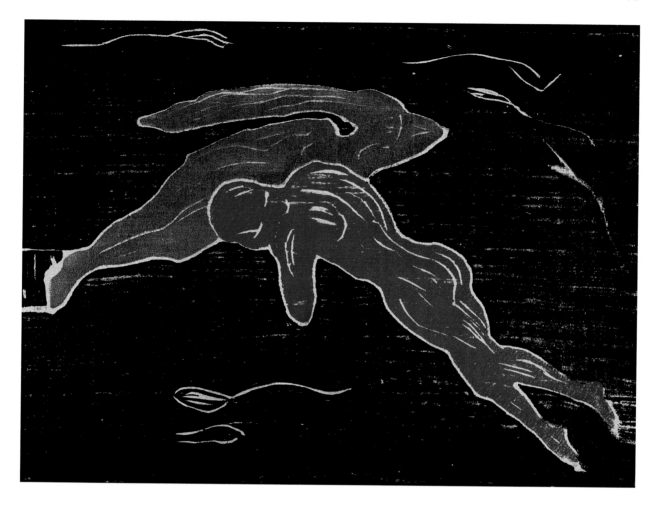

I visited him the next day. He stood at his desk. "I'm just going to write my will. I have no children – and I don't know whether to leave everything to my wife."

I knew he had been writing this will for the last 2 years.

When his wife had been kind, he left her the house in his will. When she had annoyed him, he tore it up.

He looked dreadful, and spat into a glass beside him, which was full of phlegm.

Brandt exchanged a few more words with him before going out.

He went for a walk through the dark pinewoods – then he went back to his room.

A letter from the landlady arrived, asking him to look at his bill. She wished to be paid. She also mentioned that she felt rather ill. Perhaps she wouldn't...

B. paid his bill, and sent his regards. She sent up a messenger to thank him, and returned his greetings.

By the evening she was dead.

This hellish concoction, brewed from the blood of the vine – mixed with the female vampire's poison. It was a boiling brew. The machinery and cellular tissue of the brain expanded, and the overheated, blown-out cell walls were incised, like a phonograph, with the devil's handwriting.

MEETING IN OUTER SPACE
1899, woodcut, 190 x 250 mm
Munch Museum

The cellular tissue was splitting, like a balloon filled to the bursting point – before collapsing like a crumpled leaf. The boiling and expanding process started anew, burning and screaming like a hellish choir of devils and the cremation of plant corpses. The tobacco sent forth its intoxicating and poisonous ash. It entered the infected atmosphere inside the wounded, bleeding paths and labyrinths of the cranium.

He sat in the middle of the large, over-filled café – staring blankly into space. As soon as he had emptied his glass he called the waiter and asked for another, without looking at him. Another glass and a cigar. After a while, he simply indicated with his hand, and another glass and another cigar were placed before him.

Olsen came across to him. "Listen – Miss .. wants me to say that she wishes to buy a painting from you. She's going to marry Kavli," – then Gunnar Heiberg and G.B. came in.

The blood raced in his veins. That devilish brew – the concoction of wine and woman's devilishness was bursting his cellular tissue. It was like an infected balloon – hellish music started playing in his head. He saw a man staring at him.

He held his bleeding hand in the air. He found himself on the street.

My soul is just like two wild horses. They are ripping me apart as they pull in two different directions.

A bird of prey has sunk its talons into my heart. Its beak has entered my chest. The beating of its wings has clouded my sanity. My soul is split in two – like wild doves, each flying in a different direction.

My poor bleeding heart.

T 2789

I have been unable to commit anything to paper for some time now – out of fear. Some episodes have already been repeated, and I have thought that perhaps it was necessary to try and forget everything.

There are two ways to heal a wound. One is to let it grow together the other is to let it slowly burn away – using its own poison to note down its effects and to study the characteristics of the wound. I dared not do this, as the first after-effects had shown this to be a dangerous strategy.

Now I am busy painting at a pleasant house. It is peaceful here, and when I regain my peace of mind, I shall try to dig into my wound and find an antidote. I shall try and re-live those dreadful days last spring. Seven months have passed since then. Spring is always difficult, with its seething life ... the blood seems to hammer more intensely at my temples on account of all that burgeoning growth – everything seems more intense.

I was in Hamburg – living at a small hotel – and was about to start painting a portrait.

I felt healthier and more self assured, and was determined to face the pain head-on. One spends a great deal of time avenging a wounded heart – a sick mind. I don't think it is just an expression – I believe that the heart and soul really can be wounded. This means that invisible, unhealthy scars are sometimes hardly noticed.

Alcohol has its part to play – as many know. I have had this problem before. I have said before that had it not been for alcohol, I might have ended up completely mad. Alcohol has certainly been responsible for the strength of some of my outbursts. I can try to explain it in the following way: if one is slightly worked up, and under the influence of alcohol, it can sometimes cause a half-healed wound to break through the scab that has formed over the wound. This can cause the infected wound to erupt violently once again.

T 2792
ELGERSBURG, 11 SEPTEMBER 1905

A long time has passed since I last wrote. A couple of days after my last notes were finished, something strange happened ...

I had business in town – and had decided to go home for the evening. I had the carriage drop me outside a bar. I drank a glass or two. After that, I remember nothing. I woke up in a hotel – I remembered absolutely nothing of the night before – just the vague impression of some faces at my table. My money was gone. From then on, I stayed at home, not venturing out in the evenings. I lived here, far away from my memories and my fellow countrymen. My wounded arm pained me less and less with each passing day, though I was constantly tormented by memories from the time of my accident, and a kind of suppressed anger was boiling inside me. I could avoid alcohol here.

(How it could have happened)

I thought myself to be cured, and joined my family at various gatherings. I met my old acquaintances, and everything was fine until the time came for me to make a journey to the countryside, and take leave of the E. family. From that moment onwards, I felt extremely apathetic, and I also felt the need to fortify myself. I drank quite a lot of wine and walked the streets of the city, killing time until the train was due to leave. I sauntered through the streets in a pleasant daze – I have always enjoyed wandering the streets – especially the streets of foreign cities. All the new faces – all those strangers – and I was one of them.

I wandered further and further, allowing myself to absorb new impressions. I had been in quite a hectic state for half the summer. The evening before I had been in a strange mood – it could be described as being somewhere between apathy and provocation – and my acquaintances had noticed this. They thought I was drunk. I had tried to explain that when I was asleep, my soul and my body parted company, and that my soul wandered over the roof and chimneys of the house. I had explained this condition as representing my mood swings, which moved between supreme ecstasy and utter despondency. I made a

drawing to illustrate the different mood swings in my life – from minus to plus.

ELGERSBURG, NOVEMBER 1905

I feel fairly content with my lonely situation, here in the middle of Thüringerwald. Occasionally I chat with some of the country people.

I was reading *Die Fröliche Wissenschaft* by Nietzsche recently, and the following passage struck me:

When misfortune occurs – some people hoist all the sails. They can be called those with a heroic nature. Others yield to the experience, and are marked by it. They can be called profiteers (roughly speaking).

I had to think about how I had been affected by my own misfortune, and I wondered about this written passage. In the beginning I was fairly indifferent and lethargic – almost cheerful.

Admittedly, at that time I didn't know the extent of my injuries. I was not aware of the insults I would have to suffer – and the long, painful consequences. It could be equated with the following:

When one suffers a sudden massive wound, the blood vessels immediately contract, to stop the blood from running out.

Later, once I had become aware of the amount of damage sustained – I hoisted my sails. Like the deer that rises up on its back legs after sustaining a mortal wound. Hoisting all my sails, and running before the wind in false sunshine, took its toll upon my nerves – and the reaction came.

I had to smile when I read – in the same book: If you seek repose in the arms of a woman – you will be shamefully deceived.

I thought back to my own feelings when I had approached a woman. I thought she would be able to provide me with a kind of calm in the midst of my stormy battles.

N 546

During the winter of 1904–1905, in Germany, I was tormented constantly by a nervous condition,

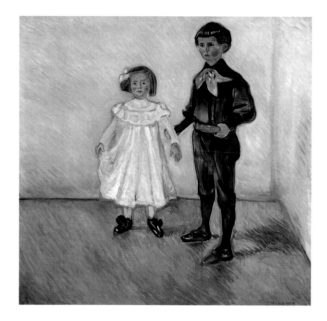

brought about by the continual persecution of myself and my art. Towards the spring, these attacks became acute. I journeyed back to Aasgaardstrand, where I resided for half a year. That autumn I received an important commission from Herbert Esche – the factory owner from Chemnitz. I travelled there, and painted my well-known painting of Herbert Esche's children. Whilst I was there, I met Van de Velde, who had just completed his finest building – Esche's new house. A little over a year earlier, we had been together in Weimar. I was the guest of Count Kessler, and we were part of a circle of acquaintances that met at the Nietzsche archive and enjoyed Mrs. Elisabeth Førster-Nietzsche's great hospitality.

My illness became worse and worse. He tried fruitlessly to find me a bed at the sanatoriums in Køsen, Elgsburg and the seaside town of Wärnemunde, where I had painted men bathing.

Finally I suffered a serious breakdown, and was admitted to Jacobsen's Clinic in Copenhagen in 1907–1908.

My only solace during this time was the fact that my capacity for work seemed to be unaffected. I told this to Professor Jacobsen, when I painted his portrait just after being confined to bed for one month. I have been faithful to the goddess of art, and now she is being faithful in return.

T 2787
15 FEBRUARY 1929

I'm considering collecting all these diary notes.

They are partly true experiences, and partly products of my imagination. My intention is not simply to note down my experiences. I wish to seek out the hidden meanings and draw out the forces that lie behind them – re-write them – intensify them, in order to clarify the energies at work in the machinery called human life, and examine it in conflict with other humans.

By collecting these thoughts, I hope to explain something of my present state of mind.

How difficult it is to discover what is not genuine. What is hidden illusion – self-delusion – or fear of showing oneself in one's true colours. And often one treats oneself unjustly. Sometimes I have forgotten the original circumstances surrounding the event, and make it appear to be more innocent than it actually was.

During the last year and a half, I have taken to reading Kierkegaard occasionally. It is strange how, in some way, one seems to have experienced things – in another life – and so I should like to draw a parallel between his life and mine.

As I now gather these notes together – I must take care not to be too strongly influenced by Kierkegaard.

I am quite sure that the following notes are from the time I returned from the Clinic in Copenhagen – that is, 1908–1909.

The influence of alcohol was responsible for the split persona of my mind and soul. They were torn apart, like two wild birds who are tied together, struggling to free themselves, each in its own direction. Their movements threaten to break apart their bonds, or tear them to pieces.

ERDMUTE AND HANS HERBERT ESCHE
1905, oil on canvas, 147 x 153 cm
Private collection, Switzerland

T 2734

THE MAD POET'S DIARY

Records I have made, or notes I have received from a dear friend, who slowly but surely became completely insane. I made his acquaintance at the Clinic in Copenhagen in 1908.

I add a number of my own notes. These consist of important moments and philosophical thoughts, including thoughts about my paintings.

I have tried to gather together all the notes I have made and those received from my mad friend, for in some way they complement each other. My friend has written a great deal which I believe he planned as novels or short stories.

There is his first love – Mrs Heiberg and Brandt – an unrequited love. Then many years later a woman who loves him. He is pursued by her and his own conscience, whilst the memory of his first love penetrates him like a dark shadow. He tries in every way to dissuade the woman who loves him. He explains to her how impossible it is for him to love. He explains that the curse of his inherited sickness, which has physically and spiritually afflicted both himself and his family, has convinced him that he has a holy duty not to marry or have children.

He makes himself quite impossible in every way, acts brutally, gets drunk. Nothing helps. Finally, in a kind of unconscious other-worldly state, he shoots himself in her presence. The shot wounds his arm, and renders him a cripple.

The damage to his arm is a constant reminder, and finally drives him to madness.

These notes, in their present form, are not suitable for the public.

Many of the notes made by my insane friend are "mad", and are interesting because they shed light upon his condition. As with Leonardo's anatomic drawings, we are discussing the anatomy of the soul, the mechanisms of the soul.

When I write down these notes accompanied by drawings, it is not in order to describe my own life. It is important for me to study the various inherited phenomena that form the life and destiny of a human being, especially the most common forms of madness.

I am making a study of the soul, as I can observe myself closely and use myself as an anatomical testing-ground for this soul study. The main thing is to make an art work and a soul study, so I have changed and exaggerated, and have used others for these studies. It would therefore be wrong to look upon these notes as confessions. I have chosen – in accordance with Søren Kierkegaard – to split the work into two parts – the painter, and his distraught friend, the poet.

Just as Leonardo da Vinci studied the recesses of the human body and dissected cadavers, I try to dissect souls. He was forced to note his findings in mirror writing, as at that time it was forbidden to dissect human bodies. Now it seems that the dissection of phenomena pertaining to the soul is viewed similarly, as disgusting, frivolous and indecent.

In my opinion, since this is in some way a work of science, it should not necessarily be seen and read by all and sundry. Specific details, for instance the mother and foetus, which describe in words and drawings the most important moment in human life, or one of the most important – birth – conception and death. Conception, in the same way as birth and death, should be framed by an altar, but if misunderstood it may appear to be in poor taste.

When I look over my notes, many of them seem to be rather naive, and I notice a tendency to complain about my own cruel fate that seems unmanly. I probably wrote it to console myself... I still do not know how I shall include this, though it does seem to belong in some way. Of course, since this is supposed to be art, it will need to be pruned, and chance melancholy episodes removed.

All in all, one could say that I am a sceptic, but not a disbeliever, and I do not deride religion.

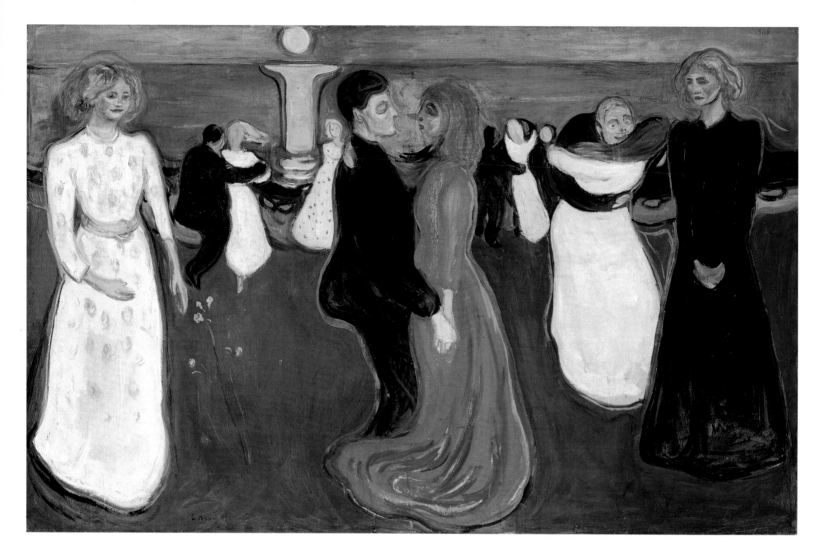

There has been a deterioration of the overly pious spirit that used to rule (it was on the brink of death when I came into the world, and had to be re-christened).

In addition, the death of my mother when I was five years old, and the constant threat of tuberculosis that was present in our home, gave me the feeling that I was cursed with a congenitally cruel destiny. At the same time, my grandfather died of spinal tuberculosis. I inherited a nervousness bordering upon madness.

T 2800

I began a new painting: *The Dance of Life*.

In the middle of a meadow on a light summer's night, a young priest is dancing with a woman whose hair is loose and wild. They are looking into one another's eyes, and her hair encircles his head.

Behind them, a wild mass of people are whirling. Fat men biting the necks of women, caricatures, and strong men locked in the embrace of women. To the left, a woman in a flower-patterned dress stretches out to pick a flower.

THE DANCE OF LIFE
1899–1900, oil on canvas, 125 x 191 cm
Nasjonalgalleriet

Brandt was frustrated. If only he could sell the large painting to the gallery. For years he had wasted his energy on the streets and cafés, he had been unable to work properly, been unable to paint as he really wanted.

The great frieze – *The Frieze of Life* – that he had begun years ago, which was to depict the circle of life. The awakening of love, the dance of life, love at its peak, the fading of love, and finally death. He squandered his strength by trying to find the money to buy food and paints.

During the course of the day, Brandt ran into his friends – first one, then another. He took a glass with them all. By twelve o'clock he was intoxicated, and sat with yet another glass of whisky, until the bar closed, when he went home and lay upon his mattress.

After a little while he was woken up.

Hauge stands smiling in the doorway, intoxicated by wine. "Excuse me, I expect I'm disturbing you, but here I am with some friends."

He had ascended the main stairs, and had to pass through my room to reach his.

"Be my guest," I replied, and with Hauge in front, a number of men passed through my room. There were about 30 of them.

I left my bed, and went over to Hauge.

"Perhaps I should explain – the Society of Postmen has been having a party. I have invited them here."

Glass in hand, Hauge launched into a long speech.

I finally went to bed, dead tired and dead drunk, as the dawn was breaking. When I awoke, the air was sickening.

I talked to Miss L. about free love.

"Why shouldn't two adults make love with one another?" I said.

"Yes, why not?" she replied.

I thought I might even kiss her.

She stood stiff and silent.

And so I retreated to the side room, and sat down on the mattress. She followed me, and looked into my eyes. She had small, brown, quite beady eyes.

"Now I'm going to do something strange," she said.

She stroked my forehead with her hands.

"What are you doing?" I said. "Are you hypnotising me?"

Shortly afterwards she stood at the studio door. Long, thin face and beady eyes, surrounded by a halo of golden hair. A strange smile hovered upon her tightly drawn lips. Something like the head of a Madonna.

I was gripped by a strange, inexplicable feeling of fear.

A shudder.

Then she disappeared, and I began painting *The Dance of Life*.

That evening I dreamed I was kissing a cadaver, and jumped up in fear. I had kissed the pale, smiling lips of a cadaver – a cold, clammy kiss. And it was the face of Miss L.

One day I said to Miss L., "What should a poor man do when he cannot have the love of his life, and cannot marry? Firstly, marriage hinders art, and secondly, he who has been burned by love, cannot love again."

I stood in the hall, and as she descended the stairs I said, "I almost kissed you."

She stopped.

"Well then, try again tomorrow," she said.

The next day I painted her without talking. The painting began to bore me, and I wanted to finish everything. She really made very little impression upon me.

I wrote to her that same day. Miss! I want to thank you for modelling for me. The painting is almost finished. I shall write to you when it is nearing completion.

I did not intend to write, and she soon left my thoughts entirely.

Things carried on as before. But my weakness returned. The attacks were worst in the mornings,

Tulla Larsen and Munch, ca. 1899.

and I carried on hoping that my paintings would be sold.

Finally, I heard that I might expect a sale.

Down to Paris, finish my frieze. Back to my good friends in Paris, visit the usual places, and of course buy a round of drinks for my friends.

The drinks became stronger. The attacks shook me more often than ever. Occasionally I had a really bad attack. Occasionally I ended up in a fight with someone or other.

When the money was paid out to me, I wanted to travel to Paris.

During the mornings I painted *The Dance of Life*.

I spent most of my time on decorative paintings; I wanted to describe something that lay close to my heart.

To copy nature. We couldn't touch nature anyway, so perhaps it was better to express one's feelings. How could one copy in a naturalistic manner, sobs and tears as they really were when one was completely dissolved by them. Like the woman I saw at the Hospital for Venereal Diseases, with the pale, wan, naked child in her arms. She who had just learned that her child was doomed from birth.

That distorted face. Swollen lips, carmine-red, swollen cheeks. Eyes like slits, streaming with tears, and a purple nose.

That face, distorted by despair, had to be painted just as I saw it at that very moment in time, against the green wall of the hospital. And the questioning, suffering eyes of the child had to be painted just as they were, staring out of the child's sallow body, as pale as the white sheet it lay upon.

I had to renounce many things. The truth of the composition, and the correct play of light.

Large areas of the painting were poster-like, wide and empty. But the most finely painted areas, which were meant to express the pain and the meaning behind the painting, I hoped were imbued with a sense of the sublime.

And now the public:

Everyone laughed at the painting. They found it corrupt and immoral, and I should be stoned and made an object of ridicule.

I knew that the accusations of immorality would torment me, even though I felt them to be unjust, and that the painting was quite the opposite of immoral. The stamp of the criminal would be marked upon my forehead.

I took my hat, and was about to leave for my usual stroll. On the stairs I meet Miss L. rushing up.

"Oh, hello. I was coming to ask you to come on a trip to Holmenkollen. Several of your friends are coming," she says breathlessly.

"Yes, thank you, I will come," I reply, and say goodbye to her. I have not seen, or thought about her for 14 days.

Yes, he is shortly expecting money from the

gallery, and would then be leaving. A little company might be pleasant in the meantime.

There was a large company gathered in the dining room at Holmenkollen. I sat beside Miss L., with a young lady on my other side. I didn't like the fact that Miss L. had taken the place beside me without question. There were various friends there – some of mine and some of hers.

The impression she made upon me was no better than before. Her arms were too long, and made swooping movements. I preferred the little lady at my other side. We ate and drank, and my spirits rose.

Miss L. had placed Mr K. in a far corner. I knew very well that they been engaged for some time.

I didn't like this – was she trying to annoy him?

"Look at those two over there," says little Miss B. "They're happy now. Two years ago she was married to another, but he had tuberculosis. Whilst he is lying on his death bed, he notices that his wife is pregnant. A terrible pain grips him. He chases her away. She goes off to happiness, love and life in the arms of her lover, whilst he enters into a lonely battle with the kingdom of death.

"A year later, Mrs H. stands curling her blonde hair over a spirit lamp. The soul of the dead rises from the lamp. It explodes, and she stands in a sea of flames. The man rushes in, burning his hands. People rush to help. They are saved, but Mrs H's face is dreadfully burnt, and she is sent to hospital."

"Come, let's go out onto the veranda", says Miss L. "Please come too, Mrs H."

Outside, in the cool air, under the starry sky, each face had such a strange mystical expression, and each voice seemed to come from somewhere else.

"Please dance, Mrs H," says Miss L, and the fragile, little Mrs H. dances. Gracefully and lightly, the little round, smiling head tossing backwards and forwards.

"My goodness, if she doesn't dance the can-can like the Bullier dancers."

I was surprised, but she was beautiful, and graceful.

Champagne had made Brandt excited, and more wine was brought in.

"Can we go upstairs?" says Miss L.

We were in the Ladies' Changing Room.

"Isn't Mrs H. adorable?" says Miss L. "You wouldn't believe how pretty her underwear is. Would you like to see?"

"Come on, take off the top of your dress," says Miss L., unbuttoning the plump little lady. Her plump, naked arms appeared, and her golden bosom lay there, hidden in the folds of her silk chemise.

I remained standing with Mrs H. on the dark stairs. We looked into one another's eyes. Her large, deep, shiny eyes came closer to my face. Our lips met in a long kiss. It lasted for ever and ever.

"You, you," we said, looking into each other's eyes again.

They had been waiting for us in the hall. The guests looked at us, but this lady and I were inexplicably drawn together, and we found ourselves sitting together in a sofa in one of the side rooms.

Miss L. comes and sits down on the other side of me.

I was intoxicated, and kissed Mrs H again. I look up, and meet Miss L's beady eyes. I surrender, and holding my hands around her waist, I place my lips upon hers. I felt two narrow, cold, clammy lips against mine.

The dream! It was the kiss of the cadaver from the other night.

Miss L., Mr and Mrs H. and Hauge – we drove together, into town. On Karl Johan Street Mr and Mrs H. said goodbye, and drove home.

We three were left, that late evening. We walked slowly down the street until we came to the Grand Hotel.

"Miss L.," I said, "I expect we should each go home. Shall I accompany you to your door?"

She stood without moving. I tried to move off, but she remained standing there.

"Shall we take a room at the Grand, and carry on talking?" asked Hauge.

"Yes, let's do that," said Miss L.

So we sat together in that little room until dawn broke, and before we left, I kissed Miss L. The next day, however, my thoughts were of Mrs H. I met Miss L. the following day at the Grand Hotel dining room, together with Mr and Mrs H. When evening came, Mr and Mrs H. went home, and I accompanied Miss L. to her house. We kissed one another farewell at her gate.

Miss L. and I sat together at the Grand.

"If like me, one is unable to really love for life, or is unable to marry – for I have seen too much, right from the beginning of my dark childhood – then all the more reason to allow one another, as friends, to enjoy some of the strange mysteries life has to offer."

"Yes," she says. "But what about the dangers, sicknesses and other things?"

"Yes," I reply. "One should be able to avoid all of that, as friends."

One brilliantly sunny morning, Miss L. and I are sitting at a café. The twittering of birds is in the air. The magpies chasing one another in the blue sky. People were on their way to work.

We had lain all night in one another's arms, and had belonged to one another all through the night. We each avoided the other's gaze.

Two strangers.

I hadn't seen Hauge lately.

At night I heard him mounting the stairs with different women.

My attacks had returned with a vengeance. I had to drink large amounts in order to keep on my feet.

One day I caught a chill, was running a fever, and had to take a room at a hotel. I had contracted pneumonia. I lay in the little hotel room with a high fever. Occasionally Miss L. came to visit me.

I have been ill for three days when J.M. comes to take a look at me.

"You need a doctor. I shall call Koren."

Koren was the doctor who attended the Bohemians. He did not charge for his services. He was a tall, red-nosed man who was a little religious and an opponent of the use of alcohol.

"Yes, you must take medicine to lower the fever, and a sleeping draught. You have a very high fever. You have pneumonia."

A little later, Miss L. came up.

"Now I have medicine and a sleeping draught," I tell her. "I shall sleep until morning, which is sure to help." After a while she says goodnight and leaves. I fall asleep.

Suddenly I am woken up.

Someone is knocking at the door. In comes a smiling Miss L., her hair flowing loosely. She is accompanied by my friend Skredsvig, the painter.

"What time is it?" I ask.

"12".

"Well then, I have slept for a couple of hours," I say.

"Let's have some Champagne," I say.

The Champagne cork popped.

"Do sing, Skredsvig," says Miss L., and Skredsvig sang.

"Look at this," says Skredsvig. "Miss L. has given me this pin."

The fever hammered at my temples. My eyes burned and stung with the heat. My cheeks glowed like coals.

Miss L. knelt by the bed.

"My prince," she said, and leant her flowing golden locks upon my bed. "You are so handsome with a fever.

"But now you should sleep," she said. "Goodbye, my prince."

The light was turned off. The fever burned in my veins. My heart began to hammer in my chest. I heard it beating louder and louder. I turned over, sat up in bed and peered into the darkness. Everything had become so quiet, apart from the wild beating of my heart. Tossing and turning in bed.

A terrible fear. Was it death? My ears were ringing. My feet were icy cold.

The next day the doctor was called. Terrible fever.

"You must be admitted to hospital."

Miss L. came to visit as I lay there the next day.

"I almost regret coming to visit you so late," she said.

"Yes," I replied, and looked at her. How strange, I thought. How droll she is. I expect it's love.

Only a few days ago I had followed her to her door. On the way there I had one of my attacks. Everything disappeared, I couldn't think, couldn't pull myself together. I staggered from side to side, expecting to fall over. Finally I managed to say to Miss L. "I think perhaps I better leave you, otherwise I may fall over."

"Yes, you do that then," she said. "I hate the sight of cadavers."

I was in bed for a long time. Miss L. visited me frequently. One day she told me an indecent story.

"I really don't understand how your mouth can utter those words," I said.

She gazed into space with a look of indifference.

I began to go out, but my strength took a long time returning. I visited the doctor, and asked him, "What is your opinion, it's taking me such a long time to recover, and I had thought of travelling to Paris."

"Well, yes, perhaps a more southerly climate would help," he said.

I had bronchitis.

I finally decided to travel, and said to Miss L., "I'm travelling to Paris."

"I had also thought of travelling," she said.

"Well, then, we have an agreement," I replied.

"I shall be travelling to Berlin first."

"Where do you lodge in Berlin?" she enquired.

"Hotel Janson."

"I shall leave tomorrow," she said.

"I shall leave in a few days," I replied.

I received the first letter from the Hotel Janson. She had taken a room there.

I received a letter from Hauge. He had been admitted to a clinic, and asked me to visit him there.

I visited him. "Well, now we're both sick," he said.

"I caught something nasty from a girl, and have been operated."

T 2789

With his arm in a sling, he travelled into town. His hand was giving him tremendous pain, and he had to drink Cognac to anaesthetize himself.

He was suddenly struck by the thought that she might commit suicide. He stopped in Drøbak, and wrote to Bødtker: Look for Miss L., and see that no harm comes to her.

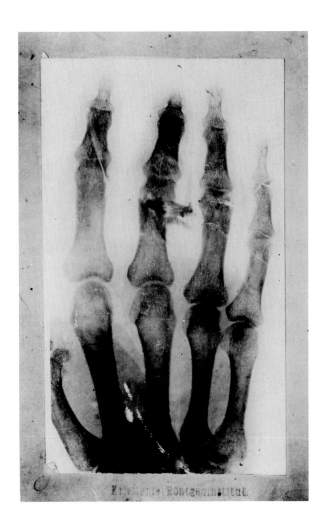

X-ray of Munch's hand after the shooting incident, 1902.

He was in hospital. The bullet had gone through two fingers, splintering them to pieces.

He lay in the large open ward, as he had no money to pay for better care. Actually, he preferred having the company of others. The patients lay in two long rows in the large ward, bed after bed. Iron beds with yellow blankets.

Beside him lay a man with a broken leg, and on the other side a patient with infected sores. On the opposite side was a farmer who had been operated many times for cancer. His face was waxy yellow behind his black beard and hair.

They talked to one another across the ward. There was a kind of gaiety amongst them, even those who were very sick. In the evening, patients from other wards came visiting.

A young boy came in to show off his newly-acquired wooden leg. He limped in on crutches. He and an elderly man from our ward practised walking. They laughed when things went wrong, and were very pleased with themselves when their efforts were successful. They looked so pathetic with their shoulders hunched up on their crutches.

"Come on, Kristian. Keep in time with the music," shouted one of the onlookers.

"I think we're in for a real dance this evening," said another. He had been in hospital for a year, after breaking all his bones in a fall from a mountain.

Raw laughter.

"No really, look at the old man, he's about to take off."

DEATH OF MARAT I
1907, oil on canvas, 150 x 200 cm
Munch Museum

The old man was doing his exercises. He was convinced that his blood would congeal if he lay still all day, so he was lifting both legs in the air.

"I must get the blood running," he said.

Raw laughter.

Then the nurses came in with their white aprons and headscarves. They walked between all these sick men in their quiet, pale manner.

A strange feeling of calm fell over him after the terrible attack of panic he had experienced.

My hand will heal, he thought, and it is nothing compared to the suffering of the others lying here.

He was waiting to be operated. The porter, a dark-haired, elderly man with a pale, unpleasant face, enters the ward.

Is it my turn, I thought, with a feeling of trepidation.

He passed me by, and went over to a man who was waiting to be operated for appendicitis. Without uttering a word, he pushes a trolley under the patient's bed, and continuing without a word, he pushes the man out of the ward and on to the operating table.

The patient's eyes gazed fearfully into space.

The next day it was his turn.

There he lay upon the table in the brightly lit room. The galleries on each side were filled with observers, just like a theatre. He recognized faces from the streets amongst the female and male students.

"Would you like chloroform?"

"No," he replied. "My heart condition will not permit it."

So he watched as all the preparations were made. The knives that were brought out, and the Professor's every move.

He felt the knife cut its way through his flesh, it scraped against his bones, and blood gushed forth. The bullet had exploded, leaving the bones in splintered pieces, which needed to be trimmed. Pieces of bone and lead were embedded in the flesh, and had to be removed.

The operation lasted a long time. He saw his fingers, hanging like a glove, swollen and bloody. The pain caused sweat to form on his brow, he wanted to scream, but the many eyes that were fixed upon him forced him to clench his jaws together instead.

His flesh was cut, trimmed, pierced, sewn, and his hand resembled a piece of chopped meat. After an hour and a half, the doctor announced, "Well, I hope that will do. The hand will not stand up to any more."

He was wheeled back. His working hand would heal, he hoped.

The days passed. He had a fever, and the pain in his mangled hand was unbearable. When the doctor made his rounds, he asked,

"Will my hand heal, will I be able to use it again?"

"Yes, we hope so," replied the doctor. The days passed.

The sick were carried in, and those who had been involved in accidents. Everyone waited to be well again.

The man with the wooden leg was to be sent home. His wife collected him, and the other patients gathered around him to say goodbye.

His wife watched, looked at the wooden leg and saw the way he moved. How changed he is, thought the wife. He used to be so handsome, and look at him now, hopping around the floor with hunched-up shoulders.

"Things are progressing quite well," he said, but his vitality had disappeared.

They left.

The pale patients stood at the window, looking out. They saw how he gathered together his crutches and his legs with difficulty, stowing them in the carriage. He waved with one crutch, and off they drove.

If only we could leave soon, too – this was the expression on their faces. Then it was his turn to leave. He said goodbye to all those he had come to know so well. The farmer with the sallow, waxy face, who was continuously operated upon

– cut up, piece by piece. The old-timer, as he was called, with the blood circulation problem, proclaimed that the farmer would never leave the hospital. Neither would the boy with tuberculosis.

And so he was finally back in town, and able to meet friends. He drove up Karl Johan Street, in a very weak state.

In the distance, his eye caught sight of a couple. A red-haired woman and a young man, walking close together, Miss L. and Kavli!

A shock coursed through him. The blood rang in his ears, and the terrible suspicion was confirmed: everything was but a game!

His hand was still in bandages, and painful. How annoying it was not to be able to use his hand – but when the bandages were removed everything would improve – he would have to concentrate on his hand from morning to night – Miss L. and his terrible suspicion would have to take second place.

He ran into Kollman.

"I have good news for you. The money has come from Germany."

He was rich!

"Why didn't you listen to me," said Kollman. "That's the way they are, women. Both Gunnar Heiberg and Kavli are her lovers. She simply used you to inflict revenge upon them, to bring them to their knees, under the yoke. She did not enjoy happiness as long as they were happy."

"That's not possible," said Brandt. But when the pain in his hand became unbearable, he was seized by anger, and began to drink uncontrollably, downing glass after glass in order to calm himself and banish his worst fears.

His bandages were removed. He shuddered. A monstrosity – his once perfectly formed hand, in perfect working order, was now dreadfully deformed.

Deformed, disgusting and useless. He knocked it all the time, against furniture, on the tram. His once willing worker was no longer able to help him.

He drank huge quantities of wine in order to forget, to deaden the pain. But at night he awoke, and felt his hand. He lit the candle and stared at his poor, deformed limb.

He had offered his hand to a female thief, and she had bitten it off. Help! Help! she had cried, I am drowning. Yet she had run away, and it was he who had drowned, betrayed by all his friends, for the sake of money. A travel agreement. That was all.

He avoided people. Refused to eat together with anyone. Everybody stared at him, at his deformed hand. He noticed that those he shared a table with were disgusted by the sight of his monstrosity.

"Your destruction saved her," said Kollman secretively. "She put out your fire, and her flame burned more strongly." The vampire. He was revolted.

His thoughts stormed in his head from morning to night. He whispered her name in hate, he clenched his fist at her, and the alcohol made him sick.

One evening, in a restaurant, he sits drunkenly, filled with rage. He notices that people are looking at him. He comes to his senses, and remembers vaguely that he has shaken his fist in the air.

He began to wander the streets helplessly, aimlessly walking around town, here, there and everywhere. One day he sees a carriage driving down Karl Johan Street. He hides in an alley. Her sees Miss L. and Kavli, and in the back seat Bødtker with Mr and Mrs Heiberg.

They are about to leave. He follows them.

They have stopped down at the harbour. The big steamship for France lies at anchor, blowing smoke from its big funnels. Happy travellers fill the decks, gazing at the horizon, and taking leave of their friends.

There is Miss L, glowing, in a new flowery hat, surrounded by a golden halo of auburn hair. Her red lips are smiling. She is smiling at Kavli, whose arm she is holding, and she is smiling at little, plump Gunnar H., who is telling a joke. Then he heard B.'s barking voice. Yapping, ribald laughter,

and Gunnar H. places his arm around the waist of his little, pink, blonde wife.

Then everybody went aboard. The steamship sounded its departure. Miss L. and Kavli were married.

Brandt sat in the big restaurant, emptying bottle after bottle. He held his deformed hand in the air.

"Bastards," he said, and everyone was upon him. The restaurateur pulled him up and threw him out. He stumbled, and fell on top of his damaged hand. He was unable to rise. Blood streamed from his hand.

He had broken his arm.

T 2776

When I recall the impressions that remain of those first few days, I must think of the disgusting things. The dance with Skredsvig while I lay burning with fever in the middle of the night – the constant cold remarks about my illness. The comparison between her and my sister – when I was embarrassed to hear the words she used – and the indecent jokes.

I had fallen from the roof. The sleep-walker was broken to pieces, and lay crushed in the street. I awoke and walked amongst people with wounds upon my soul.

The chestnut trees were in bloom, deep, green, dense greenery against the sky, the white and red chestnut blooms sprouted heavenwards. In the sultry air, the sounds of voices and noise could be heard – the birds mated and hid themselves amongst the dim shadows. People crossing one another's paths and meeting on the street.

Couples – men and women, holding one another close, parading their love in the spring air.

My blood, the blood of a mature man, pulsed steadily, engorging my veins.

My body wished and desired, but had no goal.

My arm caused me pain, and the pain burrowed its way like a sharp arrow into my flesh, it chased my blood in hate to the narrowest veins. I clenched my fist in rage against those

who had stolen the last remnants of my peace.

I wanted to unfold and develop, just like other people, like the flowers and the birds. I wanted to procreate, to be part of nature's great working plan.

The current had carried me away, it had tossed me down the rapids, and I was being crushed and pummelled by the foaming waterfall.

During these spring days, hate was born in my soul.

And so it would be!

If feelings of compassion were a weakness, was I then not worthy to be on this earth, for I had not witnessed her suffering?

She was in Paris, where she had travelled together with another, something I had not

THE PRIEST BY THE CORPSE
1908–09, drawing, 650 x 476 mm
Munch Museum

thought possible. An acquaintance came to my table and said, "Poor thing, she is having a hard time."

I was still filled with anguish about the last time I had seen her, and I replied:

"Is she?" and questioned him about her. Was she not together with another?

"She speaks of you all the time," he said.

Somebody else told me that there was reason to believe that she was involved in a love affair, and I clenched my jaws in anger.

I had sacrificed myself needlessly for a whore.

Compassion. Isn't the whole world built upon the concept of battle? All of nature is in battle.

Compassion is simply sluggishness, which hinders both battle and energy.

If this was hell, then I was already in the midst of it. Here they were, all together, all these so-called friends who had helped her in her conquest so that I should be trampled underfoot. I was forced to see them every day.

The blood pounded in my veins. I emptied glass after glass. I drank myself into the heart of revenge, and I could imagine myself creeping to her with my damaged arm outstretched, knocking on her door, kissing her feet and saying: "Here, I am yours, you have won, I will place myself under the yoke yet again in order to hear you say you believe in me, that you love me as before." Then she says coldly, "Well, now it's too late, I don't believe in you." Then I would lick the dust from the places she had stood, wet her feet with my tears, whilst she moved slowly and smiled a little superciliously. She would say, "We shall see," and offer me her hand with a smile. Then I would take my clenched fist and punch her face. But no, I knew I would never be able to do it, I knew, I knew my knees would buckle, and my fingers would be paralysed by rage at the sight of her. The middle-class girl and the knight.

I drank and drank.

They are dogs. A pack of dogs, paid dogs who have betrayed me.

I sensed the secret pleasure that these people shared. I knew they talked of the woman's conquest. I knew that she, smilingly, placed a new feather in her hat.

She had become quiet, a graceful calm enveloped her. She held her head bowed, and a sweet smile lit up her face.

How sweet she was, how could I not love her? said everybody.

A Madonna.

There they went, two young people enjoying the springtime.

The way she treated me had changed.

She was indulgent.

He had really been very pleasant, even telling amusing stories.

Then she asked why he didn't come and visit her.

What about the other?

Well, they were simply together. He was so kind.

Me. Regarding my work, my art, that I had sacrificed for the sake of happiness, or what one generally calls happiness = comfort, a wife, children.

What is art, really? The outcome of dissatisfaction with life, the point of impact for life's creative force, the continual movement of life, crystallization.

Every movement needs a form, a human being is a crystal, its genius is taken for granted – its soul. An ordinary crystal has its genius, its soul.

I had a dream.

A black Negro stood beside a friend's coffin, and ringing a bell, he passed into the land of crystals.

Death is the entrance to life. Death is the transition to new crystallization.

Everything is alive, and is moving from the mass of the earth towards the atoms of the air. Everything wishes to live, and the more that are destroyed, the more will survive.

Her happiness was therefore dependent upon my destruction, and I lay there bleeding in my room.

I have been hunted like prey, hounded between these people, and now finally she has attained peace in her soul, and is able to enjoy life.

I continue to moon around, full of desire in the dizzying spring air, drunk. A thousand sprouting lives.

Was this to be my lot in life, glimpsing the Promised Land?

All the friends that had previously taken me by surprise now reproached me for my callousness, reproached me for understanding entirely what this woman wanted, and would come to mean to me.

They came to me one by one and said, "Yes, the woman remains sovereign. The good thing about her is that she does as she pleases. A man is spellbound." Previously they had insulted me for being free.

Woman has no sense of shame or responsibility. Like a child, she is under the protection of God, and has no sense of remorse.

Man is doomed to lose, for man is incapable of understanding how low a woman will stoop, and what underhanded means she will employ, for that is the way she is.

Time passed, and clarity came little by little. Like a book, I had first read the title, then the ending, and finally started to look through it page by page, and began to understand.

My friends had caught me off guard, and after the toughest resistance, I was outwitted.

What this stage production so excellently brought into focus (playacting, the suicide story) was the fact that it was engineered by her. Her lover was already then her lover, the trip to Paris already arranged. She had insured herself against every eventuality by engineering the Honeymoon, with all its pleasures.

She was quite sure she could offer me everything.

We hadn't seen one another for two years.

I was working, had begun to live again and was contented. She could not endure this fact. I was simply a stone in the path of her happiness. This thought was impossible for the spoiled girl to understand.

One evening I met a woman on the street. I was attracted by her eyes – they were like the large eyes of a child.

I looked at her, and she turned round – and we continued walking together. I asked her to come back home with me. Back in my room, I noticed that she was quite shabbily dressed, that there was a look of depravity about her – but that she had beautiful, childlike eyes.

"Why did you come back with me?" I asked.

"That's why I walk the streets – it's my job," she replied.

"Are you registered?"

"Yes – you have to be."

"How old are you ?"

"19 years old."

"And do you go with any man?"

"Yes – I was walking together with a girl friend one day, and met a rich man – that's how I began.

"And now – I can do nothing about my situation. My landlady demands money – nobody in the world cares about me. Today I thought about throwing myself into the river."

I looked at her – and still thought of her – as a plump, hardened whore.

Those who already have, shall receive more. Those who have almost nothing shall lose even the little they have.

The strong shall conquer.

But why should the rich woman be the strong one? I was poor, and weakened by the exertions of my body and my mind. She was made strong by her prosperity and her life of leisure – she was strong then. But now my soul has become stronger – stronger than that thoughtless middle-class woman.

Three terrible years had gone by. New life – new hate. The large, completed *Frieze* was hanging at the Berlin Exhibition.

After three years of ill health he began to live again.

The Way of the Law was being exhibited in Berlin.

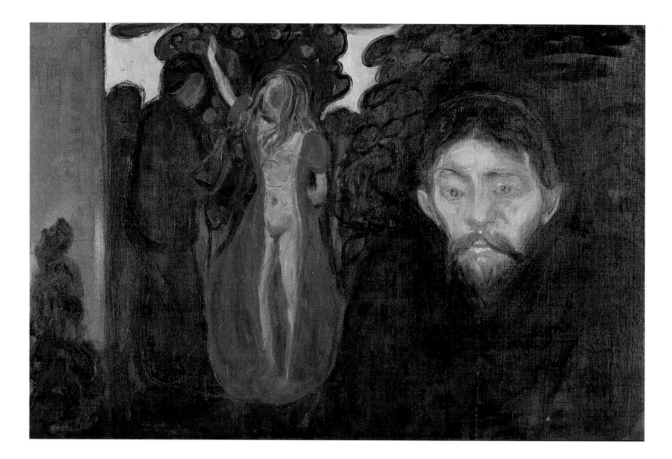

All the paintings were being exhibited in the entrance hall to the Secession.

Man and woman are attracted to one another. The subterranean cable fed their nerves with electricity. The cables united their hearts.

These are my words.

All the paintings were there – *The Kiss* – *Vampire* – *Envy*.

The big painting I did last summer was hanging in the middle of the room. I danced with my first love – this painting was based upon those memories.

The smiling blonde woman enters – she wants to pick the flower of love – but it escapes her grasp.

On the other side of the painting she appears dressed in black mourning clothes, looking at a dancing couple – she is an outcast – just like me. Rejected from the dance. Behind her, the dancing mob moves like a storm in one another's arms.

And so to *The Scream...*

It ends with the image of death – the eternal background to *The Dance of Life*.

I travelled back home to my garden. New hope had awakened in me – renewed energy. I looked around my little garden – saw the sprouting greenery – my flowers – my birds – my animals and my sky.

I had almost become accustomed to not thinking about Miss L. – One-and-a-half years had passed since I had left her.

I had heard that she had lived life to the full in Munich, and she had met Gunnar H. once again – and that she had been sharing his bed for the last six months.

You could have saved yourself all that misery, he told himself. How easily she has allowed herself to be comforted.

JEALOUSY
1895, oil on canvas, 67 x 100 cm
Rasmus Meyer Collections

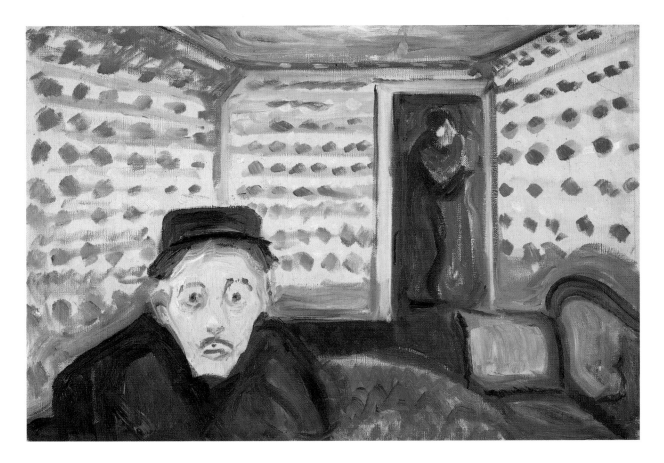

That winter, his old aunt had been terrified by the most terrible letters.

She was about to begin her fight for survival.

I was portrayed as a villain – a scoundrel.

A friend told him that she had been spreading unpleasant rumours about me in Munich. That I had lived on her money – that I had used up her money, and then left her, like a scoundrel.

I heard that she had written letters to my family – informing them that I had behaved like a scoundrel – a disgusting scoundrel, not worth spitting upon.

His three years were ruined. He had arrived, like a minstrel, at the rich woman's door.

"Open up your door," he had said. "You are lovely – I am tired and lovesick. May I help myself from your heavily-laden table of love?"

"Sit down minstrel," the rich woman had replied. "Of course – please take what you will from my table of love." And so he ate with all his heart. But the food was poisoned – and he was sharing a table with Death – Illness and Poison.

To think that you ruined three years of your life for her.

He hardly left the garden.

Summer arrived – with all its strong colours. Bright green against bright blue – bright yellow against bright red.

The place was filling up with women from Oslo, dressed in their pale colours.

Tourists filled the streets – and the countryside, like big red, white and yellow flowers.

The fishermen and local people retired from the fray.

The golden white summer night cast its luminosity and pale obscurity over the gay colours.

JEALOUSY II
1907, oil on canvas, 57.5 x 84.6 cm
Munch Museum

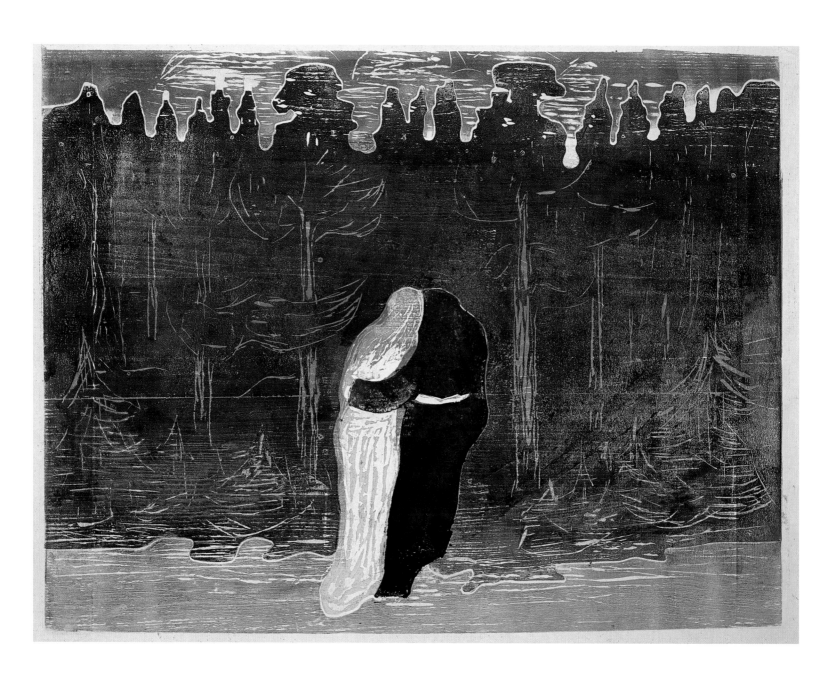

TOWARDS THE FOREST II
1915, woodcut, 50.4 x 64.7 cm
Munch Museum

The people walked in pairs – men, women and lovers. The women in their pale colours gathered in large groups – talking and joking – like a great bunch of flowers.

The men stood in ranks – they were dressed in black, or in darker colours – looking at the women as if they were about to mount an attack.

N 642

Time swept over the earth –
thousands of years passed and
pain was born – a little hope, a little smile
Voices and crying could be heard
And the smile disappeared!
And the sighs subsided and generations
trampled upon generations.

T 2783

The Present
Pain is born
A little hope
A little smile – and
the smile disappeared
The sighs
subsided
thousands of years passed
and generations trampled upon generations.

To a Woman
I am like a
sleepwalker that
wanders the ridges
of a roof – carefully.
I walk calmly
in my dreams
Don't call me
loudly or
I
shall lie broken
amongst the children
of the street.

T 2783

THE KISS

A warm rain was falling
I put my hand
around her waist. She walks
along slowly.
Two big eyes across from
mine. A wet
cheek against mine –
my lips
sank into hers.

The trees, the air and
the whole earth disappeared
and I looked into a new
World. I had never suspected
its existence.

Mankind, you are
great, because you have
the world within yourselves.
But you are
small because you
are a tiny bacteria working
upon the surface of the earth.

The crying of the woman
and the child
is like the cunning
enemy that strategically
retreats before
attacking without notice
to win new
ground.
Plants animals and
humans
Spring forth
from the scorched slime
of the earth.

The earth loved
the air. It
consumed the earth

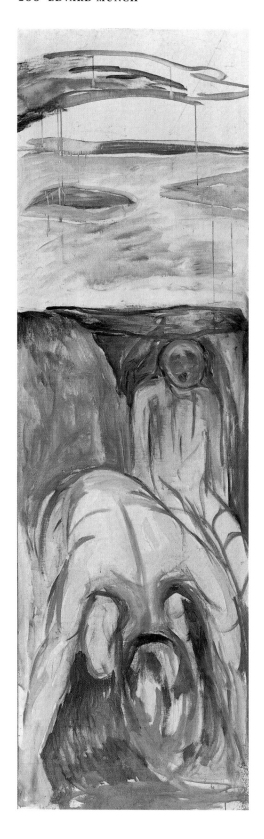

and earth became
air and air
became earth.
The trees stretched
their branches
heavenwards
past the choking atmosphere
of the air.
The trees loosened
themselves from the earth
and began to move.
They became mankind.

Everything is life
and movement
even in the slime
of the earth one can find
the spark of life –
the crystal.

T 2759

They sat in pairs on the stones that covered the beach. Beyond them lay the fjord veiled in blue, and long waves rolled across the stones before breaking. Out on the fjord, golden sailboats were moving slowly in the gentle breeze.

Both men and women were drinking to one another's health – they looked like gaily coloured flowers, and music and laughter could be heard in the background.

A golden moon hung above their heads.

A golden column rose from the water. It rocked in the waves. The local people carried on with their lives, whilst the visitors from the big town staged their lively events. They were like two currents running side by side.

I had been living a secluded life in my garden for some time, when the young painter C. came down.

"You must go out and see people. You live too quietly."

"It's really very lively here." He started to frequent the town's hotels and local club.

FRAGMENT OF WAR (THE STORM)
1919–27, oil on canvas, 205 x 61 cm
Munch Museum

MADONNA
1895, lithograph, 443 x 434 mm
Munch Museum

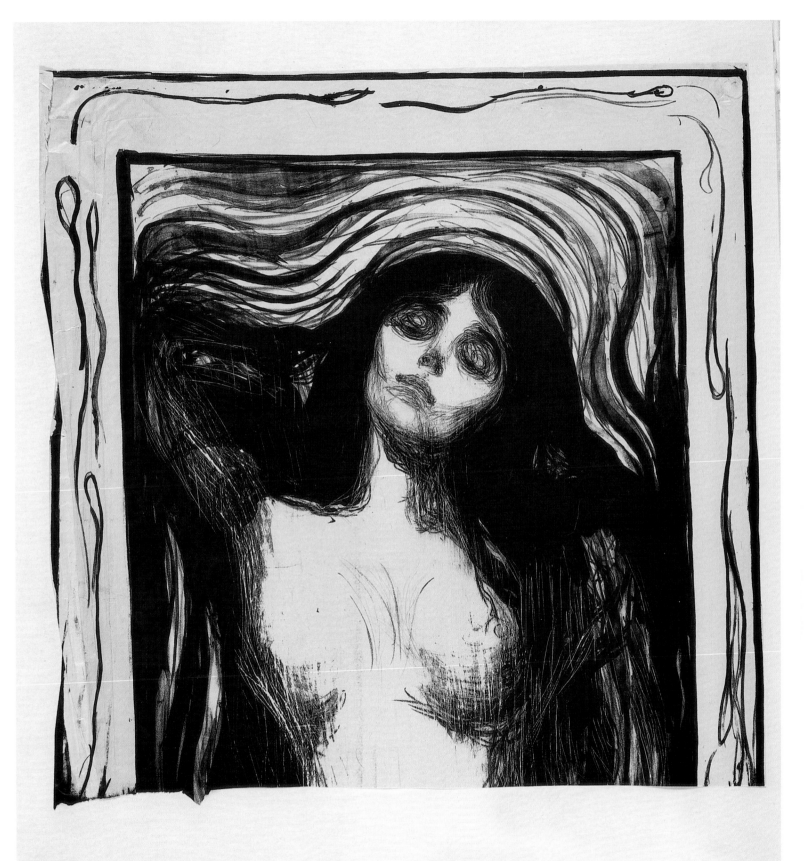

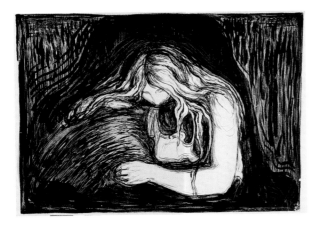

DECORATIVE SKETCH
1897/98, lithograph, 295 x 381 mm
Munch Museum

VAMPIRE
1895, lithograph, 386 x 553 mm
Munch Museum

Aasgaardstrand had been blessed with a new institution – a police officer.

The new man was a proud sight in his uniform.

He usually stood in the town square with his left arm bent at the elbow – looking like Napoleon III.

Occasionally he had a black eye.

I was involved in a small scuffle, he would say.

This meant that he had been intoxicated.

He also boasted of the heroic deeds he had accomplished as a policeman.

On Midsummer's Day I sat together with S. on the hotel's veranda, sipping a whisky and soda.

A white, dreamy veil seemed to settle over the town's simple white houses. It lay there by the pale violet water.

The chestnut trees were in full bloom.

In the morning I walked in the direction of the woods – I walked along the road with small, peaceful houses on each side – each with a garden of flowering cherry trees, flowers and plants.

I greeted all the sweet little children – their voices seemed like a refreshing drink to my parched and sickened soul. Their big eyes – reflected a beautiful world I had once been part of. Their graceful, coltish movements were a pleasure to the eye.

And the little girls – how they resembled grown women, and how the little boys resembled grown men. The little girls were shy and waggish – graceful and wily. The boys were awkward – with arrogant naivety and courage – they attempted to overturn the ruling laws of nature.

Then I came to the woods – the newly planted nursery trees – pale, green, young fir trees – like small church spires – the further into the wood one looked, the taller and more impressive they became – stretching up like enormous cathedral spires. Voice upon voice – column upon column – the birds provided the music.

My thoughts went back to one spring day last year, when I had been walking in this very place

with Miss L., who had been dressed in pale blue. Together with her, I had experienced nature as a festival of celebration. Until autumn arrived – colouring nature like a blood-stained scream. The memories churned round and round in my head – until finally I saw her as the black angel of my life. These thoughts cut me to the quick – remorse – despair – pity – suffering and hate.

And my thoughts see-sawed backwards and forwards, between self-recrimination and despairing hate. Had I led her into the fires of hell ?

Should I still feel guilty, even though our relationship had been based upon mutual consent ?

If I had not believed her to be serious, I would not have asked her to have patience – to wait until I had peace of mind and a stronger constitution.

Had she not danced upon my sickbed – thrown herself into the arms of both friends and enemies – poured scorn upon me, insulted me?

Christian Krohg used to be a stout fellow – somewhat of a dandy. He had turned into a slimy – soft-horned snail – carrying a brothel upon his back. They had watched without pity, whilst I had been tormented and tortured before her very eyes. My only aim and will had been to sacrifice everything for my work, for my art – and was it not her duty to sacrifice herself for the art of her beloved?

She and I were not born under the same conditions. I was born into a poor home – inheriting ill-health.

She was the spoiled youngest daughter of a rich family.

Health and vitality – she inherited both.

I inherited two of humanity's most dreaded enemies – consumption and mental illness.

Sickness, madness and death were the black angels that surrounded my crib.

My mother died prematurely – from her I inherited the seeds of consumption. My father was obsessively nervous and obsessively religious – to the point of madness. This had been the fate

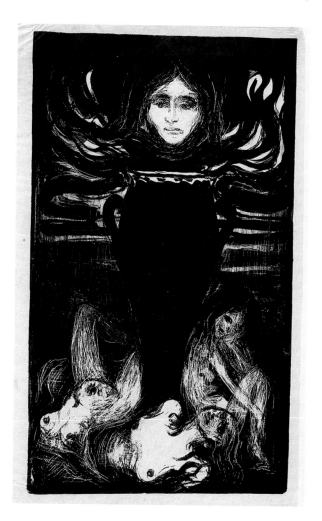

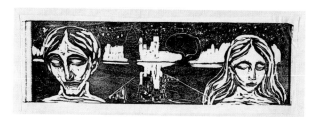

THE URN
1896, lithograph, 460 x 265 mm
Munch Museum

MAN AND WOMAN AGAINST A CITY LANDSCAPE
1898, woodcut, 152 x 498 mm
Munch Museum

of his family for generations. From him I inherited the seeds of madness.

The angels of fear – sorrow and death – had stood by my side since the day I was born. They followed me when I played – followed me everywhere. Followed me in the spring sun and the glory of summer.

They stood by my side at bedtime when I shut my eyes – they threatened me with death, hell and eternal damnation.

Often I awoke in the middle of the night – I gazed around the room in wild fear – was I in Hell?

Illness was a constant factor all through my childhood and youth. The tuberculosis bacteria turned my white handkerchief into its victorious, blood-red banner. The members of my dear family died, one after another.

I remember one Christmas Eve when I was 13 years old. I was lying in bed – blood trickling from my mouth – fever raging in my body – fear seething inside me.

I believed that the moment had come for me to be judged – and that I would be condemned to eternity.

He was saved – but his entire youth was worm-eaten. He was tormented by doubt – fear and illness.

He was almost alone in this life – his vitality was broken. He had accustomed himself to the idea that he was unsuited to marriage. That it would be wrong of him to start a family – his children would certainly inherit the same seeds of illness. Should they follow his footsteps and experience the same terrible childhood and youth?

What about his life as a painter? Art became his sole aim. He believed he might find a woman – outside the bonds of marriage – who might mean something to him. Free love was the hallmark of the Bohemian era. Inhibitions were overturned – even God was invalidated – everything whirled along in that wild Dance of Life – a blood-red sun hung in the sky. The cross was empty.

But I was unable to free myself from my fear of life – and my thoughts of eternal damnation.

I met a worldly-wise woman, and she was responsible for my baptism by fire. Through her I came to know the heated misfortunes of love – and for several years I was almost mad. That was when the fearful, grimacing mask of madness appeared.

You are acquainted with my painting *The Scream*? I was at the end of my tether – completely exhausted. Nature screamed through my veins – I was falling apart – then I met a blonde woman with a spring-like smile. She helped me. You have seen my paintings, and know about the things I experienced.

After that, I gave up all hope of ever loving.

Then I met another woman – rich – spoiled – full of life – without a care. I thought I recognised her. She used to run around the backyards of Homansbyen when she was a child. A scheming – nasty red-haired little girl. She was always playing the boys off against one another – pulling her girlfriends' hair. She had so many toys – which she always ripped to pieces.

She always screamed when she didn't get the doll she wanted – and broke it once she had it.

She came into money at the age of 15 – she started travelling, but continued her decadent life. She schemed, lied, cried when she didn't get the man-doll she wanted – and broke him once she had him.

If I had loved her, she would have discarded me. That's the impression I had of her – during the course of three years. She discarded things with ease. Accepting presents from rich people is double theft – first they steal the money, then buy hearts with it.

She gave away a great deal of money – in Berlin – Munich – and here. She had a retinue of friends – all ready to help her.

They became my executioners.

Her face told the whole story.

You know the painting – a woman – a blonde-haired, spring-like woman – *The Whore* and *Sorrow*.

SELF-PORTRAIT IN HELL
1903, oil on canvas, 82 x 65.5 cm
Munch Museum

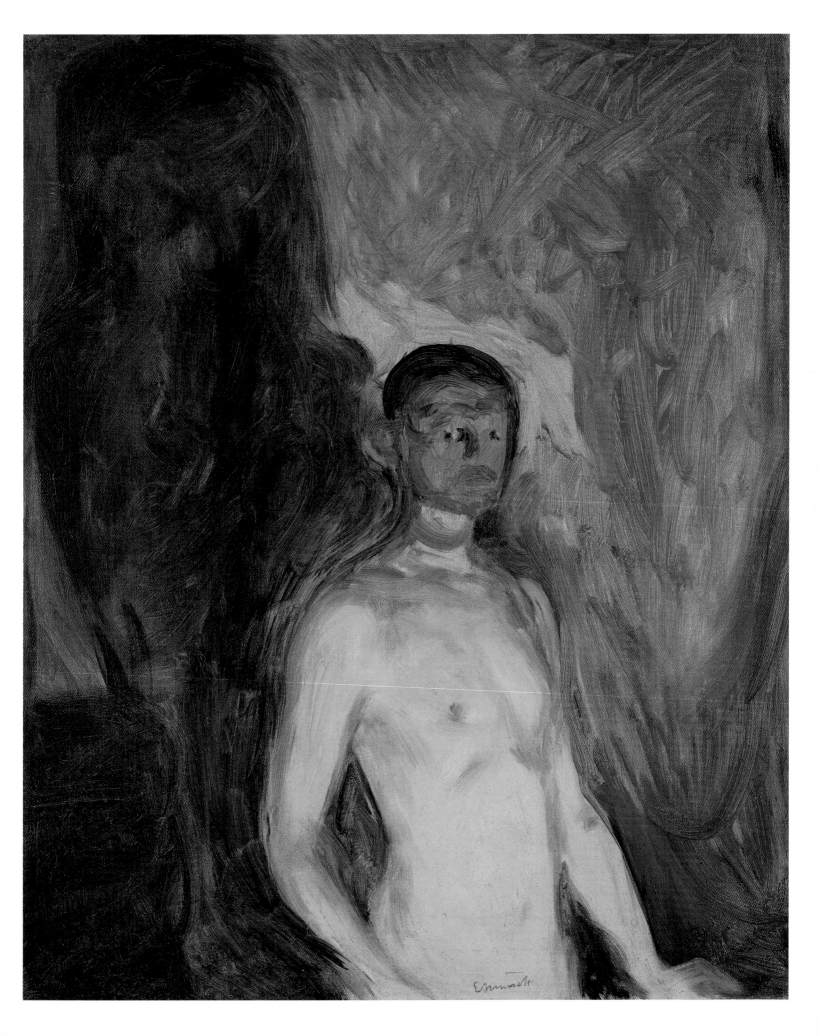

Her smile – it began as a seductive spring-like smile, evolving into a happy, maternal smile.

The smile of a mistress – a grimacing smile – the bloody smile of the mask. The actress in the theatre of life – and the face of night or sorrow has become the terrifying image of the head of the Medusa.

I was afraid of her face the first time I saw it.

But she knew how to use pity, tears and reproach, to keep me at heel.

It almost felt like a duty – allowing her to torture me – until the crisis had passed.

I wanted to help her conquer two dreadful demons – the obsession she had for me – and the consumption that threatened her. I became ill – and madness showed its ugly head again.

She was cured of her consumptive illness – and I had to believe that time would cure her other affliction.

I have come to the end of my tether. My bowstring cannot be tightened any more, do you hear? – it is your responsibility.

I didn't think it correct for me to marry. I promised to explain this, and she knew the conditions of our relationship.

It was late summer – the chestnuts were ripening on the trees. I had promised to come and talk to her. I dreaded this conversation – it was a threatening ghost – and he had waited and waited in order to prepare himself.

It was life and death now. Either or. Either she was transformed into a new person – or it was death.

A woman's smile – is threefold.

Spring, summer, winter.

As alluring as spring – sweetly scented and expectant – shy and gracefully seductive – like the song of the spring birds and the flowers of the meadow.

The full smile of summer – like the ripening fruit – the happy smile of a mother.

The winter smile – of sorrow – the smile of death – as serious and painful as a death potion – the consummation of life.

The caricature of the mistress. The eternal smile – the ever-alluring smile. The smile of seduction and victory. Victory over man. Which also resembles the smile of a Jew – a completed coup – a bloody smile.

The proud, happy smile of the mother disappears.

It is replaced by the smile of winter – that sorrowful, serious smile – the head of the Medusa with its dreadful, fateful smile – the smile of misfortune – of grief – the terrible grimace of evil.

THE POWER OF MONEY

That badly-behaved girl from Homansbyen had – since she was 15 years of age – been responsible for all kinds of intrigues in the backyards of her middle-class district. She came into money at the age of 15, and left her childhood behind her. At an early age, she learned to use her money to pursue her own intrigues.

She became accustomed to dispensing things, if it was to her advantage.

Nothing can be worse than receiving gifts from rich people – it is theft. The rich man is a thief twice over – in the first place he has stolen the money – in the second place he steals people's hearts by giving them gifts.

She was constantly dispensing gifts – at Christmas and Easter and on other days – presents and flowers – she had a whole contingent of friends who were bought off with trifles.

She always felt herself to be the injured party, because she was used to having the money to buy whatever she wanted.

She alone had the right to love – or kiss the man if she felt like it. When somebody kissed her, he became an object for her to use – if he was unwilling, he was a scoundrel who deserved punishment.

She quickly became bored with those who loved her – and she reserved the right to destroy those who did not love her. She used her money and her bodily charms to entice willing

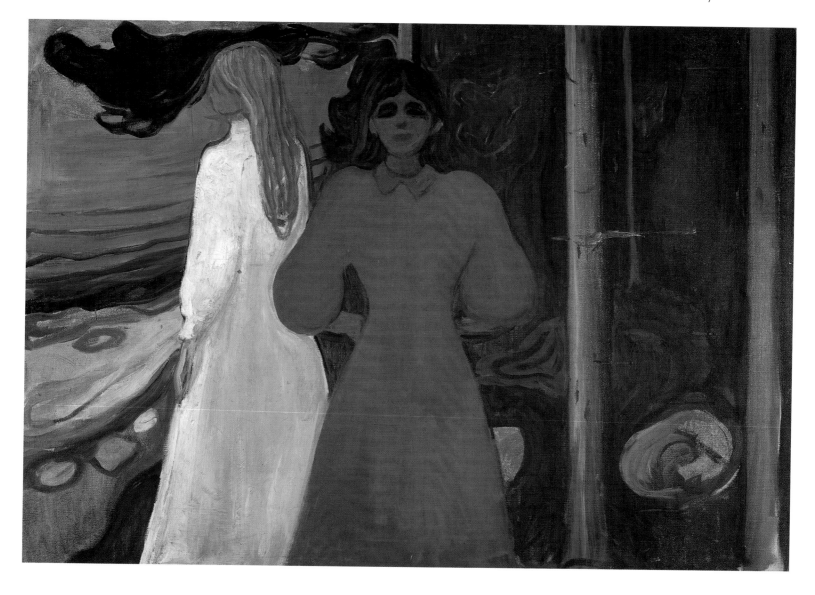

executioners to carry out her vindictive deeds.

And she knew her wicked deeds had no bounds – even if she had committed the most dreadful scandal – she assumed an angelic expression – the expression of a repentant woman – and meted out money with her cold hand.

After having destroyed a painter, who was known to be one of the best in the country – by using base intrigue – she knew exactly what to do. She married a painter of mediocre talent – and bought a few paintings here and there.

She became interesting – with her "tragic story" with that pathetic genius – and she became a crowned martyr – a generous patroness of the arts.

Man is by nature a dreamer. In his dreams, he gathers the strength to impregnate woman – who is always receptive to man's energy.

Man is the dreamer – the child and the god – and therefore also courageous.

Woman is of the earth – fearful, and always ready to be impregnated when man wishes.

RED AND WHITE
1894, oil on canvas, 93.5 x 129.5 cm
Munch Museum

Anxious for the impregnation to take place at the right time – and fearful for the growing seed. This is the reason for woman's countless lies and cunning moves.

The caricature of a man is the dreamer, walking over the rooftops, and falling when his name is called out loud. The caricature of a woman is the whore, trying day and night to outwit the man – bringing him tumbling down.

T 2776

I told her that ill health had stolen my youth and marked my view of life – that I was afraid of starting a family, etc.

Then I told her that I was more than well acquainted with the misfortunes of love.

What did she reply ?

Of course – you knew already – that I should be so easily manipulated – and my entire well-prepared speech vanished into thin air. The only thing I could think of was to say that we would speak no more of it – at which point she took to that dreadful sobbing again.

My nerves were in shreds, and the blood hammered at my temples in anger and despair – and compassion – alternately.

But had she ever felt pity, or seen how I suffered? Everyone else saw it.

N 131
REGARDING MY RELATIONSHIP WITH A WOMAN

I would like to offer the following explanation as an extension of my remarks about my relationship with this woman:

My grandmother, Mrs Bjølstad, died of tuberculosis – as did my mother and one of her sisters – Hansine. My mother's sister, who came to live with us after my mother died, suffered constant bronchitis, spitting of blood, and was generally in very poor health.

My sister Sofie died of tuberculosis. All we other children suffered from terrible colds and bronchitis throughout our entire childhood and youth.

From birth, and during much of my adulthood, I suffered from bronchitis with high blood pressure and raging rheumatic fevers – these illnesses put paid to any normal schooling.

My grandfather died from skeletal tuberculosis, and I believe this was responsible for my father's nervous condition, which we children, in turn, inherited from him.

It is my belief that my art is not sick, as Scharfenberg and many other incompetent individuals claim ... They know nothing of the essence of art, nor do they have any knowledge of art history.

When I transform sickness into a painting, like *The Sick Child*, it is on the contrary, a healthy expression. It represents my health. When I paint suffering, it is a healthy reaction to it – something others can learn from.

N 153
MY RELATIONSHIP WITH A WOMAN

Regarding my relationship with this woman, some of the expressions I used should perhaps be modified.

I have always put my art before anything else – and I often felt that this woman hindered my work.

Due to the seed of ill health that I inherited from my parents, I decided at an early age that I would not marry. I felt it would have been a crime to marry.

MODEL BY THE WICKER CHAIR
1919–21, oil on canvas, 122.5 x 100 cm
Munch Museum

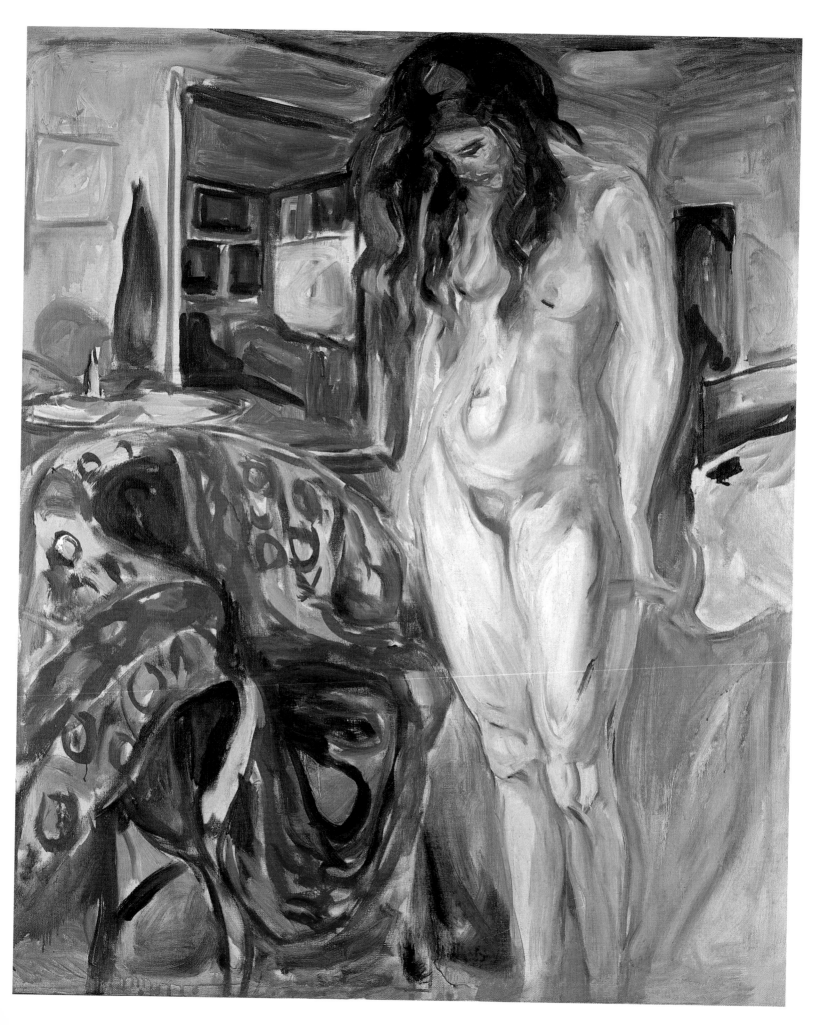

Photograph with drawing by Edvard Munch.

MY LIFE AS MUNCH

Munch was himself well aware of it: that he was Munch, but also that Munch, that was him. He was well aware that the role lies in wait of fate, that it is difficult to know what is staged and what is the simple life that is lived. That maybe the latter just cannot be found in the case of an artist such as Munch, who abolishes boundaries between himself and his works in order to be able to make the works definitively independent of him. It was not for nothing that he emphasized his enthusiasm for the equilibrist of the ego, Søren Kierkegaard. Munch is well aware of his somewhat ambiguous relationship to truth, and that fiction plays tricks with events. So much so that he therefore tried his hand at fiction based on the vicissitudes of life.

One has to say that in general his texts are not for those who stick by the rules. What is fact and what is fiction continues to be difficult to determine. Maybe the real point is that the sensitive character, Munch, appears precisely as exposed as he is through this lack of ability to discern. It controls him imperceptibly – and concretely: I becomes he, which then becomes I again. Munch stands in this grammatical maelstrom and alternates between the external and internal viewpoints. Neither of these positions is especially attractive.

His nervous breakdown and subsequent hospitalization in Copenhagen in 1908 is clearly dealt with, although well after the fact. Munch wrote a great deal in retrospect. It is the distance that impels his writing. This distance gives the writer shape, whereas the present dissolves. It invests his writing with a kind of authority, which nevertheless does not always avoid sounding hollow. Quite a lot of echo comes from Nietzsche's bombastic staging of himself – with the eternal questions from "Ecce Homo" as the most grandiose: why am I so wise, why am I so intelligent – in Munch's attempt to portray his own persecutions. There can hardly be any doubt that his isolation became the principal cause of his sporadic twisting of proportion. There was noone to correct him.

Fortunately, the pictures kept coming as the truest message of a constant self-correction. One senses that Munch has, in fact, no more to say. And this has to be shown, which is what he does. He shows what there is when there is no more to say.

BIOGRAPHY

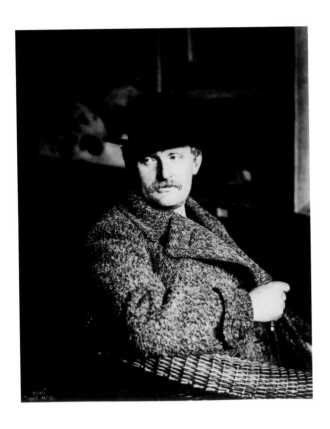

1863 Munch is born on 12 December, son of military doctor Christian Munch and Laura Cathrine Munch. There are four other children in the family: Sophie (dies 15 years old), Andreas (dies 30 years old), Laura, and Inger.

1864 The family moves to Kristiania (Oslo).

1868 Mother dies of tuberculosis, 30 years old.

1880 Munch begins to study drawing and painting after one year at Technical School.

1884 After his first exhibition (1883) Munch becomes acquainted with the Kristiania Bohemian crowd – Hans Jaeger *et al*.

1885 First stay in Paris.

1886 Causes sensation and scandal with *The Sick Child* at the Autumn Exhibition in Kristiania.

1888 Visits Copenhagen, becomes acquainted with contemporary international trends.

1889 First solo exhibition in Norway, about 110 works.

1890 Lives in St. Cloud outside Paris, frequents Bonnat's School of Art.

1891 Travels to Nice, and then around Europe.

1892 Exhibition opens in Berlin creating a scandal, which leads to formation of the Berlin Secession. Meets Strindberg in Berlin.

1893–94 Berlin – associates with a group of artists from Scandinavia and elsewhere, with Strindberg as the central figure.

1896–98 Paris, Brussels, Kristiania – travels and exhibits, meets Tulla Larsen for the first time.

1899 Nasjonalgalleriet in Kristiania buys its first Munch. Travels around Europe, takes part in the Venice Biennale, has chronic alcohol problems.

1900–02 Sanatorium in Switzerland, travels about, Kristiania, Berlin, works on graphics.

1903–04 Berlin, exhibits in Vienna and Paris, stays in Weimar, Kristiania, Copenhagen, Lübeck.

1905–07 Major exhibition in Prague, stays in Chemnitz, Bad Kösen, Weimar, Berlin, the Reinhardt frieze is completed.

1908 Berlin, Paris, Warnemünde: nervous breakdown in Copenhagen, admitted to Dr. Jacobsen's clinic for six months.

1909 Lives in Kragerø south of Aasgaard beach by the Oslo fjord. Prepares the Aula decorations.

1910 Buys Ramme in Hvitsten by the Oslo fjord, continues work on proposals for publicly commissioned art.

1911–16 Stays along the Oslo fjord, interrupted by a series of journeys to Paris, Berlin, London and other cities. Impressive presentation at the Sonderbund Exhibition in Cologne in 1912, receives high honours on 50th birthday, 12 December 1913.

1916 Purchases Ekely just outside Oslo, where he lives until his death, Aula decorations are unveiled.

1917–21 Exhibitions in Copenhagen and Stockholm, travels to Bergen, Gothenburg, Paris, Berlin and Frankfurt.

1922 Major exhibitions in Zurich, Bern, and Basle.

1923–25 Exhibitions in Europe, becomes honorary member of various academies.

1926–28 Munch's sister Laura dies, extensive travels through Europe, retrospective exhibitions in Berlin and Oslo.

1929 Builds studio at Ekely.

1930–32 Struck by a haemorrhage in the eye, exhibitions in Zurich and elsewhere.

1933–36 Lives the life of a hermit at Ekely, is nevertheless celebrated on his 70th birthday.

1937–39 Classified in Germany as *entartet* [degenerate], exhibitions in Stockholm, Amsterdam, Paris.

1940–43 Lives secluded life at Ekely, no contact with the German occupation forces, exhibition in New York.

1944 Dies peacefully of a severe cold on the afternoon of 23 January. Leaves all his works to the City of Oslo.

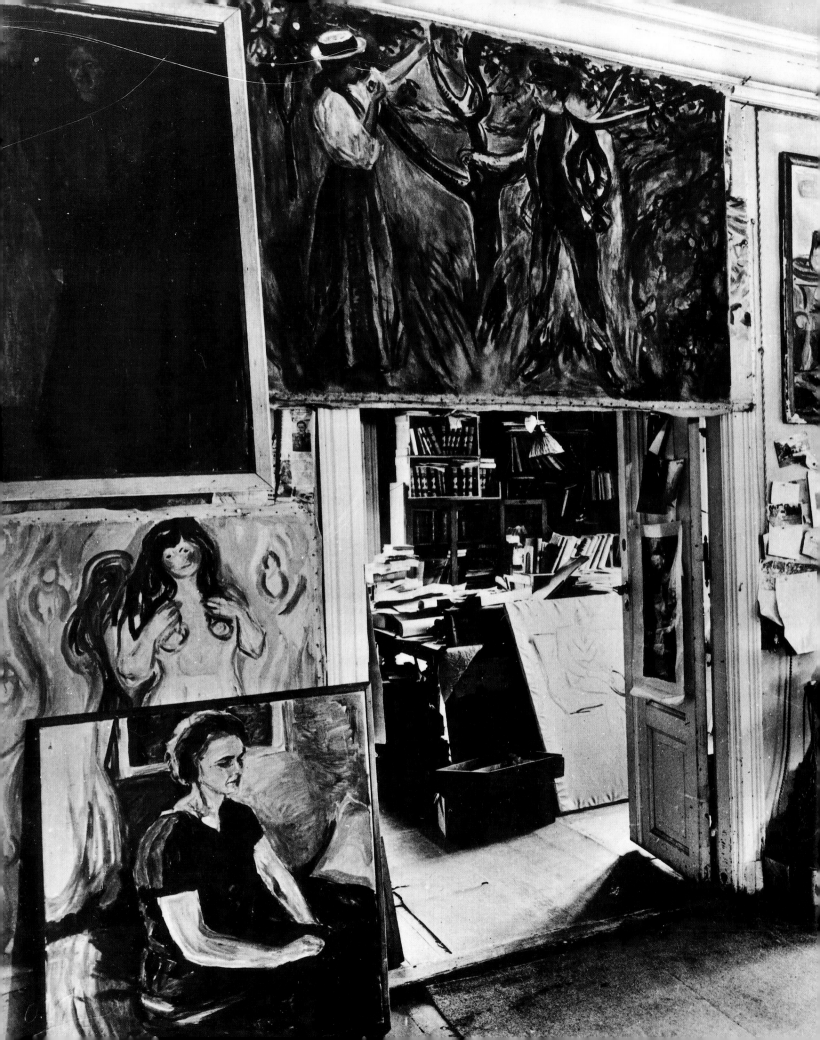

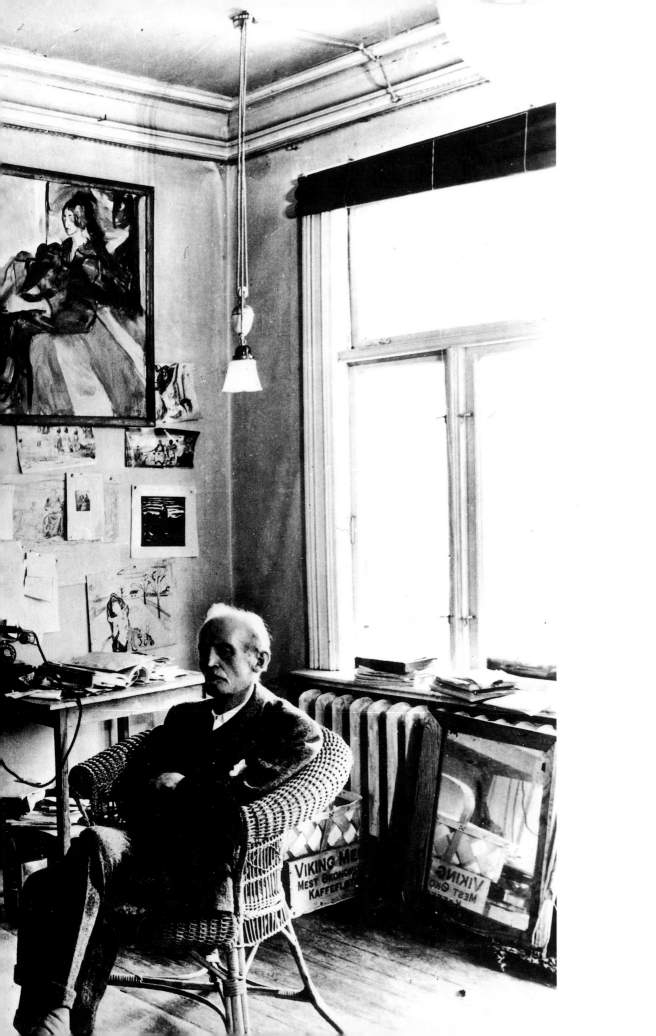

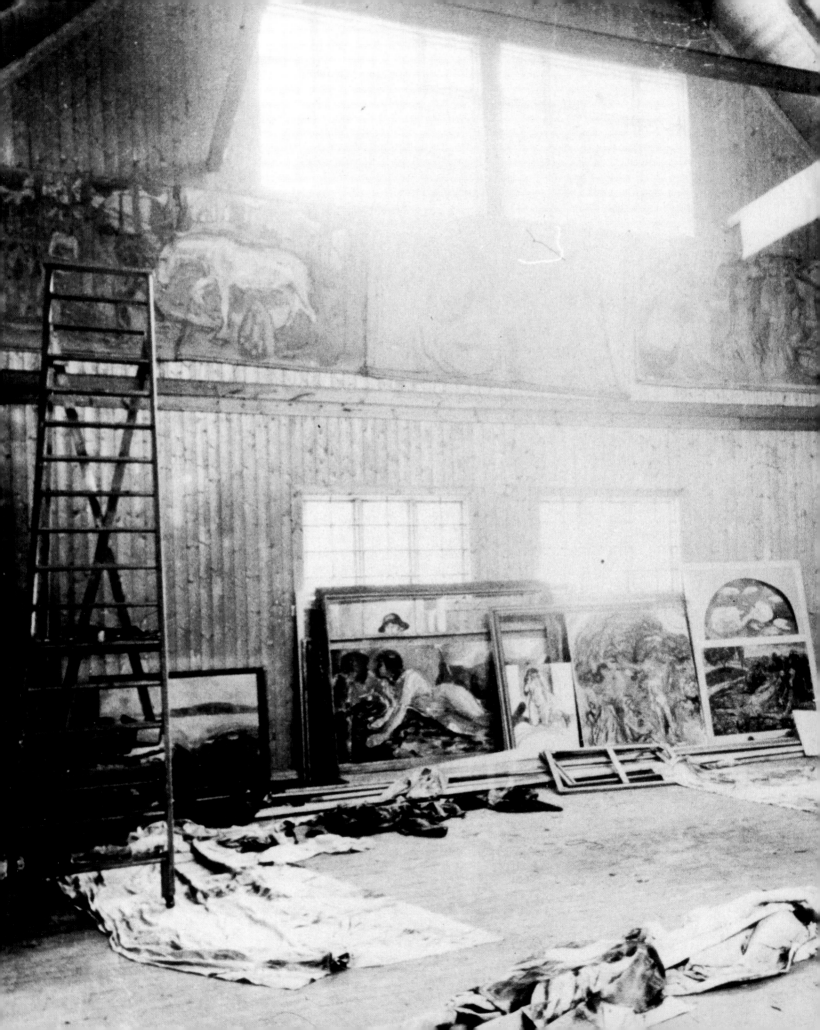

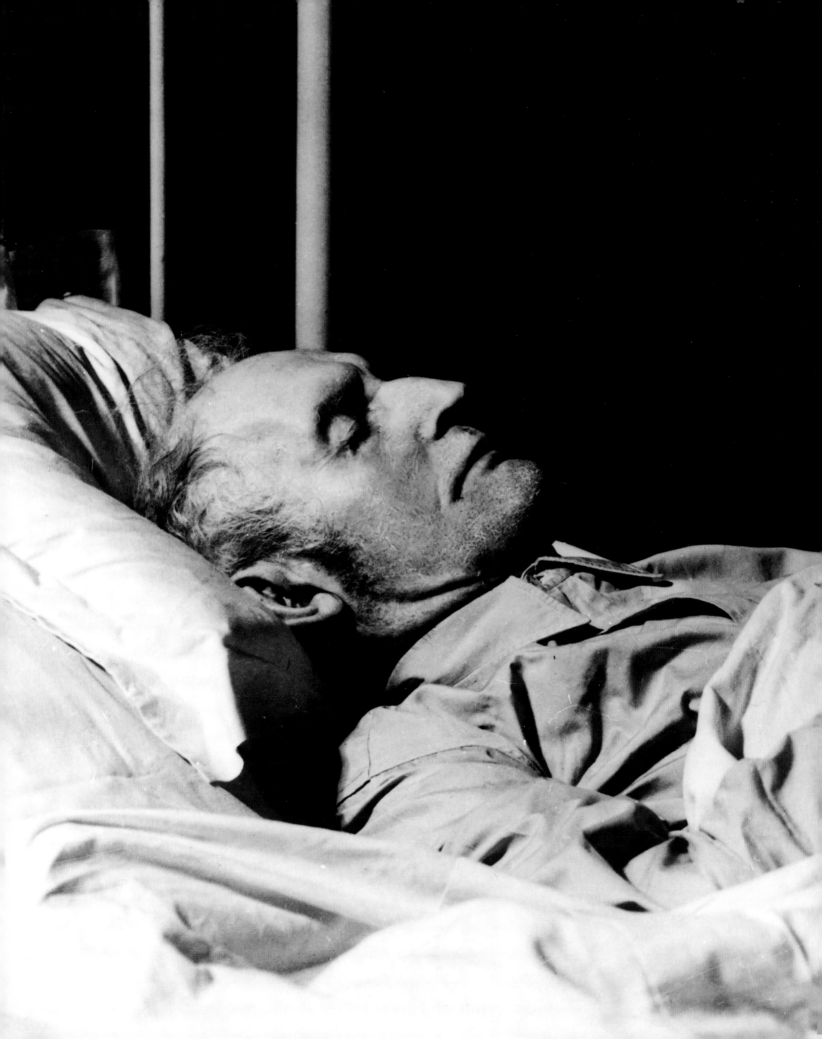

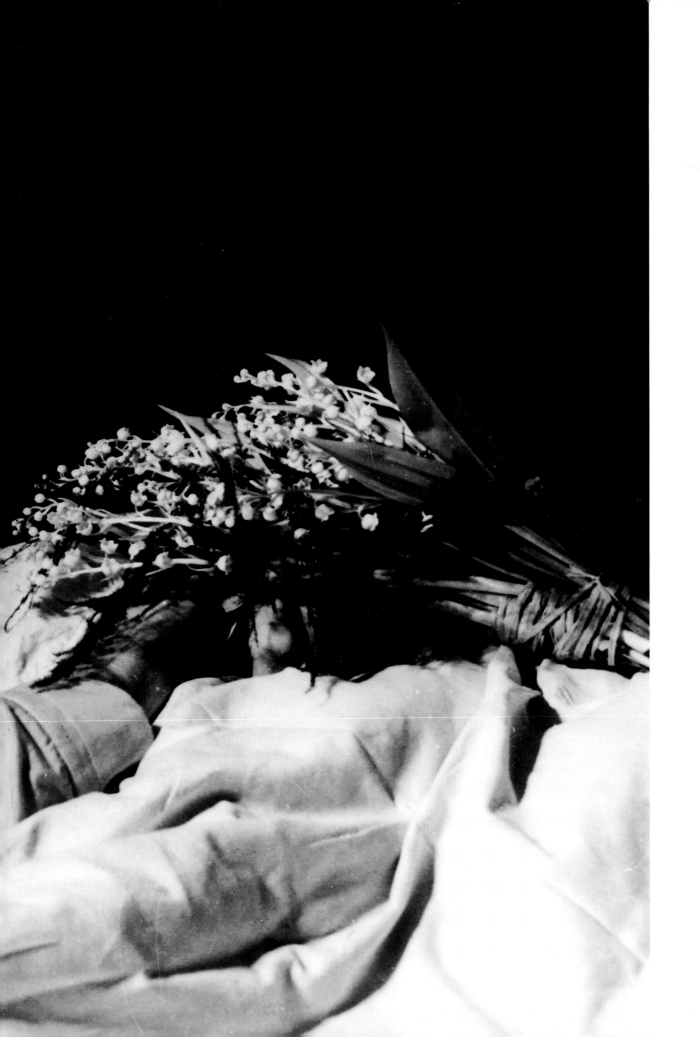

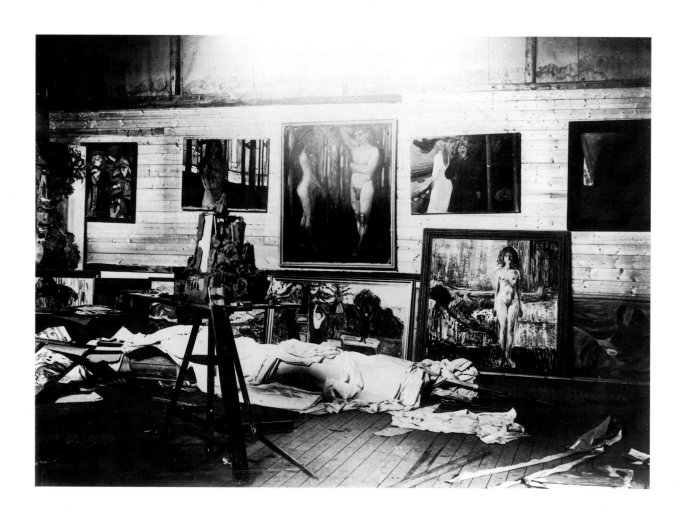

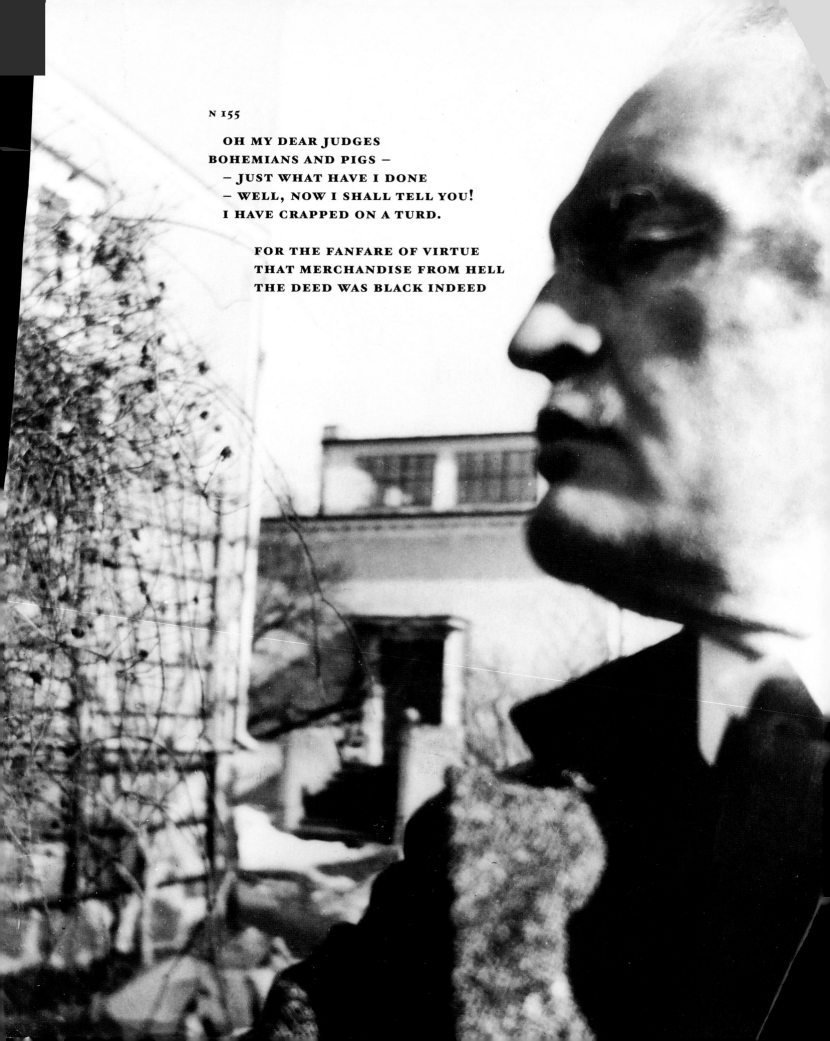

OH MY DEAR JUDGES
BOHEMIANS AND PIGS —
— JUST WHAT HAVE I DONE
— WELL, NOW I SHALL TELL YOU!
I HAVE CRAPPED ON A TURD.

FOR THE FANFARE OF VIRTUE
THAT MERCHANDISE FROM HELL
THE DEED WAS BLACK INDEED

Munch's dogs on the day of Munch's funeral, January 1944.